OTHERWORLDS

OTHERWORLDS

THE ART OF NANCY SPERO AND KIKI SMITH

edited by Jon Bird

BALTIC

REAKTION BOOKS

Published by Reaktion Books Ltd in association with BALTIC

Reaktion Books Ltd
79 Farringdon Road
London ECIM 3JU, UK

www.reaktionbooks.co.uk

First published 2003

This book is published to accompany an exhibition held at BALTIC

Printed and bound in Italy by Graphicom Srl

British Library Cataloguing in Publication Data

Otherworlds : the art of Nancy Spero and Kiki Smith
 1. Spero, Nancy, 1926– – Criticism and interpretation
 2. Smith, Kiki, 1954– – Criticism and interpretation 3. Art, American – 20th century
 I. Bird, Jon
 709.7'3'09045
 ISBN 1 86189 188 1

Contents

Acknowledgements

The research and preparation for this book and the exhibition that it accompanies have been made possible by an award from the Arts and Humanities Research Board and Middlesex University.

Sune Nordgren, Director of the Baltic Centre for Contemporary Art, Gateshead, Tyne and Wear responded immediately and positively to my proposal for a major exhibition on the work of Nancy Spero and Kiki Smith and contributed significantly to making this publication possible. Vicki Lewis provided invaluable support through-out the early stages of exhibition planning and Wendy Lothian meticulously transcribed and ordered the artists' CVs. The New York galleries of both artists have been extremely helpful in providing background information and illustra-tions, in particular Susan Dunne, Emily-Jane Kirwan and Jon Mason at PaceWildenstein, and Mary Sabbatino at Galerie Lelong. Kiki Smith's studio assistant, Zachary Wollard, aided and abetted in background information on her works and, as always, Samm Kunce and Alexandra Sax were invaluable in support and advice on Nancy Spero's works, as was Leon Golub, who knows the debt I owe him over many years of friendship and dialogue. I would also like to thank the other contributors to this book for responding so enthusiastically to my invitation to reflect upon the art of Nancy Spero and Kiki Smith and who tolerated in good spirit my editorial bullying and coaxing over their texts. Friends and colleagues also gave me valuable feedback and support at various stages, in particular Gill Perry and Lisa Tickner. My publishers, Reaktion, have again been patient and enthusiastic supporters in realizing this project.

I would like to thank the various lenders to the exhibition, both private collectors, galleries and museums in Europe, North America and Canada.

Finally, my gratitude to Nancy Spero and Kiki Smith for their time and generosity in particip-ating fully in this exhibition and this publication and for their extraordinary art: it is through their work that we come to know ourselves, our bodies and our (other) worlds.

LENDERS TO THE EXHIBITION

For Nancy Spero: The Artist and Galerie Lelong, New York; Crown Gallery, Brussels; Vancouver Art Gallery; Rhona Hoffman Gallery, Chicago; Barbara Gross Galerie, Munich; Renata and Gabriel Mayer, Munich; Museum of Modern Art, New York; National Gallery of Canada, Ottawa.

For Kiki Smith: The Artist and PaceWildenstein Gallery, New York; Milwaukee Art Museum; The Dakis Joannou Collection Foundation, Athens; Whitney Museum of American Art, New York.

Notes on the Editor and Contributors

JON BIRD is Professor of Art and Critical Theory at Middlesex University, London. He is an independent curator and writer on contemporary art. In 2000–01 he curated the retrospective of the artist Leon Golub for the Irish Museum of Modern Art, Dublin, the South London Art Gallery, the Albright Knox Museum, Buffalo, and the Brooklyn Museum, New York. *Leon Golub: Echoes of the Real* (2000) accompanied the exhibition. He is co-editor (with Michael Newman) of *Rewriting Conceptual Art* (1999), and has contributed essays to books on *Nancy Spero* (1996) and *Hans Haacke* (forthcoming).

ROSETTA BROOKS is a writer, critic and founder of *ZG* magazine, London and New York. Her art criticism has appeared in numerous publications including *Artforum*, *Art in America*, *Flash Art* and *Frieze* and she has written catalogue essays for Edward and Nancy Keinholz, Robert Rauschenberg and, most recently, the Guy Bourdin exhibition at the Victoria & Albert Museum, London. She wrote the Survey essay on Richard Prince for a monograph on the artist (2003). Rosetta Brooks is the Director of the Graduate Program in Art Criticism and Cultural Theory at the Art Center College of Design, Pasadena, Southern California.

JO ANNA ISAAK is Professor of Art History at Hobart and William Smith College, Geneva, New York, and an independent curator and writer. She is the author of *Feminism & Contemporary Art: The Revolutionary Power of Women's Laughter* (1996) and many articles on contemporary art and critical theory including the catalogue essay for Kiki Smith's exhibition at the Whitechapel Art Gallery, London, in 1995. Jo Anna Isaak has also written extensively on Nancy Spero. She wrote the catalogue essay for the exhibition *Notes in Time: Leon Golub and Nancy Spero* (University of Maryland Baltimore County, 1995) and contributed to the monograph *Nancy Spero* (1996). An exhibition that she curated on water and the human body is currently touring the US. She lives in New York City.

ANN REYNOLDS is an Associate Professor in the Department of Art and Art History at the University of Texas at Austin. Her book, *Robert Smithson Learning From New Jersey and Elsewhere*, was published in 2003 and she is currently working on a new, book-length project on Ruth Vollmer and artistic communities in New York during the 1960s and '70s. She has most recently contributed an essay on Minimalism to the third volume of the Open University's forthcoming *Art of the Twentieth Century*.

MARINA WARNER is a freelance writer, critic, academic and curator living in London. She curated (with Sarah Bakewell) *Metamorphing*, an exhibition for the Wellcome Trust on transformation in art and science, which included Kiki Smith's 'Harpie', at the Science Museum in London (2002–3). She is the author of many books and articles on a range of subjects, including *Monuments and Maidens* (1985), and of several studies in mythology, most recently *Fantastic Metamophoses: Otherworlds* (2002). Her fictional writing includes a collection of short stories, *Murderers I Have Known* (2002), and she has recently published *Signs and Wonders* (2003), a collection of essays.

Foreword

SUNE NORDGREN

When Nancy Spero raised her voice and became an influence and inspiration for a generation of women artists, Kiki Smith, just recently arrived in New York, was intrigued and challenged by what she saw. But her first reaction to Spero's work was mixed with concern that the impact of this powerful yet vulnerable work was too exposed to the culture's destructive impulses. It was this combination of sacrifice and anger, fragility and strength, that brought the two artists together.

What now unites them is fundamental and indestructible, a strong and confident practice, embedded and balanced in the female body, provoking an identity articulated by a new, true voice.

It is an honour for BALTIC, and a milestone in this young institution's phase of establishing its international credibility, to be able to arrange an exhibition of major works by both Nancy Spero and Kiki Smith.

This exhibition has been made possible thanks to the contribution of several committed individuals and to generous lenders of key works by the artists. First of all a heartfelt thank-you to Jon Bird, the initiator and curator of the exhibition, who worked closely with the BALTIC team to create this unique dialogue; to all the staff at BALTIC who have worked on the exhibition; and to the authors of the thought-provoking essays in this book that provide the artistic and historical contextualization for Nancy Spero's and Kiki Smith's 'otherworlds'.

Most importantly, we are deeply grateful to the two artists for their immediate support for the project, their ongoing commitment and invaluable critique, and for their contribution to the installation and final creation of the exhibition.

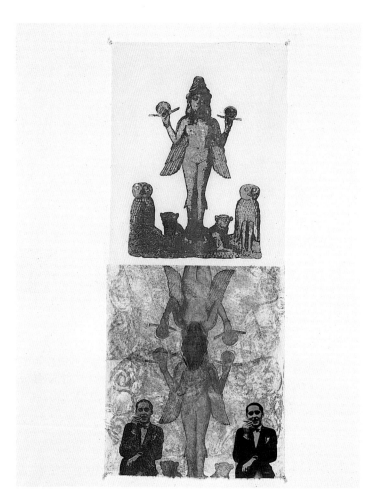

1 Nancy Spero,
Lilith, 1992, hand-
printing and printed
collage on paper,
116.8 × 49.5 cm. (46 ×
19.5 in.).

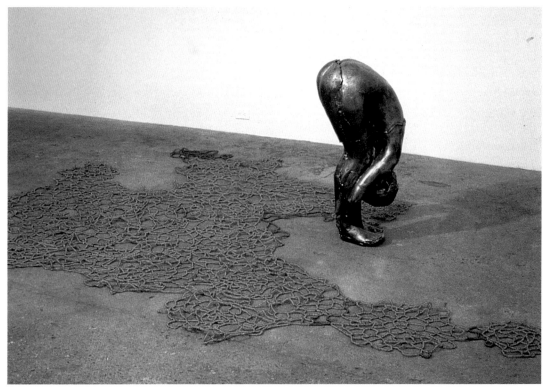

2 Kiki Smith,
*Untitled III (Upside-
Down Body with
Beads)*, 1993, white
bronze with glass
beads and wire,
figure: 94 × 37.5 ×
48.3 cm. (37 × 15 ×
19 in.); beads: 375.9
× 190.5 cm. (148 × 75
in.), installation
dimensions variable.

Imagining Otherworlds: Connection and Difference in the Art of Nancy Spero and Kiki Smith

JON BIRD

Feminism should go on asking for too much, or rather for things which have often
been deemed politically incompatible, even by feminism itself. To struggle for justice,
go in to the dark and hold on to the immeasurable nature of happiness.

JACQUELINE ROSE[1]

Nancy Spero and Kiki Smith are both artists who 'ask too much': greedy in their creative imaginations, they have – for fifty years in Spero's case, more than twenty for Smith – made art that is both formally and conceptually excessive, in scale, content, material and technique, fashioning visual languages, working with and against the signs of meaning that constitute art's language to trace the disposition and expressivity of the body. Everything starts with a name, and the title given to this book and the accompanying exhibition of these two artists needs some explaining. It emerged from the long process of examining their artwork and thinking about their connections and differences, and the particular configuration of their aesthetic imaginations. The most obvious difference – flat surface or sculptural form – exists only at a general level. Spero's work, through scale and, particularly, her printing onto the surface of walls and buildings, introduces considerations of space and the body central to our experience of the physical world, and Smith has always explored her ideas both sculpturally and graphically, moving freely between mediums and processes, from modelling and casting to drawing, printmaking, photography and installation. Beyond the thematic relations and certain similarities in their technical and

productive processes, then – the use of paper, the attention to surface, colour and texture – something else seems to run through their art, which finally, I believe, comes down to the fashioning of convincing alternative visual scenarios for our encounters with the world; of how the world we inhabit and struggle with and against in our daily lives is, simultaneously, the world of cultural and religious myths, and that these also press, consciously and unconsciously, upon social being. So, at first I had been simply descriptive – 'the art of Nancy Spero and Kiki Smith', but after a while 'otherworlds' presented itself, with all the connotations of the relations between self and other, the difference that is gender, the feminization of the body that is the (m)other, and the contradictory promise of a redemptive aesthetic formed in the imaging of other visions for our sense of embodiment.

Since the 1970s feminist critics and art historians have been asking whether there is a difference[2] to the art made by women, or, perhaps more specifically, how the social and historical circumstances of gender might be integral to deciphering the patterns of meaning emerging at the intersections of subjectivity and art-making. Perhaps this is no more than to say that art is made out of the narratives of individual histories

3 Nancy Spero,
Codex Artaud VI,
1971, typewriter and
painted collage on
paper, 52.1 × 316.2
cm. (20.5 × 124.5 in.).

and experiences (including the imagined worlds of the unconscious – its phantasies and repressions) formed from and against the cross-currents of the culture, in Raymond Williams's famous formulation as 'a whole way of life'. Certainly the art of Nancy Spero and Kiki Smith has been formed by the historical conditions of feminism and the Women's Movement in America (however fractured and conflicted these formulations now appear), and in their working-through the contradictory spaces of the New York art scene from the early 1960s to the present.

Spero's experiences as a 'first generation', postwar American feminist artist – a member of the Art Workers Coalition (AWC) and Women Artists in Revolution (WAR), of picketing the Whitney Biennial of 1970 for its exclusion of women artists, co-founder in 1972 of AIR (Artists in Residence), the first women's alternative gallery in New York – were the visible and public expressions of the exclusion and alienation experienced by most women artists in the aftermath of Abstract Expressionism and the engagement of younger male artists in the iconography of popular culture and mass media imagery.[3] During the 1970s Spero developed a powerful metaphorical visual language combining word and image, first discovering in the anguished writings of the French poet Antonin Artaud an equivalent voice to her own sense of angry disempowerment, which resulted in the *Artaud* drawings and her first 'scroll' – the *Codex Artaud* (1971; illus. 3) Following this, she extracted from the documents of Amnesty International gut-wrenching testimonies to women's suffering, personal narratives of female victims of the prison houses of totalitarian regimes, which she recorded on a bulletin typewriter directly onto the delicate surface of handmade paper and set them along-

opposite page
4 Kiki Smith, *Hard Soft Bodies*, papier-mâché, life size.

side collaged images of imaginary creatures and human figures, making her first explicitly feminist work – *Torture of Women* (1976).

Kiki Smith's remark to Jo Anna Isaak on her response on first seeing Spero's work: '. . . you are going to get killed making things like that . . .', is completely understandable, as is her recognition of Spero (along with Louise Bourgeois and Eva Hesse) as a significant early influence. Artaud has also been an important figure for her, an interest instigated by seeing Spero's *Artaud* drawings and, in an interview with Sylvère Lotringer, she traced the connective links between her own approach to drawing as mediated through Spero's interpretations and the material qualities and linear energy in the visualizations of the 'mad poet':

The way Nancy Spero drew, the way she combined the aggressive language of Artaud with the aggressiveness of the physicality of her drawings made me want to look at his drawings. That kind of erasing and annihilating images. The self-mutilation, too, the anger and hatred, either self-hatred or the hatred of other people. It's both aggressive and pleasurable.[4]

Smith grew up in an artistic household – Jane, her mother, was an actress and opera singer, and her father, the sculptor Tony Smith, was a central figure in American art of the 1960s–70s. Trained as an architect, his geometrical and modular sculptures were definitive of Minimalism's emphasis on physicality and relation to the viewer, and in his iconic work – *Die* (1962), a 2-metre (6 ft) steel cube – the Vitruvian proportions prefigure Kiki Smith's own concerns with the body as a spatial and material presence.

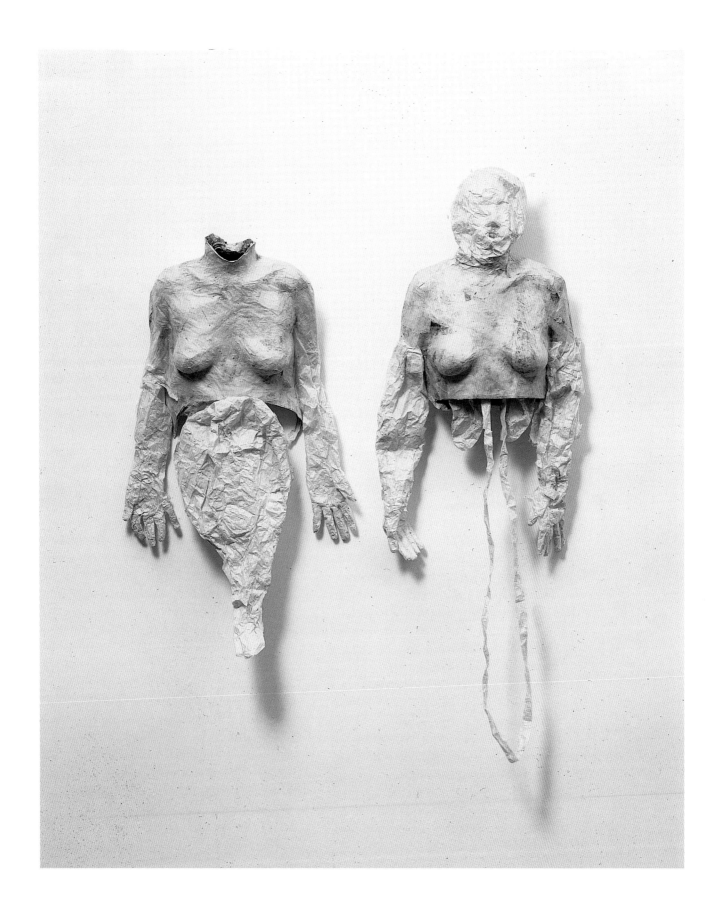

In 1976 Smith moved to New York, the same year that Spero began compiling the texts and images for her monumental 25-panel scroll *Notes in Time on Women* (1976–9), and, after various part-time jobs to support herself, she joined the artists' collective 'Collaborative Projects Inc.' (COLAB), one of several alternative activist groups (others of note include 'Group Material' and 'Fashion Moda') using non-gallery spaces and opening up New York's Lower East Side as a cultural environment. In 1979 COLAB took over an empty building owned by the City for the 'Real Estate Show', a mixed-media event that critiqued New York housing policies and, in 1980, the group occupied a former four-storey bus depot and massage parlour near Broadway and West 44th Street for the 'Times Square Show'. This eclectic exhibition of 100 artists ranged across media and aesthetic forms, from painting and graffiti to film and photography, and from fashion to cross-cultural and hybrid mixtures of sexual and erotic subject matter. It included work by John Ahearn, Jean-Michel Basquiat, Nan Goldin, Keith Haring and Kiki Smith, who exhibited paintings whose content derived from illustrations in Gray's *Anatomy*. (In the mid-1980s both Smith and her sister Beatrice studied for a time to become emergency medical technicians, an education that provided a practical supplement to her interest in the structure and workings of the body.)

Although the critical and theoretical discourse of feminism and the possibilities for practice had substantially shifted and grown by the time that Smith was becoming recognized in the mid-1980s, the key terms of debate, and increasingly central to the visual arts in particular, were issues pertaining to the representation of the (female) body, to sexuality and the framing of the feminine – a politics of identity formed from the radical social movements of the 1960s, but recasting the body as 'a construction, a representation, a place where the marking of sexual difference is written'.[5]

BODIES THAT MATTER

For both artists, it is the body that carries the trace of culture, memory and history (illus. 4). Foucault, following Montaigne (whose essay 'Of Experience' describes his own experience through the exigencies of the body), has drawn our attention to the body-as-text, a construction that, through its modalities and materiality, attests to lived experience and social being: a body, moreover, whose dispositions and inscriptions changed according to the reigning regimes of truth, for example, from torture to surveillance.[6] In addition, as artists living and working in New York in the aftermath of '9/11', the body has become present in ways that could not have been predicted. Both artists were in the city on the day that the Twin Towers collapsed, and the ensuing media images that saturated daily life conveyed the awful reality of the body's vulnerability – of actual bodies vaporized in the moment of implosion and of the damage to the symbolic body, a scar across the collective psyche of a nation suddenly awoken to the knowledge of its exposure to assault from unknown and unpredictable sources.

The body is symbolically and psychically invested, subject to the culture's founding and contemporary myths, the narratives of the sacred and profane body that invest lived experience with significance beyond our everyday engagement with the world of things: 'We are at once the beneficiaries and the victims of our mythological tradition as we are of our linguistic and social traditions, one of the differences being that our mythological conditioning is more difficult to perceive.'[7] Both Spero and Smith make art that, to some extent, invites us to consider what images of redemption are possible in a post-Freudian, secular anthropology. If life is lived always already estranged from the ground of its being (Nietzsche) and in a state of cultural despair (Adorno), what is left for the work of art other than the production of images that either

confirm that diagnosis, abandon all serious endeavour and celebrate the power of the spectacle and the consolation of things, or to attempt to recover something of the past's criticality as it presses upon the present and speaks to the future. This is, in Adorno's conception of 'negative dialectics', an aesthetic of contradiction. Redemption exists only in the guise of its refusal, the necessary incompleteness of the (art)work attesting to the impossibility of transcendence – 'artworks that unfold to contemplation and thought without any remainder are not artworks' – imagining a world in which 'nothing similar [Auschwitz] will happen' whilst simultaneously rejecting the illusion of reconciliation.[8] Something must always be withheld from meaning, remain an open question; if no longer the possibility of transcendence, then, at best, offering the world as otherwise: of fashioning otherworlds.

Bodies, specifically the female body, are the semantic units of the visual language of Nancy Spero and Kiki Smith, a language whose grammar is drawn from the characters of mythology, scripture, history and the contemporary world: an expressive visual poetics of movement, gesture, colour and form – the embodied subject travelling a route from interiority to exteriority, from victimization to liberation, abjection to wholeness and unity. (We should note, however, that although Smith's works selected in discussion with the artist for the exhibition that this publication accompanies focus upon the figure, she has explored a very wide range of themes in a variety of media, and that issues of embodiment, corporeality and the shadow of our mythological traditions shape all aspects of her practice.) And besides the thematic and cultural factors that illustrate the associative links in their respective practices, and that I shall shortly come to, there are the formal and textual elements of the works themselves, the physical properties of surface inherent in handmade paper printed and over-printed with colour and image. These

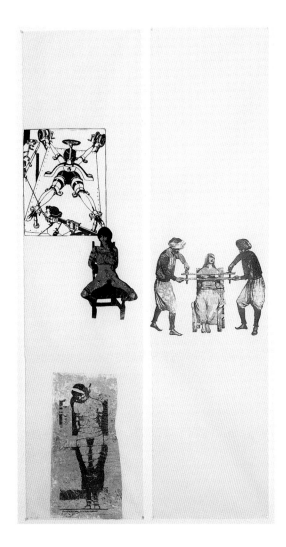

5 Nancy Spero, *Victimage*, 1990, diptych, hand-printed collage on paper, 209.6 × 50.8 cm. (82.5 × 20 in.).

include the plastic tension between fragility and strength, the decorative with its connotations of craft, and the skills of hand/eye coordination employed by both as a tough and subversive play with form against propriety and the judgement of (good) taste, the carnivalesque inversion of the codes and regulations of social normality opening the work to fantasy, and encounters with alterity as a reframing of the self. Here in their individual patterns of meaning the visual worlds of Nancy Spero and Kiki Smith find their reciprocity.

Suppose we consider the shifts in their respective practices not as narratives of artistic development or progress, or the evolution of a

signature style, but more as a movement in and out of focus of certain central and repetitive themes, where each return is modified slightly by its altered context – pattern and decoration, mythical and historical reference, the invaded body and the body-made-whole, the sacred and the profane, flesh and spirit, singularity and series. Taking this framework we can discern similarities between Spero's mapping of the figure, from an emphasis upon the body in pain (victimage) (illus. 5) to the dance as a symbolic image of freedom and choice (in her installations the figures literally dance across walls and into space), and Smith's initial modelling and casting of bodily parts and functions (abjection) (illus. 6) to her engagement with the whole figure and images of restoration and unity. In both cases their imaginative explorations are conducted with reference to foundational cultural myths – the archaic goddess, the Judaeo-Christian

Creation story and its antecedents, the Law of the Father (the origins of patriarchy), the 'outsider', the hybrid and the cyborg, and all those transgressive figures from legend, myth and folk tales that erupt into and subvert normative social narratives and traditions (illus. 1). Many women artists in the 1970s were interested in mythologies of the Goddess, for example, Carolee Schneeman, Buffie Johnson and Mary Beth Edelson, and the feminist journal *Heresies* devoted its issue of Spring 1978 to 'The Great Goddess'. This has been seen as part of a broader 'cultural feminism' in America that also incorporated environmental concerns, a renewed sense of the possibilities of nature as a source for both imagery and renewal, and a general 'primitivizing' tendency across the art of the period. It should be clear, however, that I am suggesting that Spero's and Smith's appropriation of figures from mythology is both selective and reflexive.[9]

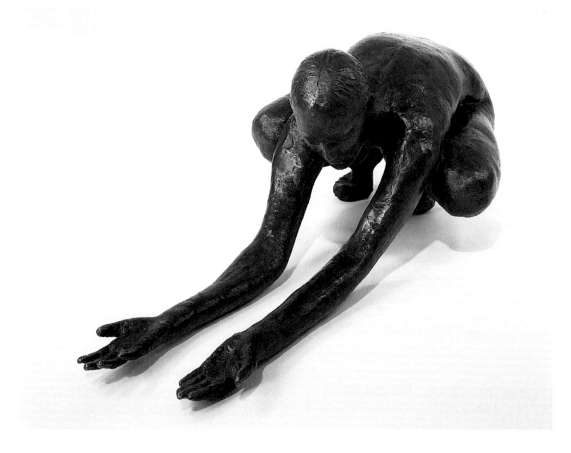

6 Kiki Smith, *Untitled*, 1992, bronze with patina, 139.7 × 71.1 × 61 cm. (55 × 28 × 24 in.).

One such shared reference is the Celtic fertility figure, 'Sheela-na-gig', a name derived from the Irish *Sile na glioch* meaning 'sheela of the breasts'. Sheelas vary in shape and size, but, despite the etymological reference, generally conform to the model of a scrawny body with non-existent or tiny breasts but protuberant and hugely exaggerated vulvas, the two lips stretched apart by the figure's hands. 'Fertility figure' is a non-specific archaeological term that can include procreation, protection from evil, a warning against the sins of the flesh, or, in this case, a derivation from the Celtic goddess trinity: maiden-mother-whore. Despite her contradictory connotations (or, perhaps, because of them), Sheela became something of a feminist icon – an exhibition of the power of female sexuality, and sharing an iconography with the Indian death-goddess Kali (illus. 7). Sheela also invokes that aspect of the aesthetic described by Freud and much employed in recent art writing and curating – the 'uncanny'.[10] At the conclusion to his paper, Freud returns the reader to the psychic origins of repetition as trauma – death and abjection, and to the male's (mis)recognition of our own origins; our 'home' (*heimlich*) in the mother becomes 'unheimlich' through the culture's repression of her sexual body, which represents the threat of an engulfing or castrating femininity. In Spero's repetitive figuring of Sheela-na-gig throughout her scrolls and installations, and in Smith's depictions of displayed female genitalia – for example, *Untitled III (Upside-Down Body with Beads)* of 1993 (illus. 2), which she refers to as her Sheela figure, the carnivalesque surfaces

as an offence against the Law (the patriarchy), a Dionysian disturbance of social and sexual taboos that confront the viewer with the undeniable evidence of an actively sexual, female body. (Smith's *Peacock* of 1994 might well be seen as another Sheela work, for although the female figure is portrayed sitting on the floor tightly holding her knees to her body in a gesture of protection, she nevertheless trails lengths of string leading to repeated drawings of vaginas attached to the nearby wall: what is concealed in the body's gesture is revealed in the mind's imaginings.)

OF MYTHS AND OTHER THINGS

If a recourse to the figures of mythology for subject matter to reconnect with the contemporary and embodied (female) subject of history is common to both artists, another shared thematic is their reference to scripture and the sacred. Julia Kristeva has distinguished between 'historical time', the time of political movements and social change, and 'monumental time', the female body's temporality, marked by the capacity for mothering. For Kristeva, 'women's time' is measured in terms of 'repetition' and 'eternity', the cyclical rhythms of the body and resurrection myths traced in the cults of maternity that occur throughout many cultural traditions, most recently embodied in the figure of the Virgin Mary.[11] In their representations of the body's dispositions and cultural significations, Smith and Spero frequently associate these temporalities,

7 Nancy Spero, *Chorus Line*, 1985, printed collage on paper, 50.8 × 279.4 cm. (20 × 110 in.).

8 Nancy Spero, *The First Language* (detail of panel 7), 1981, hand-printing and printed collage on paper, 0.5 × 57.9 m. (20 in. × 190 ft).

sometimes in a single work, for example, Spero's *The First Language* (1980–81; illus. 8) and Smith's *Milky Way* (1993; illus. 9). I have previously written on Spero's relation to Judaeo-Christian texts, in particular the place of the word as a signifier of both presence (the speaking subject) and absence (that which cannot be spoken), of a dialogue between body and voice, flesh and word.[12] In her borrowing of images of women, the depictions of the suffering body frequently refer to the torture of Jews and the Holocaust (for example, *The Jews Whore*, 1990; *Goddess Nut and Torture Victim*, 1991; or the large temporary installation *The Ballad of Marie Sanders / Voices: Jewish Women in Time* at the Jewish Museum, New York, 1993; see illus. 10). Spero has recognized her split identity resulting from a double exclusion from the culture as both woman and Jew, and to this can be added her identity as an embodied subject – the constant everyday experience of the pain caused by progressive arthritis. As Elaine Scarry argues, 'the scriptural (exposes) with startling clarity the depth of moral and psychic categories that are eventually invested in material culture. To the question, "What is at stake in material making?", the Hebrew scriptures answer, "Everything".[13]

Kiki Smith's ambivalent and complex relation to Catholicism – again Raymond Williams's words come to mind, of 'a power that has to be recognized and resisted' – informs such works as the decidedly non-idealized male and female figures of *Untitled* (1990; illus. 29), the vulnerable

écorché body of *Virgin Mary* (1992; illus. 11), the chained and hair-covered *Mary Magdalene* (1994; illus. 37), the slumped and defeated figure of Christ, *Untitled (Fallen Jesus)* (1995; illus. 30), or, in a different register, the decoratively intricate *Bird Chain* (1993), where she modelled the Holy Spirit as a glass-winged dove. Catholicism's emphasis upon the body's potential for redemption and divinity, and of flesh as the mediation between the sacral and the profane, is prefigured for Smith in her interest in the writings of Thomas Aquinas and in northern European art of the Late Gothic period. In the pre-Cartesian world, Christian theology was dominated by the doctrine of *capax infiniti*. Aquinas's philosophy of the existence of the soul throughout the body, in every cell and particle, provided a belief system that gave rise to the important place of the relic in institutional worship: the saint's spiritual power flowing from the remnants of the fragmented body. Smith's body parts, from the early *Hand in Jar* (1983), *Ribcage* (1987) and *From Heart to Hand* (1989), to the installation works like *Nuit* (1992), *Trinity* (1994) and *Bed With Arms* (1996), make the associational link with this tradition and the contemporary landscape of the body, from the literary to the medical. Furthermore, for an artist so attuned to the role of the hands in the process of fabrication – the indexical trace of the body – Aquinas's placing of touch as the most necessary of the senses, the primary intermediary between the conscious self and the external world, gives emphasis to the acute

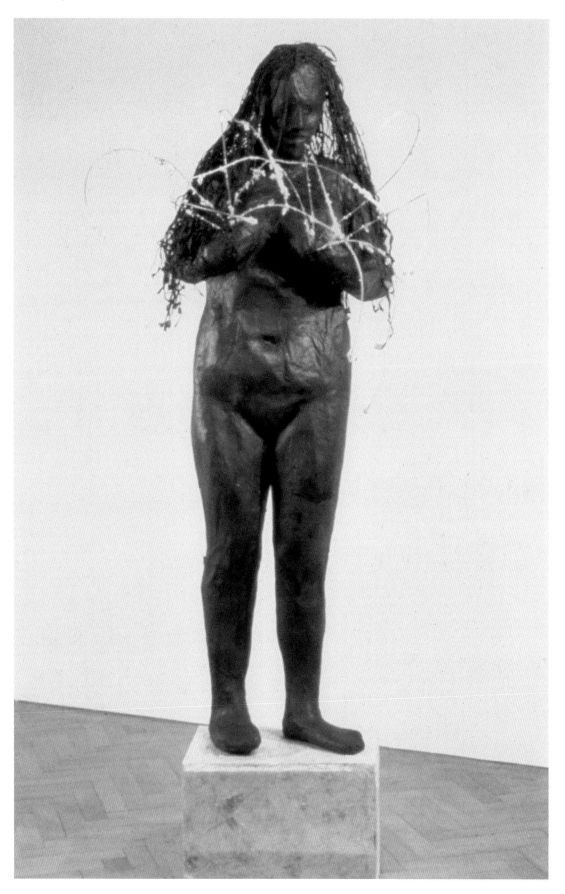

9 Kiki Smith,
Milky Way, 1993,
papier-maché, wire
and white gold leaf,
life-size.

corporeality of her figures, whether fashioned from wax, papier mâché or cast in bronze or other hard material.

Of all Smith's figures, *Virgin Mary* (illus. 11) most clearly represents the pivotal role of touch as both index and symbol in the long tradition of images of the body as either individuated and contingent, or idealized and universal. For Aquinas, a touched body is a corruptible body (as I am writing this, the exhibition of *Titian* at the National Gallery in London includes the profoundly expressive painting *Noli me tangere*, in which the pictorial narrative centres on Christ's body as he twists awkwardly to avoid the Magdalene's inquisitive gesture), so, after the Resurrection, Christ's invitation to his doubting disciple Thomas to plunge his finger into the gaping wound in his side (another canonical work pictures this exact moment – Caravaggio's

The Incredulity of St Thomas) is an essentially bloodless act; nothing flows from this void, the resurrected body is beyond corruption. Smith reverses this testament in her flayed and bloodied sculpture of the Virgin; Mary is the very opposite of the untouched body – the body as wound, arms held away from the bleeding flesh, palms up in a gesture of openness and appeal, displaying the eruption and conflation of interior and exterior, flesh and skin, body and soul (another Titian comes to mind – the extraordinary late *Flaying of Marsyas*); in Christian doctrine, the path to wholeness and redemption lies through pain and suffering, the legacy of the Fall. It is important to recognize, however, that the suffering body does not become the foundation for a transcendental ethics; history interferes with scripture and insistently campaigns against any abdication of responsibility – this is an aesthetics

10 Nancy Spero, *Ballade von der Judenhure Marie Sanders*, 1991, lithograph, 53.3 × 121.9 cm. (21 × 48 in.).

opposite page
11 Kiki Smith, *Virgin Mary*, 1992, wax, cheesecloth and wood with steel base, 171.5 × 66 × 36.8 cm. (67.5 × 26 × 14.5 in.).

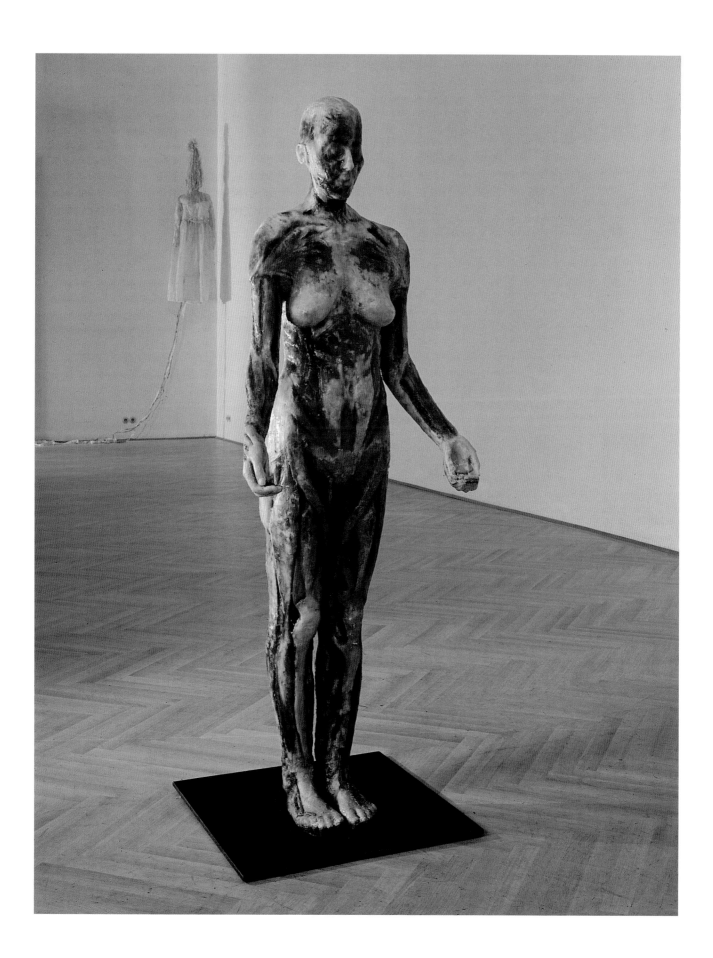

closer to Marx and Freud than the myths of Judaism or Catholicism. Metonymically, the route from wound to vulva, from Christ's body to Sheela, is the reintroduction of sexual difference into the field of representation – a direction taken by many feminist artists during the 1960s–70s as interventions into the Western figurative tradition.

THE DECORATIVE

In a short essay on the American artist Milton Avery, Clement Greenberg states his antagonism to the decorative in art, describing it as 'the spectre that haunts modernist painting'.[14] In fact, a recurrent theme throughout his essays written between the 1940s and early 1960s is the formal struggle of both European and American artists against decorative patterning, a critique that reflected the machine and functionalist aesthetics of early modernist architects and designers, for whom ornamentation posed the same threat. In critical accounts of Renoir, late Picasso, Collage, Kandinsky, Soutine, Easel Painting and many more, Greenberg constructs an argument for the conditions for pictorial innovation as emerging in opposition to the negating effects of the 'purely decorative'; decoration became the excluded other of a genuinely successful pictorial art. Even the 'old master' Picasso was subject to its corrupting influence: '[he] succumbed in the end to unities whose real impact, if not their intended one, was truly decorative in the pejorative sense'.[15] In this account the only artist able to engage directly with the lure of the decorative without risking the loss of imaginative invention was Matisse, who managed to maintain a balance between decorative and structural elements in the painting, effecting a dynamic tension between pattern and surface that transcended the limitations of either.

Both Nancy Troy and Gill Perry have described the shifting aesthetic value of the decorative and the unstable boundary between 'high' and 'low' art, particularly during the period of early modernism in the work of the Symbolists and the Fauve circle.[16] Greenberg, however, attempted to wrest abstraction from the broad category of the decorative and, although avoiding explicitly gendering the opposition between the pictorial and the decorative, in numerous essays (for example, on Georgia O'Keeffe, Stuart Davis, Morris Graves, Alexander Calder) he associates the decorative with craft skills (paint as 'embroidering', attention to detail, surface finish, etc.), a criticism that implicitly referenced a long cultural history equating a devalued and utilitarian aesthetic with the feminine and 'women's work'.[17] A further link in the signifying chain ideologically binding aesthetic values to issues of gender is traced in Andreas Huyssen's mapping of the gendering of mass culture as feminine since the late nineteenth century:

the political, psychological, and aesthetic discourse around the turn of the century consistently and obsessively genders mass culture and the masses as feminine, while high culture, whether traditional or modern, clearly remains the privileged realm of male activities.[18]

Huyssen argues that it has only been the relatively recent recognition of women artists and performers across cultural forms and media practices that has undermined these dichotomies, despite the rejection of such traces within their work by, for example, Eva Hesse and Louise Bourgeois, and, even into the late 1970s, the decorative could still be judged an interference or distraction in the critical artwork of some feminist artists.[19]

These remarks are, I think, a necessary preliminary to discussing how the decorative functions in the art of Nancy Spero and Kiki Smith. An alternative historical reading to Greenbergian modernism, and one that creates

fold-out
12 Nancy Spero, *Azure*, 2002, 39 panels, hand-printing and printed collage on paper, 0.61 × 84.43 m. (24 in. × 277 ft).

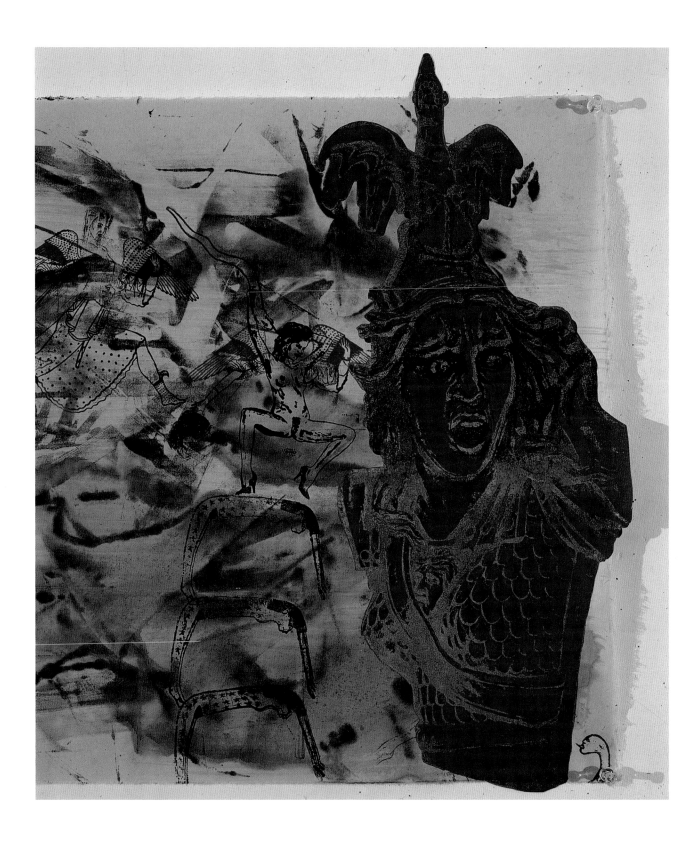

Detail from panel 18.

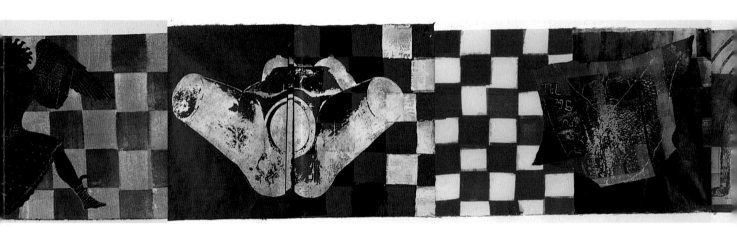

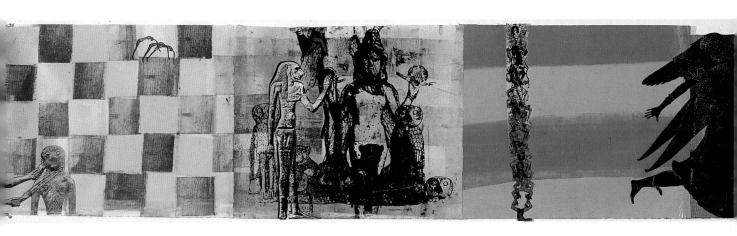

Panels 22, 23, 24 and 34

Panels 1 (*top*), 19 (*centre*) and 35.

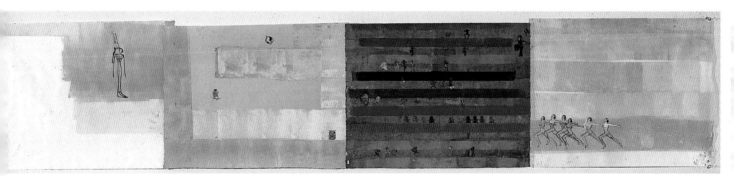

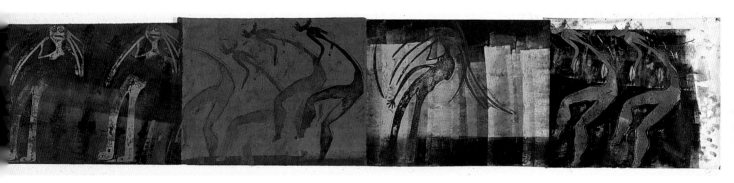

Panels 21 (*top*), 20 (*centre*) and 36.

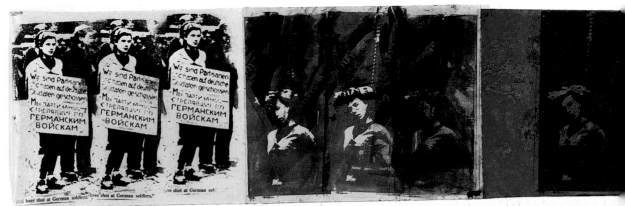

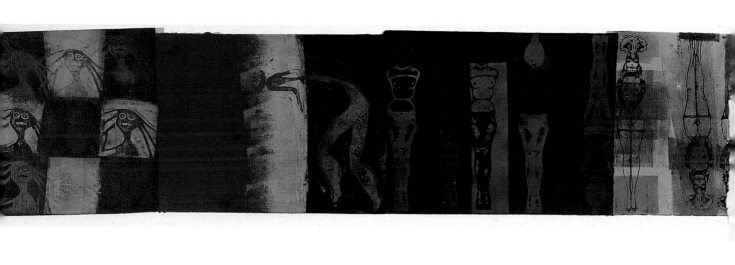

Detail from panel 23.

13 Nancy Spero,
Premiere, 1993, hand-
printing on walls.

a more appropriate genealogy for their practice, is Peter Wollen's reordering of the relations between the decorative and the body in his essay 'Out of the Past: Fashion / Orientalism / The Body'.[20] Recognizing that the decorative is 'almost always taken to distract', Wollen maps the histories of two rival aesthetic models – one that favours the engineer, the machine, the functional and the reductive and which is implicitly coded as masculine; the other stresses the body, fashion and the dance, all of which carry the cultural connotations of the feminine. In this alternative modernism, the role of the Russian Ballet and its associated artists, designers and choreographers was pivotal – not only in the performing and decorative arts, but for introducing a whole new erotics of the body that filtered into and shaped the early avant-gardes, particularly Surrealism, as both a practice and a politics. In reclaiming this territory, the initial tendency of critics and historians was to recognize the equal validity of craft-based and decorative forms and practices,[21]

whereas Wollen's analysis, following a trajectory from Revolutionary Russia, through Surrealism and George Bataille's celebration of waste and excess as economies of desire, to the transgressive street cultures of postmodernity, makes a case for the deconstruction of the familiar oppositions that have defined modernism. Now the decorative is seen as always intruding a subversive presence within the modern, unravelling its myths of progress, autonomy, masculinity and order.

This framework seems to me a much better structure for analysing the function of the decorative for both Spero and Smith. Whether it is located in Spero's phantasmagoria of hybrid forms dancing along hand-printed backgrounds of dramatic colour and texture, or spiralling across the walls and interior spaces of her installations, laying claim to a utopian architectonics of movement and freedom, or Smith's introduction of decorative elements to disrupt the sanctity of material or art-historical reference –

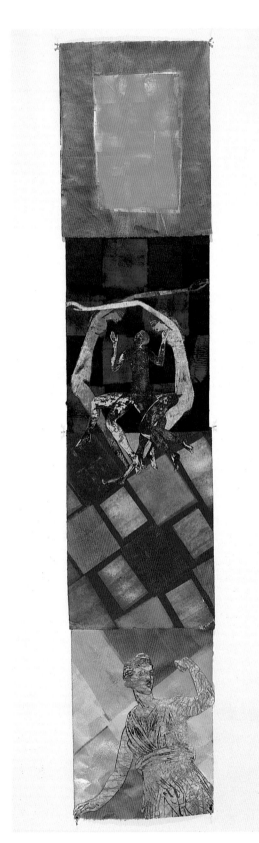

14 Nancy Spero, *The Hours of the Night II* (detail of panel 7), 2001, hand-printing and printed collage on paper, eleven panels, 6.7 m. (22 ft) long.

15 Kiki Smith, *Mother's Coat*, 1994, silver leaf over wax with felt and metal; figure: 127 × 38.1 × 22.9 cm. (50 × 15 × 9 in.).

the classical nude transformed into a body-in-process, its expulsions and liquidities (Bataille's 'waste') – semen, piss, blood, tears – translated into strings of beads, glass or precious metals, the decorative is nothing if not a powerful and transgressive force in their aesthetic imaginations. In fact, in one of her permanent installations, *Premiere* (illus. 13), composed of cascading figures printed directly onto the interior walls of the Ronacher Theatre in Vienna, Spero presents her own version of modernism's 'others': an orientalizing, feminized, balletic occupation of space in which she combines images of Josephine Baker, Mistinguett and Yvette Gilbert with the Sky Goddess Nut, Egyptian musician tomb frescos, Aboriginal dancing figures, acrobats and athletes. And there is yet another connection in both artists' characteristic use of colour, particularly the intense fields of colour saturation deployed by Smith in some of her installations and sculptures, or in the arresting chromatic contrasts that have come to play an increasingly central role in Spero's scrolls since the late 1980s (illus. 14 and 15).

In her (psychoanalytic) account of Giotto's cycle of frescos in the Arena Chapel, Padua, Julia Kristeva argues that colour escapes censorship, offering possibilities for symbolization that the Western pictorial norms of narrative and perspectival representation inhibit: '. . . it is through color – colors – that the subject escapes its alienation within a code'.[22] In this tradition, colour has consistently been placed on the side of the decorative, subordinated to the power of line to define structure and form, an opposition mapped by the history of art as the repetitive struggle between *colore* and *disegno*.[23] Colour is excessive, evading the analytical and descriptive grasp of language as it evades the scrutinizing gaze; colour is altered by light, texture, the proximity of other colours, the codes and ascriptions of cultural myths and taboos from the formal relations of modernist abstraction to the connotations of racial difference. Challenging every nomination, colour can incite the range

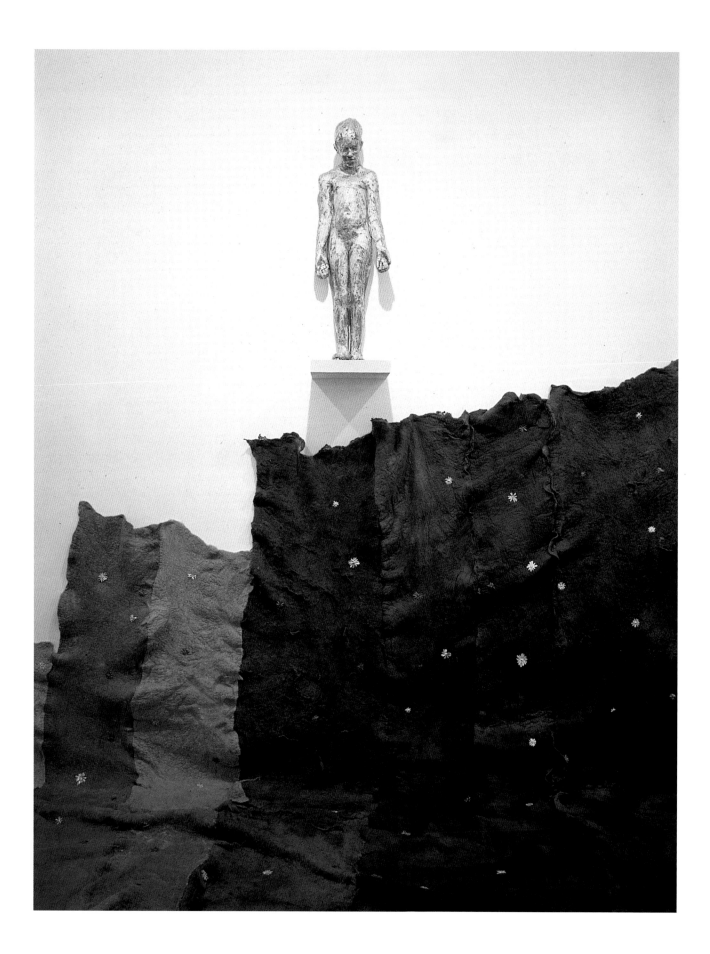

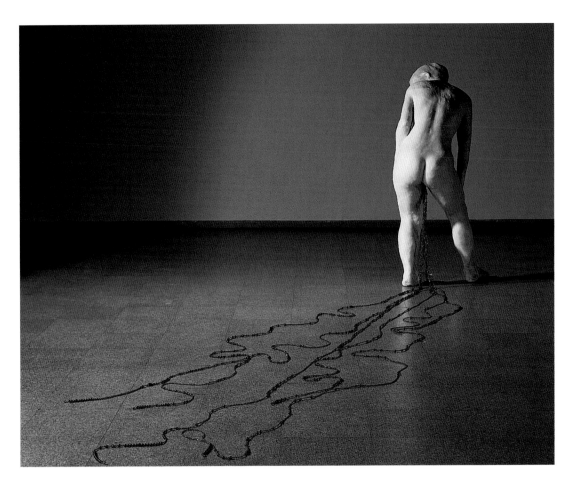

16 Kiki Smith,
Untitled (Train),
1993, wax with beads,
134.6 × 139.6 × 427 cm.
(53 × 55 × 168 in.)

of sensory response; colour can be hot and cold, loud and muted, aromatic, sensuous, tactile, charming, dangerous, defying the writer's prose, 'the color of ambigous depth, of the heavens and of the abyss at once; blue is the color of the shadow side, the tint of the marvelous and the inexplicable, of desire, of knowledge, of the blue movie, of blue talk, of raw meat and rare steak, of melancholy and the unexpected . . .', a seemingly inexhaustible list that still falls short of its object.[24]

Smith's application of colour to form falls primarily in the range from red to blue, signifying her repetitive reference to the body and the Catholic mysteries: the blood of a wound, menstruation, sexuality as a life force – figured in the glass beads pouring from the body in *Untitled (Train)* (1993; illus. 16), in the blown

glass forms of *Red Spill* (1996) or *Shed* (1996), in the stained red paper sheets enclosing the suspended figures of *Untitled* (1990) – whereas the blue of the cosmos floods the installation *Paradise Cage* (1997) or the floor piece *Stars and Scat* (1996; illus. 17). For Spero in such works as the 22-panel *Black and the Red III* (1994), *Hours of the Night II* (2001) and the 39-panel *Azure* (2002; illus. 12), it is colour that immediately overwhelms the viewer. Colour is the subject – pictorial space is delineated in visual rhythms of pulsating hot and cold colours working in push–pull contrasts that react with and against the profusion of figures taken from her extensive data bank of trans-cultural and trans-historical images.

The outside bears with the inside a relation-
ship that is, as usual, anything but single
exteriority. The meaning of the outside was
always present within the inside, imprisoned
outside the outside, and vice versa.
Jacques Derrida[25]

Spero and Smith are both concerned with the
reciprocity of outside and inside, although this is
registered differently in their respective practices.
For Spero, her signature-style scrolls and instal-
lations extend the visual field of the artwork,
projecting figure–ground relationships laterally
or dispersed across architectural space, bringing
peripheral vision into play, bodily orientation
(thereby adding a temporal dimension), non-
linear and non-hierarchical narratives (the work
can be scanned sequentially or discontinuously),

and challenging the stable identity of the frame
as a boundary between work and non-work, a
formal ensemble that creates a scattered, yet
additive, interaction that questions the traditional
logic of viewing and implicates the viewer as
an active and embodied subject. Formally and
symbolically, fixed-point perspective constructed
a pictorial field of causal relationships – a place
for everything and everything in its place – the
visual equivalent to literary narrative whose
technical elements produced a world of order,
stability and intelligibility. The modernist dis-
ruption of this model is one of its key features
that, in literary and visual culture, is characterized
by attention to the new, the present and the
subject's relation to the world as both observer
and observed. There is, I think, a connection
here with the phenomenological demands made
on the conditions of viewing by certain works of
Minimal art, and it is perhaps significant that

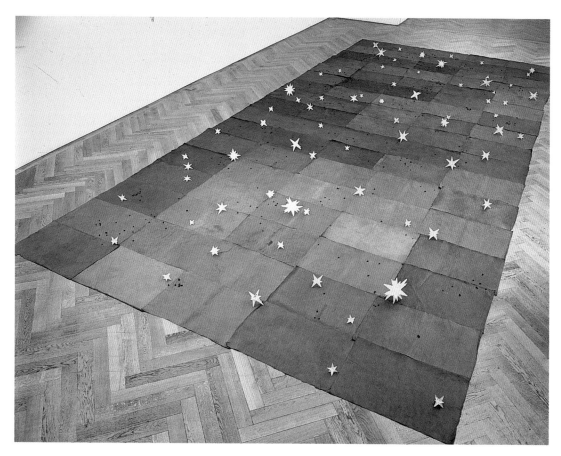

17 Kiki Smith,
Stars and Scat, 1996,
crystal and bronze,
installation, dimen-
sions variable.

Notes in Time on Women, which is more than 68 metres (210 ft) in length, was made during the period of Minimalism's ascendancy. This is indeed the 'theatrical' triumphing over the 'absorptive' (in Michael Fried's distinction), the beholder made aware of the act of beholding through the invitation of the work to look, to be self-aware in the presence of the work rather than expelled from the representational field.[26] In fact, it can be argued that Spero's scrolls and installations interpellate the viewer performatively, which is, of course, the antithesis of the position required for perspectival viewing, whereby the viewer is either fixed positionally, or, in the absorptive relation, denied 'the supreme fiction of the beholder's nonexistence'.[27] Indeed one could go further and argue that access to meaning, in the profound sense of the work's total affect, is possible only through a sense of embodied subjectivity.

Kiki Smith's work also invites an openness to the tactility of the body and a recognition of the interdependency of vision and touch; looking becomes an experience that opens the perceptual field to other senses – like Spero, there is a relation between the appearance of the work and the viewer's kinaesthetic being in the world. In her

work – her figures, fragments, installations, drawings and prints – she documents the making of the body through particular histories, cultures, institutions, the discursive field of the mythological, theological, medical and sexual apparatuses that have their say in the body's representations. In this respect, each specific body – its physiognomy and psychology – is an inscription of what lies beyond; the body-as-text, as a scene of writing. (Spero stresses this in her appropriation of Hélène Cixous's notion of *l'écriture féminine*, in the past describing her own practice as *la peinture féminine*.[28]) Although for both artists, then, it is the body that is placed at the centre of their aesthetic language, in neither case is this a reductive or essentializing focus. Both emphasize the variety and instability of the self – for Spero in making meanings for the feminine through relational and diversified narratives that colonize the visual field, a dancing and gesticulating army of female figures pulled from the databanks of different cultures and histories, for Smith in improper acts of embodiment that figure the oozings, leakages and transformations that constitute the stuff of the body – its circuitry and sexual geography. Thus the anatomical body becomes the narrated body: piss and blood are transformed into beads; tears crystallize; intestines erupt as gaily patterned streamers; vertebrae sprout flowers; and Little Red Riding Hood and the Wolf become one – a hybrid allegory of a rite of passage from innocence to experience (illus. 98).

Smith's imaging of the transition from childhood to maturity and self-knowledge through lived experience derives from another point of connection with Spero – their shared interest in myths of origin, including the Judaeo-Christian Creation story, and the articulating motifs in these accounts, particularly the concept of the 'Fall'. For Spero, this is figured in the image of the 'Serpent' that first appears in *Codex Artaud*, in one example as a three-headed snake with protruding, exaggerated tongues (*Codex VI*)

18 Nancy Spero, *Codex Artaud VI* (detail), 1971, typewriter and painted collage on paper, 52 × 316.2 cm. (20.5 × 124.5 in.).

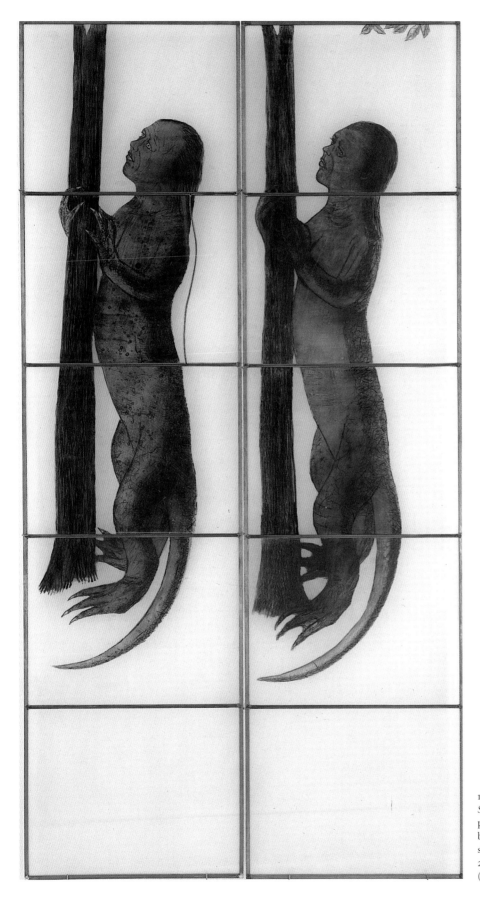

19 Kiki Smith,
Serpent, 1999, fired
paint on glass with
brass, two glass
sheets, each
227.3 × 58.4 cm.
(89.5 × 23 in.).

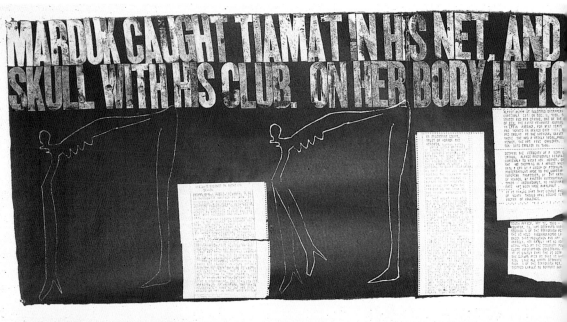

MARDUK CAUGHT TIAMAT IN HIS NET, AND
SKULL WITH HIS CLUB. ON HER BODY HE TO

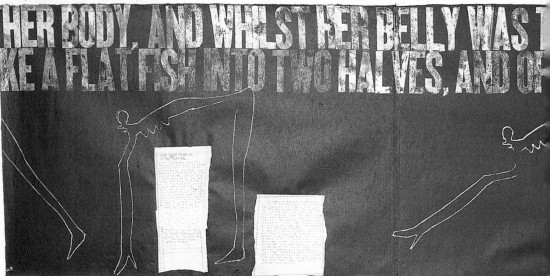

HER BODY, AND WHILST HER BELLY WAS T
KE A FLAT FISH INTO TWO HALVES, AND OF

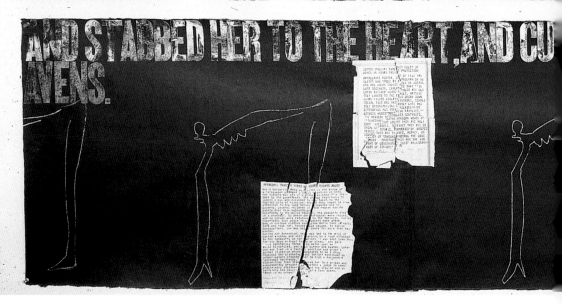

AND STABBED HER TO THE HEART, AND CU
AVENS.

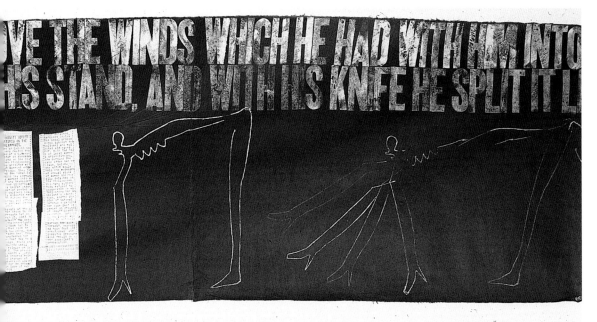

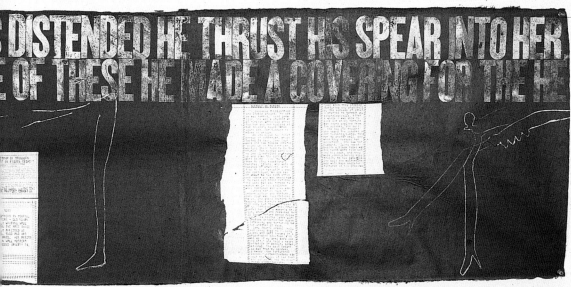

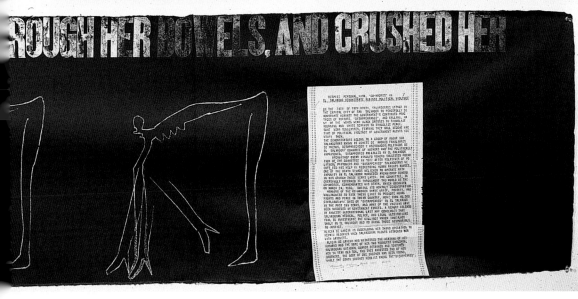

20 Nancy Spero,
Marduk, 1986, hand-
printing and type-
writer collage on
paper, triptych
60.9 × 914.4 cm.
(24 × 360 in.).

(illus. 18), in another detail two serpents consuming each other encircle a staff – a complex iconography that combines theologies of gender (the 'staff' signifies the 'tree of life' of the Great Mother Goddess) with the origins of historical time – self-consumption enacts the cycle of death and renewal (*Codex VIII*). Smith's *Serpent* (1999; illus. 19) makes explicit the association of the snake with the figure of Eve (which in the Hebraic texts reverses the older connection between goddess and serpent as a life-giving force), and derives from a painting of 1460–70 by the Netherlandish artist Hugo van der Goes, *Adam, Eve and the Serpent*. In *The Myth of the Goddess: Evolution of an Image*, Anne Baring and Jules Cashford devote a whole chapter to the narratives of Eve, charting her evolution from the Sumerian period, through the Hebraic scriptures to late Christian doctrine, and in most of the accounts they uncovered they found a connection of the goddess with the serpent. In the Western imaginary, Eve signifies the fundamental division between the human and the divine and introduces self-knowledge and the temporal boundaries between birth and death. As Baring and Cashford argue: 'The Genesis myth is unique in that it takes the life-affirming images of all myths before it – the garden, the four rivers, the Tree of Life, the serpent and the world parents – and makes of them an occasion not of joy and wonder, but of fear, guilt, punishment and death.'[29] Something of this seems to linger in Smith's version of the Fall – *Untitled* (1990), her first representation of the whole figure after the many body parts of the 1980s, a male and female body modelled in beeswax (illus. 29). Helaine Posner relates this imagery to a later moment in the biblical narrative, to the Crucifixion and the soul's ascension,[30] but Smith's own likening of them to Christ's crucified companions – the two thieves – suggests to me the earlier reference, the tragic guilt of an unavoidable loss – the expulsion from the Garden as represented in Masaccio's great cycle of paintings in Santa

Maria del Carmine, Florence, to which, in my mind, they bear a formal resemblance (*The Expulsion of Adam and Eve from Paradise*, 1425).

Nancy Spero's triptych *Marduk* (1986; illus. 20) relates the Sumerian founding patriarchal myth of the dualism of spirit and nature, of the god Marduk's murderous assault upon the original serpent mother-goddess Taimat, whose dismembered body then forms the vault of heaven and the bowels of the earth. Between Spero's *Marduk* and Smith's *Serpent* lies the absolute distinction between Creator and Creation; the serpent is no longer the symbol of regeneration but the first recipient of Yahweh's curse – denied the vertical posture of awareness and curiosity (the Tree of Life), it must crawl on its belly 'all the days of thy life' (Genesis 3:14). However, Spero's serpents defiantly stick out their tongues and Smith's hybrid creature is both doubled and upright, albeit holding on to the Tree for support, an interpretation supported by Mieke Bal's reading of Genesis 1–3 in which she suggests that the serpent initiates sexual difference, and in Eve's response is found the first expression of an independent subjectivity.[31] In fact, Smith's *Eve* (2001) expresses neither guilt nor remorse for initiating the first sinful act – Adam's disobedience in eating from the Tree of Knowledge – rather, she portrays her as a sexual young woman who, instead of hiding her shame, walks confidently forward with uplifted arms, her long hair snaking around, but not concealing her body (illus. 21).

A very different representation of femininity comes from another crucial character in the Genesis creation story – *Lilith* (1994 and 1995), the first wife of Adam whose Sumerian predecessor was 'Lil' (meaning air), the Queen of Heaven, an etymology that in the Hebraic version merges *lil* with *layil* (night), a compound that gave a meaning for terror: a demon of the night. Unlike Eve, sprung from Adam's rib, Lilith shares his origins in the earth, an equality that marks her difference and independence and subsequent rejection of

opposite page
21 Kiki Smith, *Eve*, 2001, manzinei (resin and marble dust) and graphite, 51.8 × 12.7 × 17.1 cm. (20 × 5 × 7 in.).

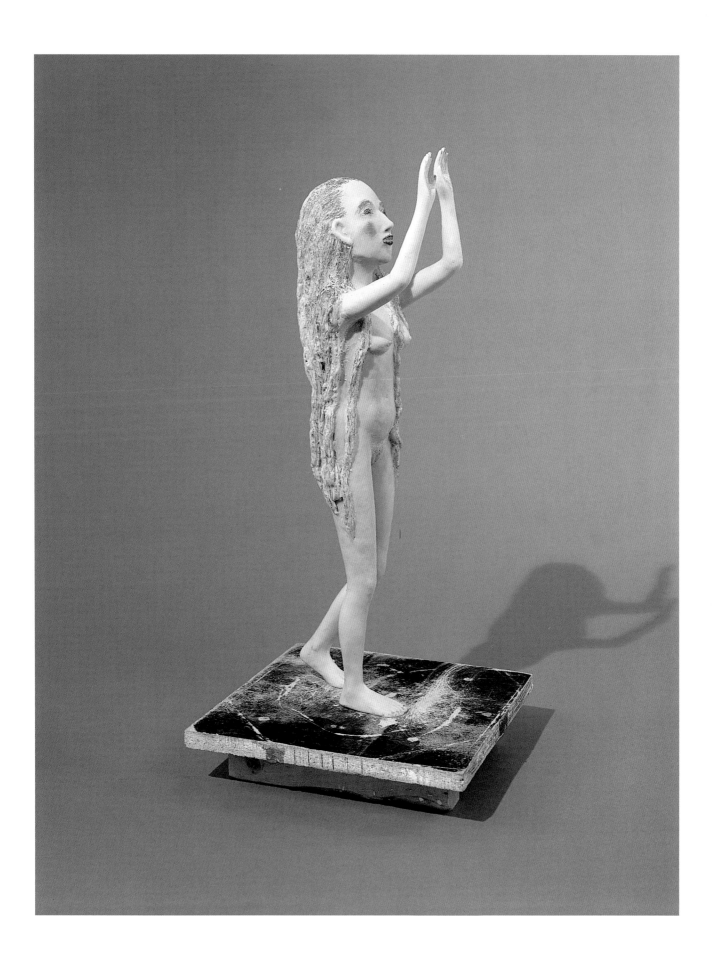

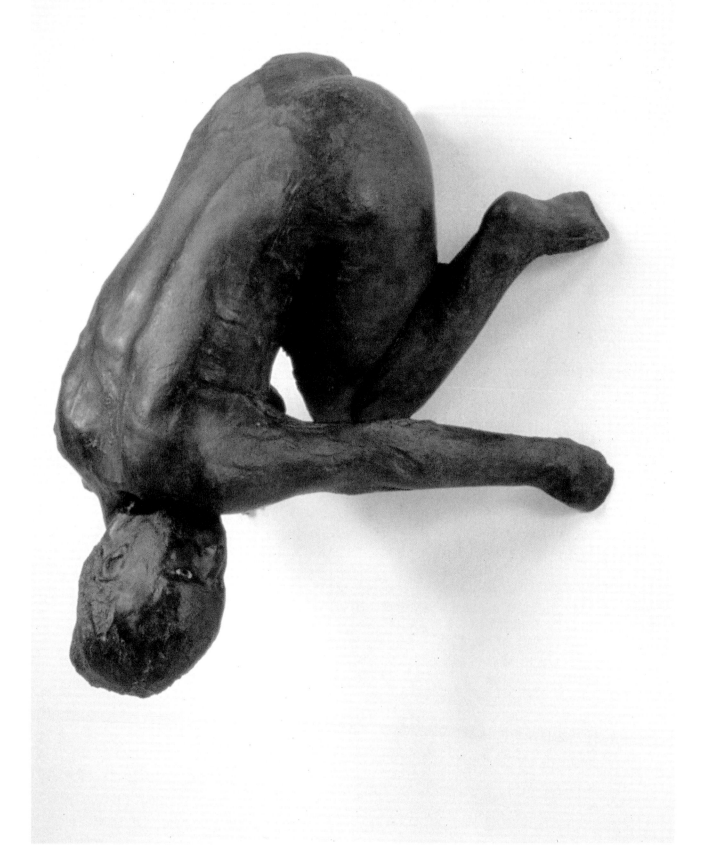

sexual subordination (to lie beneath him). Uttering God's name, she flees to the wilderness, giving birth to demons, only later returning to roam the world in search of children who need to be punished, or sexually to possess sleeping males: 'to the terror of inexplicable suffering that can strike without warning is added the new dimension of the demonization of sexuality'.[32] Lilith is the mythological and scriptural ancestor to the figure of the witch who haunts the literary and cultural imagination, inhabiting the orthodox and apocryphal texts from the medieval period to the seventeenth century. Smith's two versions of Lilith, a papier mâché figure followed a year later by a silicon bronze cast, both fitted with piercing blue glass eyes, allude to the Hebraic myth; displayed as gravity-defying bodies, they crouch high up on a wall looking down on the viewer, conveying the impression of both threat and escape (illus. 22 and 38).

Spero's seven-panel work *Marlene, Sky Goddess, Lilith* combines contemporary and archaic reference to create a narrative of repeating images of powerful female mythological and historical figures. A frieze composed of sky goddesses hovers protectively over the composition, a movement echoed in a line of crouching forms taken from a fifth-century Greek decorated vase which is, in turn, interrupted in panel 4 by a horizontal line of sexually explicit images from contemporary pornography (illus. 23). The base of the work carries the image of a fourth-century 'Maenad' whose aggressive action is then countered by Marlene Dietrich in male attire, confidently striding towards the viewer. Placed next to Marlene, on panel 6, is Spero's version of Lilith – or, rather, her Bronze Age ancestor 'Inanna-Ishtar', adapted from a terracotta plaque of a winged female deity accompanied by lions, owls and the rod and line of measurement. Inanna

was the Sumerian goddess of sky, earth and the underworld, and Baring and Cashford suggest that the Hebraic Lilith is most probably 'a distorted image' of Inanna-Ishtar, both having the power to bring death, although the later figure loses the capacity for regeneration.

In these two works we see something of the connections and differences in their art-making. The reference to the texts of mythology and scripture, the female body as an expressive vehicle, the unsettling of the relationship to the viewer, are for both artists conditions of intelligibility, but differently expressed. Smith here, as in many of her works, focuses on the isolated single figure as the bearer of meaning – but what a complex semiotics: a multi-layered sculptural object whose interpretive pathways range across the body as corporeal and metaphorical, the body of ritual and romance, abjection and desire, but suggesting the transformative possibility of escape from the culture's repressive visualizations. Spero also ranges across the archives of memory and experience to make complex relational visual dialogues, recycling from her lexicon of images cinematographic collages depicting the female subject both in and of history, always breaking with the bonds of culture and convention to offer a vision of the unrestrained libidinal body. (Although, again, I stress that there is a dialectical relation between image and image, and image and text, the concept of 'freedom' is always and only posited in relation to 'unfreedom'.) Perhaps a more appropriate way of describing the utopian element within their work that lingers as a trace of the body's potentiality is 'longing'; as the other to suffering, longing articulates the universal within the particular, the figuring of a yearning for consolation against the vagaries and tragedies of everyday life and the long-term effect of all forms of domination.

opposite page
22 Kiki Smith, *Lilith*, 1994, silicon bronze and glass, 83.8 × 69.8 × 48.3 cm. (33 × 27.5 × 19 in.).

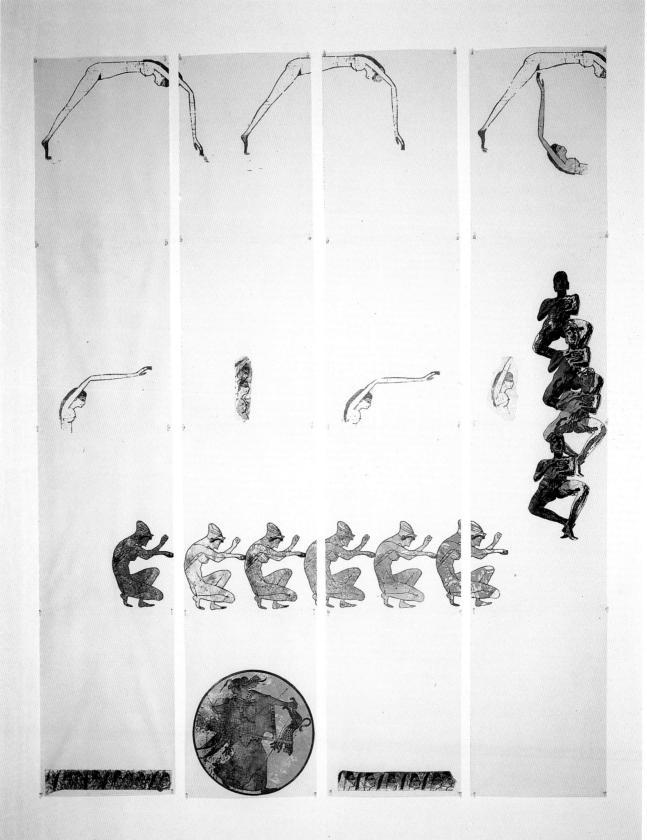

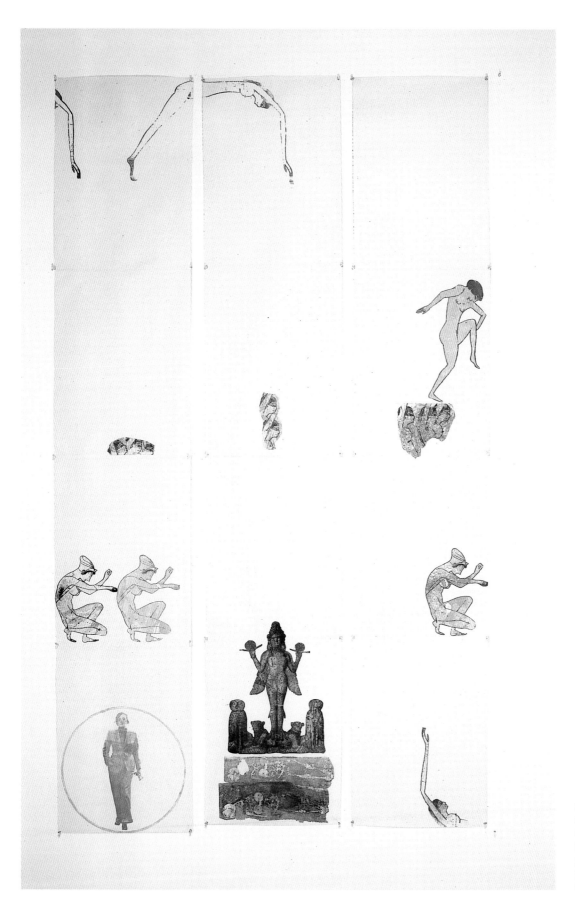

23a and b Nancy
Spero, *Marlene, Sky
Goddess, Lilith*, 1989,
hand-printing and
printed collage on
paper, seven panels
2.7 × 3.7 m. (9 × 12 ft).

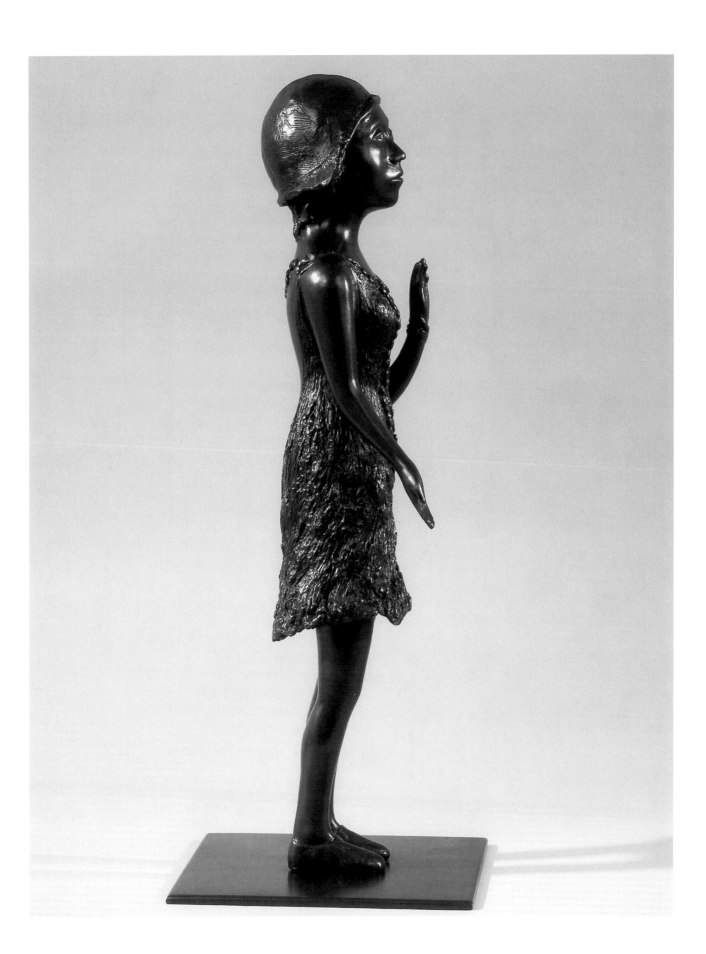

Working in the Rag-and-Bone Shop of the Heart

JO ANNA ISAAK

Those masterful images because complete
Grew in pure mind, but out of what began?
A mound of refuse or the sweepings of the street,
Old kettles, old bottles, and a broken can,
Old iron, old bones, old rags, that raving slut
Who keeps the till. Now that my ladder's gone,
I must lie down where all the ladders start,
In the foul rag and bone shop of the heart.

My title is taken from William Butler Yeats's poem 'The Circus Animals Desertion'. In this poem, written in 1939, the year of his death, Yeats surveys his long career and provides a kind of inventory of his imagination, the raw materials he found in 'the foul rag and bone shop of the heart'. The contents could be a description of Kiki Smith's studio. She refers to her studio as a 'chop shop of bodies', a redemption centre for *lumpen* material and reliquary. In deference to Jon Bird's wishes I omitted the word 'foul' from the title. I understand his reservations. 'Foul' is so strong a term, so pejorative. Even Angela Carter omitted the word when she used Yeats's line describing a whorehouse full of grotesque, discarded women as 'this lumber room of femininity, this rag-and-bone shop of the heart'.[1] Kiki Smith, however, is not so decorous. She has never been squeamish about stirring the beach rubble or exploring the grottoes of the abject. Lately, she has taken on the *personae* of Crone and Witch, all the better to go on those cavernous excavations. And the stuff she yards back – a rib cage held together with string as if kept in the hope of future resurrection; an empty womb made of bronze; an arm torn from a shoulder, its skin flayed; a head and hands hung from the ceiling by straps of burlap; lopped limbs trailing a long train studded with

sequin stars and flowers; lymph glands; veins and arteries; male and uro-genital systems; glass jars etched suggestively with the names of bodily fluids – Milk, Blood, Pus, Vomit, Semen, Saliva, Tears; human figures that crawl on all fours, hang from the walls, defecate, lactate, ejaculate, urinate and decay. 'For a couple of years', she says,

> a lot of my work was just basically about orifices, and different body fluids and language and foreign substances that go in and out through orifices; certainly pus and things like that come out of the skin. It's also like the inside world making itself evident, becoming physical.[2]

'I want to ooze out all over the place', she says, by way of explaining the modus vivendi of her working process.[3] 'Foul' therefore is a good adjective for a lot of Kiki Smith's art. Walking into one of her installations one is reminded of Oscar Wilde's comment about bagpipes: 'It's a mercy there's no odour!'

Kiki Smith is the artist of the abject, and she was so long before the abject became a fashionable topic in the art world. She has a housewife's knack of taking whatever has been jettisoned, or considered a mistake, and using it to advantage.

opposite page
24 Kiki Smith, *Flapper*, 2002, bronze, 52 cm. (21 in.) high.

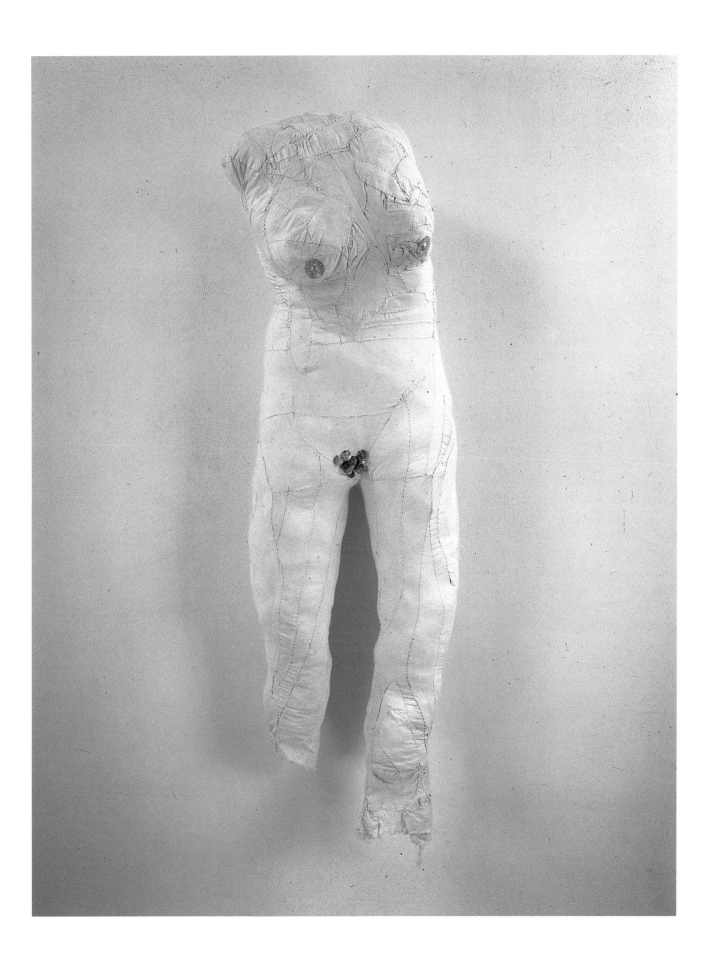

'The trick', she says, 'is to use everything you felt so bad about. That is what you're given; this constellation of assets and deficits.'[4] Call her a shrieking banshee and she will identify with the role of the banshee as prophet of death, manipulating multiple lithographs of her own face, flowers and skeletal death masks to create the self-portrait *Banshee Pearls* (1991). Accuse her of making decorative or ornamental art and she will knit or string beads with all the obsession of Penelope forestalling her suitors. Call her work 'girlie art' and she will cover the walls of the PaceWildenstein gallery with doilies. She likes certain women for the mistakes they made – Lot's Wife, looking back in spite of the prohibition, and lusting for the flesh pots of Egypt; or Mary Magdalene the sinner banished to the wilderness for her repeated failings of the flesh; or Lilith, that first female prototype, the first of many women to be expelled. She is particularly fond of Eve for the size of the bite she took out of the symbolic apple: 'Eve is like a superhero, because without her there's no spiritual growth. She is the activator, the person who starts the world going. Without her, nothing happens.'[5]

In the exhibition that this book accompanies, Kiki Smith is joined by Nancy Spero. It is a natural pairing. In a sense, the two of them have been collaborating for a long time. They have both been rummaging around in that foul rag-and-bone shop for years, bringing back relics from the strange carnivalesque diaspora of the repressed female body and imbuing them with a certain alienated majesty. When they get talking together it is like listening to two Old Believers. They share the same promiscuous idea of religion and rite, imputing similar artistic value to Classical or Indian goddesses, Catholic saints, figures from European folk tales or aboriginal fertility fetishes. They display their cache. Kiki hangs up the dangling arms and legs of Nuit the Egyptian sky goddess. In Spero's version the Sky Goddess is flayed and her skin stretched out across the sky. They both like the ancient Celtic fertility goddess Sheela-na-gig for the directness with which she exposes her 'lack'. Spero has her displaying her genitals like a wry smile. In some arrangements, she has Sheela link arms with a row of her identical sisters in a comic chorus line of *cunnus*. In Smith's version *Untitled (Upside-Down Body with Beads)*(1993) Sheela is a life-size sculpture bent double, her genitalia 'mooning' the spectator while a pool of jewels spills out on the ground around her. *Body* (1995; illus. 25), a soft cloth torso similar to a dressmaker's mannequin, is another fertility figure; the nipples and pubic area are intricately formed out of gold discs – tender buttons. *Lucy's Daughters* (1992; illus. 26), a mass of silk-screened female figures printed on delicate, organic paper that buckles and swells in response to the multitude of figures, is Smith's homage to the three-million-year old Ethiopian hominid skeleton known as Lucy. Paper threads dangle from their bellies – umbilical cords connecting them to what is possibly the prehistoric mother of us all. Making a feminist fiction involves remaking the idea of woman, and where better to look for the spare parts with which to fashion your own creation myths than from the scrapheap created in the wake of the great normalization of the body undertaken in the modern era. 'Our bodies are basically stolen from us', Smith says, 'it is about trying to reclaim one's own turf, or one's own vehicle of being here, to own it and to use it to look at how we are here.'[6] Eve, the Virgin Mary, Mary Magdalene, Lot's Wife, Lilith, Medusa, Daphne, the Egyptian sky goddesses Nuit or Hathor, the Witch, the Crone, the pregnant old hag Baubo . . . all those irregular female figures that by their abjection have served to consolidate the cultural identity of the norm are brought back to play their part in a new *écriture féminine* (illus. 27). Even the body of the mad poet Antonin Artaud – 'this unusable body made out of meat and crazy sperm', as he described it in *Here Lies*, can become a protagonist in these new narratives.

opposite page
25 Kiki Smith, *Body*, 1995, cotton, polyester fibre fill, gold, 154.9 × 45.7 × 37.5 cm. (61 × 18 × 15 in.).

26 Kiki Smith, *Lucy's Daughters*, 1992, silkscreen and paper, 243.8 × 452.1 cm. (96 × 178 in.).

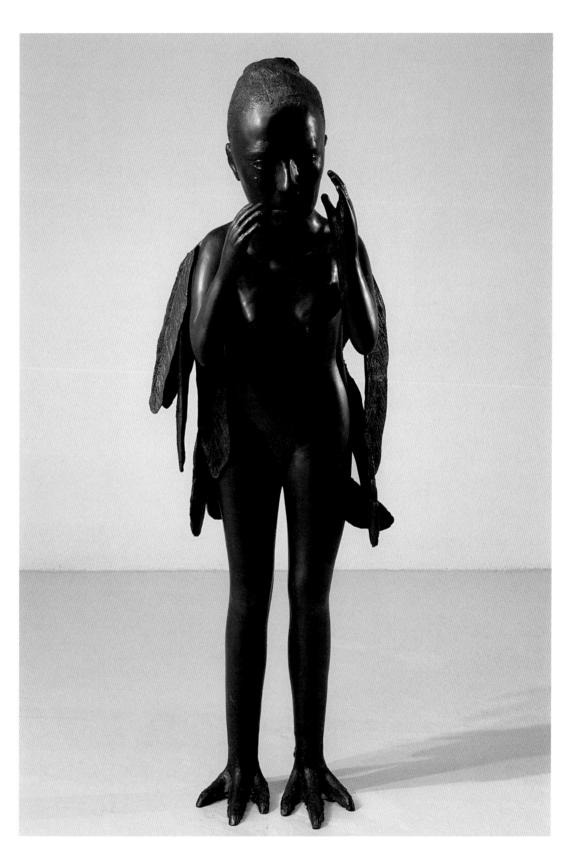

27 Kiki Smith,
Standing Harpie, 2001,
bronze, 121.9 cm.
(48 in.) high.

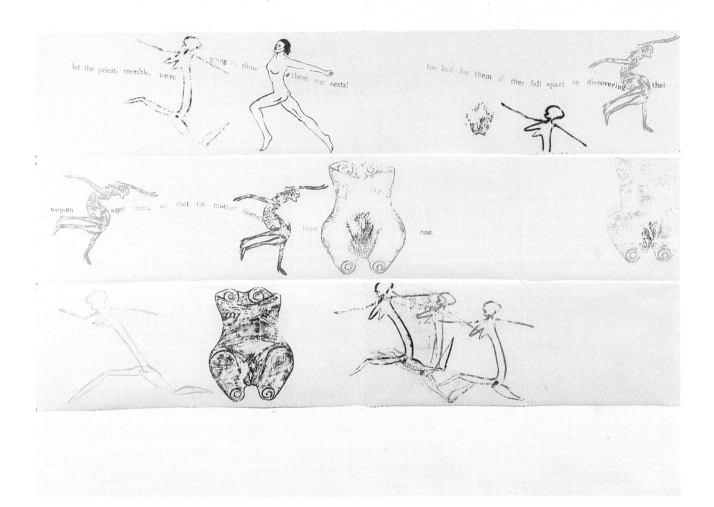

I understood the impulse, the need to drag all that repressed feminine out into the open and, more than that, to treat it with tenderness and affection, to bestow upon it a kind of benediction. Nancy Spero and Kiki Smith are part of my feminist movement, the movement that came into its own in the late 1980s and early '90s. While they are a generation apart, their art came out into the same art world, the same political climate. Still in place were the lingering effects of the Minimalist aesthetic with its injunctions against the figurative, the decorative, the hand-made, the autobiographical, the personal, the messy, the emotional. They both knew the com-

mandment: 'Thou Shalt Not Create Unto Thyself Any Graven Image.' 'When I first saw Nancy Spero's work', Kiki told me several years ago, 'I thought, you are going to get killed making things like that – it is too vulnerable. You'll just be dismissed immediately for making things like that.' And dismissed they were – and why not? It was as if the two of them had gone on some ex-centric shopping trip into the very terrain that Jean-François Lyotard described as:

> the feminine (women, children, foreigners, slaves) banished outside the confines of the *corpus socians* and attributed only those

28 Nancy Spero, *Let the Priests Tremble*, 1982, hand-printing on paper, 157.5 × 274.3 cm. (62 in. × 9 feet).

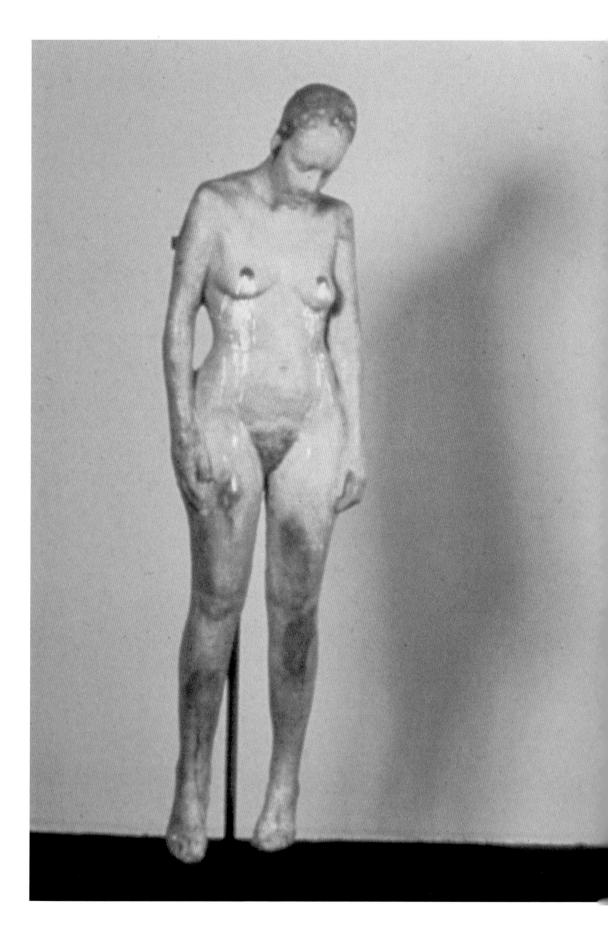

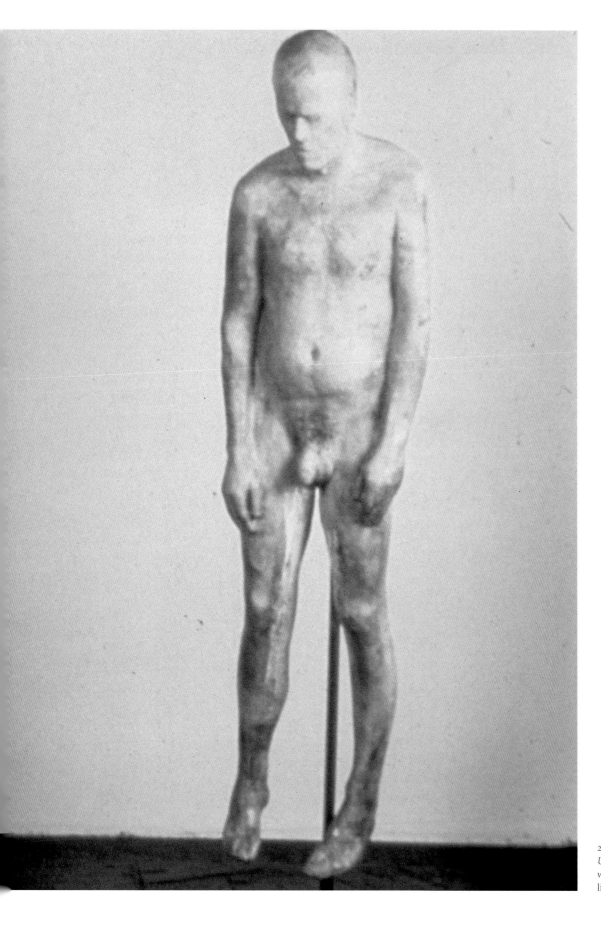

29 Kiki Smith,
Untitled, 1990,
wax and pigment,
life size.

properties the *corpus* will have nothing to do with: savagery, sensitivity, matter and the kitchen, impulsion, hysteria, silence, maenadic dances, lying, diabolical beauty, ornamentation, lasciviousness, witchcraft and weakness.[7]

In the process they even alienated some feminists with whom they should have found political and conceptual solidarity. This was a generation of theoretically informed women artists who were sensitive to the dangers inherent in representations of the female body. The imagery of Spero and Smith came too perilously close to many patriarchal conceptions of the body that had served to establish an identity for women in essentialist, ahistorical or universalist terms. When I organized the exhibition *The Revolutionary Power of Women's Laughter* in 1982, I included Spero's work *To the Revolution* and *Let the Priests Tremble* (illus. 28). But when the show was reviewed, her work was criticized for the way it 'reinscribes the traditional male/female opposition', for 'its celebration of Otherness' and 'for returning to the Goddess and the Body'.[8] At that time Smith worried that she could be condemned like the ancient icon makers for making graven images, or burned at the theoretical stake of essentialism. She mentions a friend's warning against making figurative art.

No wonder they caused such anxiety. The bodies they presented were so fragile, so unreliable, so subject to uncontrollable flow, so close to nature, so biologically vulnerable. In 1983 Smith collaborated with David Wojinarowicz on an installation at the Kitchen called *Life Wants to Live* in which their bodies appear as abstract parts or as CAT scans and x-rays while a stethoscopic recording is played of their hearts and lungs and the sound of their fists as they pounded on each other. Going inside the body, recording its sound or making abstract sculpture of disconnected parts or internal organs, as she did in *Second Choice* (1987) – a bowl of human intestinal organs mixed with vegetables – is, in a sense,

safer than dealing with the externalization and objectification of the body, especially your own body. 'It is much more scary to be a girl in public than to talk about the digestive system. They both have as much meaning in your life, but I've been punished more for being a girl than for having a digestive system.'[9]

It took several years before the anxiety subsided and it became generally acknowledged that Kiki Smith and Nancy Spero were among the leaders in what was to become a campaign on the part of many artists against the profound somatophobia of our culture. With this exhibition entitled *Otherworlds: The Art of Nancy Spero and Kiki Smith* the critical paradigms have come around full circle. We are now celebrating these artists explicitly for their forays into the terrain of the Other. Jon Bird explains the genesis of this exhibition in his introduction:

> . . . at first I had been simply descriptive – 'the art of Nancy Spero and Kiki Smith', but after a while 'otherworlds' presented itself, with all the connotations of the relations between self and other . . . the feminization of the body that is the (m)other, and the contradictory promise of a redemptive aesthetic formed in the imaging of other visions for our sense of embodiment.

While the theoretical understanding of their work may have changed, especially with the renewed interest in the body that took place in the 1990s, neither Spero nor Smith adhered, in a doctrinaire way, to any of the theoretical positions that were so much a part of the worlds of art and academia in the 1980s. When asked if theory played a role in her work, Smith is vague:

> Probably in a trickle-down manner. But you know, I'm probably getting all this stuff in a supermarket version. I'm certainly not studying it. But I also like that Bob Dylan line: You don't need a weatherman to know which way the wind blows.

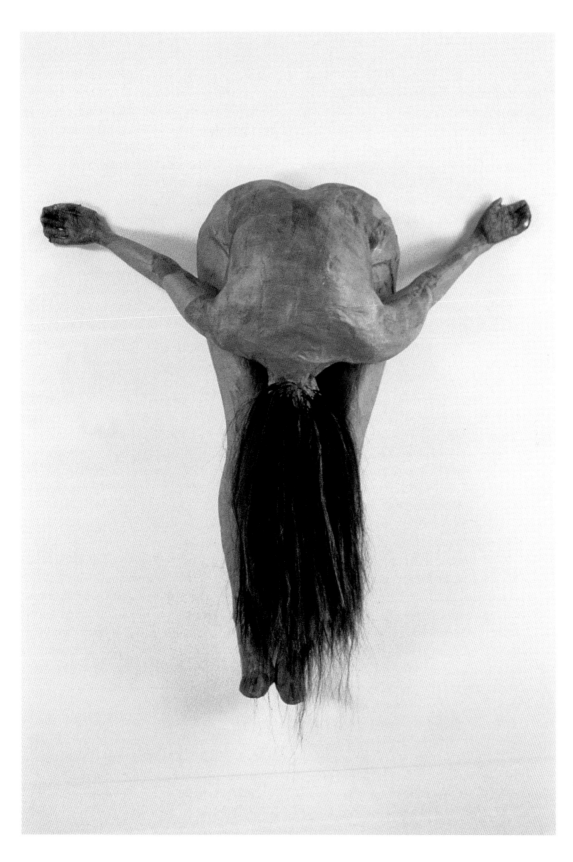

30 Kiki Smith, *Untitled (Fallen Jesus)*, 1995, brown paper, methyl cellulose and horse hair, 134.6 × 45.7 × 127 cm. (53 × 18 × 50 in.).

On the other hand, she is very clear about her debt to the feminist movement: 'I came of age in the sixties and seventies and *that I exist is a result of feminism*.'[10] Both Spero and Smith share this clear conviction that they were part of a feminist movement that *enabled* them to become artists. In a conversation with Chuck Close, Smith talks about growing up as the daughter of the sculptor Tony Smith, yet feeling that the art world was male, and not a place she could enter.[11] Spero, too, even though she is living and working with her artist husband Leon Golub, speaks of her acute sense of alienation from the art world, of not having a voice. When she did find her voice the first words she uttered were 'merde', and 'fuck you'. Later she adopted the voice of Antonin Artaud because, as she says, she 'didn't know anything else that extreme'. Susan Sontag in *Under the Sign of Saturn* describes Artaud as 'one of the great daring mapmakers of consciousness *in extremis*'.[12] When Smith saw Spero's *Codex Artaud* she responded to the manifest aggression and violence that Spero was able to *deploy* through the energy and physicality of her drawings. Artaud's vituperative outpourings, bringing language into direct visceral contact with the body, became a catalyst for the expression of Smith's own anger.

Anger is something that Smith learned to use as *fuel*. I mention this because young women today are not angry. My female students share the same sense of entitlement as the male students. In a sense, this means the feminist movement was successful. Rachel Whiteread acknowledges feminism's liberating force: 'When things change they become part of the fabric of life rather than something one has to constantly fight against.'[13] Smith began fighting on the domestic front. She began with an inventory of newspaper accounts of domestic violence against women in *Life Wants to Live* and soon became involved in AIDS activism. However, throughout her career she has felt the need to battle with the whole Christian or Judaeo-Christian history because,

as she put it, it 'owned' her. 'Those who are owned by it are the ones who fight it', she said by way of explaining the connection between her anger and that of Artaud's: 'People who aren't owned by it don't bother. I am definitely owned by it – maybe less now than I used to be.'[14]

At the same time, Catholicism has been an enormous resource to Smith in her explorations of its vast centuries-old warehouse of art and reliquaries, and for the deep connections it has forged between the spirit, flesh and inanimate objects. Especially relevant to her working process is the doctrine of transubstantiation, the doctrine that, in the Eucharist, the substance of bread and wine are changed into the body and blood of Christ, with only the accidents of bread and wine remaining. In Smith's work inanimate objects are imbued with meaning. In *Untitled* (1995; illus. 30) a papier mâché female figure attached to the wall by the back of her hands, as if nailed to a cross, falls forward; its long hair hangs to its feet. Smith refers to this collapsed figure as analogous to the fallen Jesus – it is the passion of Christ in the sense of something suffered that is conveyed.

Pain and vulnerability are palpable in the bodies that Smith depicts. She never forgot, even at a time when so many artists were engaged with the body, particularly the female body, as an object of desire, that the body is also the site of pain, suffering, decay, disease and death. Smith's father died in 1980. She was living in the East Village – the centre of the AIDS epidemic in New York City. Her sister died of AIDS in 1988; four years later her friend David Wojnarowicz died. Death, Maurice Blanchot claims, makes of the body something of a work of art. Smith became adept at making death masks. In her work she depicts women making their way in the morass of difficulty and suffering that comes with the very condition of being 'matter'. Women's bodies are flayed, chained, crucified, dragged through the streets, hanged as witches, or, like Joan of Arc, about to be burnt atop enormous pyres of wood (illus. 31).

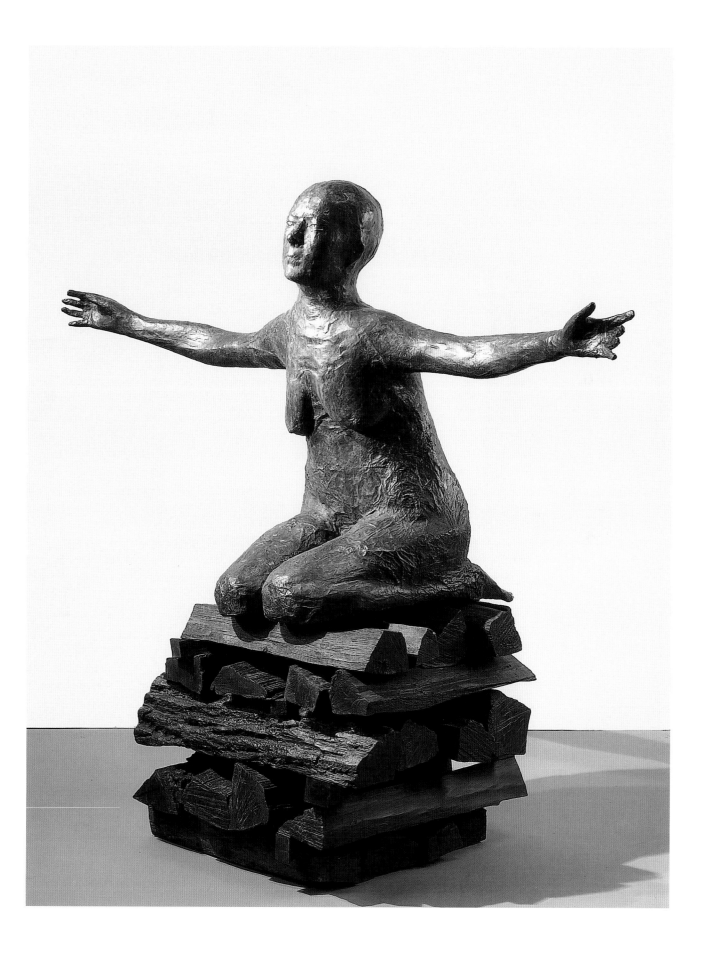

While Smith was struggling to wrest even the most maligned images of the female body from the rubbish heap of the repressed, what she was revealing wasn't easily accepted. There is a good deal of ambivalence amongst women about being aligned with the abject and, even when faced with the social reality, we are reluctant to see women as victims. 'I'm just trying to survive', Smith responded to accusations of making work about victims. 'I think most people are like that. You can see the glaring scars of their life, sort of on the surface.'[15] There is always a price to be paid for being in this world, why deny it. 'That's the cost', she says of a sculpture of hers with a broken hand, leaving it to its accidental fate.

While she never flinched from looking at the derogation that the body, particularly the female body, has endured, there is nothing passive about the images she presents. In the process of reclamation, these bodies go through a kind of alchemical transmogrification. The coherence of the body is shattered and reassembled again in arrangements both horrific and elegant. 'The abject is edged with the sublime . . . a sublime alienation', Julia Kristeva tells us because both involve a loss of self.[16] The vulnerability of the human body, its wounds, scars and lacerations, are the very source of transcendence – deep from within the wounds of Smith's phosphorous bronze *Virgin Mary* (1994) it flames out like shining from shook foil.

The bodies that Smith presents us with are not the kind of bodies and objects we are accustomed to looking at; they are not the finished, polished objects of desire produced by modern photography or film. In her work the mirror, where the ego forms itself in Lacan's Imaginary, is shattered and the ego gives up its image. Gone too is any clearly demarcated border; there is nothing so definite, only passages, resemblances changing places, mutations, metamorphosis. The body is always in process – emerging from, or slipping back into inchoate matter. Bodies shed skin or grow excessive hair or sprout feathers; fluids ooze from various orifices; the spine grows vines from which flowers bloom; arms and legs

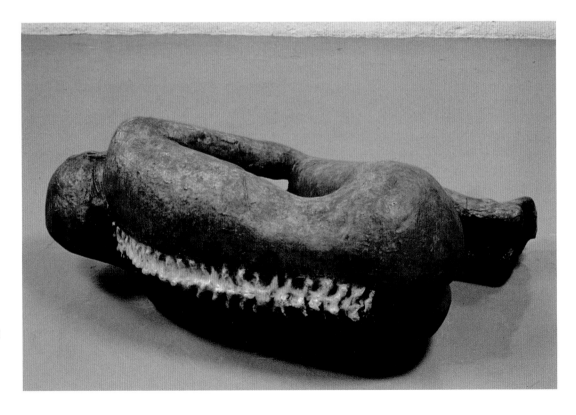

32 Kiki Smith, *Blood Pool*, 1992, painted bronze, 35.6 × 99 × 55.9 cm. (14 × 39 × 22 in.).

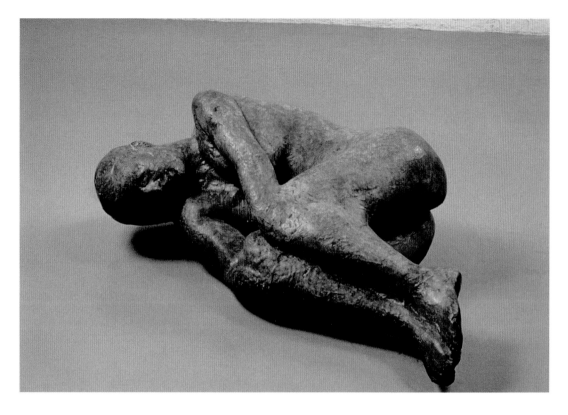

morph into branches or commingle with the stars. In *Blood Pool* (1992; illus. 32, 33) the figure, curled in foetal position with vertebra protruding along the spine outside the skin, seems to be made of congealed blood; there is the sense that it could return to liquid form and ooze into oil. Even when the body is presented as whole, as in Smith's first full-sized sculptures of a naked man and woman done in 1990, the coupling is not erotic. Instead this pair, made of beeswax, dangle limp from their mounts totally subjected to gravity and their own bodily functions (illus. 29).

It is the tactile, the intimate sense of touch rather than the more objectifying sense of looking that is invoked over and over again in Smith's work. The flesh of the wax figures such as *Honeywax* (1995; illus. 34) or *Pee Body* (1992; illus. 35) seems as if it would yield if pressed – *morbidezza*, the Renaissance called this quality. Smith likes to work with paper and papier mâché, in part because of its proximity to the texture of human skin. *Virgin* (1993; illus. 36) is wrapped in a protective sheet of white paper, all orifices sealed except for her eyes and her carefully articulate labia formed on the outside of her long dress. The opening of the vulva is a wound into which the doubtful could insert a finger to test her mortality. In contrast with this *tabula rasa* virgin, Smith's depiction of the Virgin Mary stresses her carnality rather than her spirituality. 'Women are always being reduced to their sexuality, but the Virgin Mary got robbed of her sexuality', Smith says by way of explaining the viscous, striated, exposed muscles and veins of the wax figure of her *Virgin Mary* (1992).[17] This is no 'belly without blemish'; the person of the Virgin appears in a state beyond nakedness; she is *flayed*. Even the works made of bronze invoke the sense of touch. The breasts and belly of *Mary Magdalene* (illus. 37) are smoothed as if from human touch. This is not the result of the quick grope invited by Duchamp's *Please Touch*, but the fervent rubbing of the ancient faithful.

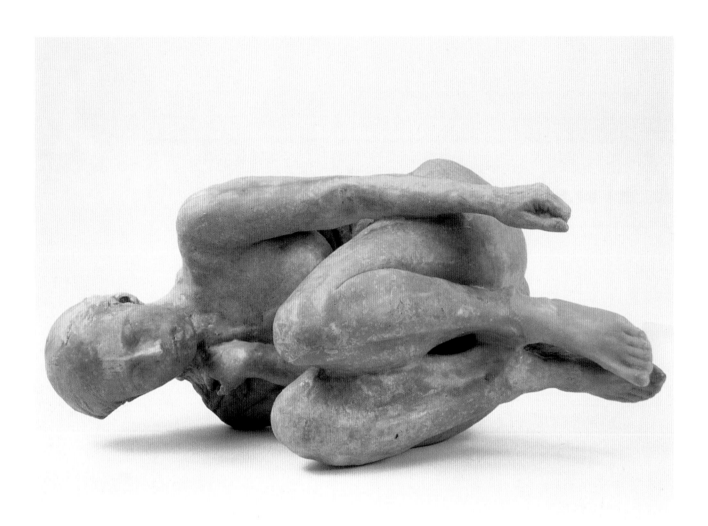

34 Kiki Smith, *Honeywax*, 1995, beeswax, 38.1 × 91.4 × 50.8 cm. (15 × 36 × 20 in.).

Smith's bodies, bones and broken bits are the devotional icons of a more credulous era; an old authentic hunger has curled around them and clings. If the figures acquire a polish it seems to have been the result of age and wear. Her statue of Mary Magdalene recalls Donatello's wooden *Penitent Magdalene*, hair covering her body, the source of so much temptation. In Smith's version the hair seems to have grown like a coat providing protection against the elements. She drags a broken chain from one leg, like a dancing bear escaped from the circus, but she is dancing mad, caught between animal and human heat. When she was making this sculpture Smith had in mind an old French folk tale of Mary Magdalene's life after the death of Christ. The story of Mary Magdalene is one of many cautionary tales that every culture tells to repress the sexuality of its young women:

Mary Magdalene lives in the wilderness for seven years to atone for her sins. One day while drinking from a pool she sees her image reflected back to her and is condemned again for her narcissism. Her tears create the seven rivers of Provence.[18]

While Smith undertakes her reclamation of women's bodies in very material terms – working in fabric, wax, clay, paper, papier mâché, glass, bronze, iron, burlap, beads, etc., she searches for exceptions to our biological determinism in the stories of women who have been expelled from the social order or disappeared from the dominant cultural narrative. *Lilith* (1994; illus. 38), for example, Adam's first wife who refused to lie under him, clings like a gigantic fly upon the wall, warily keeping her distance from the fate she has escaped. Her wraith-like, papier-mâché

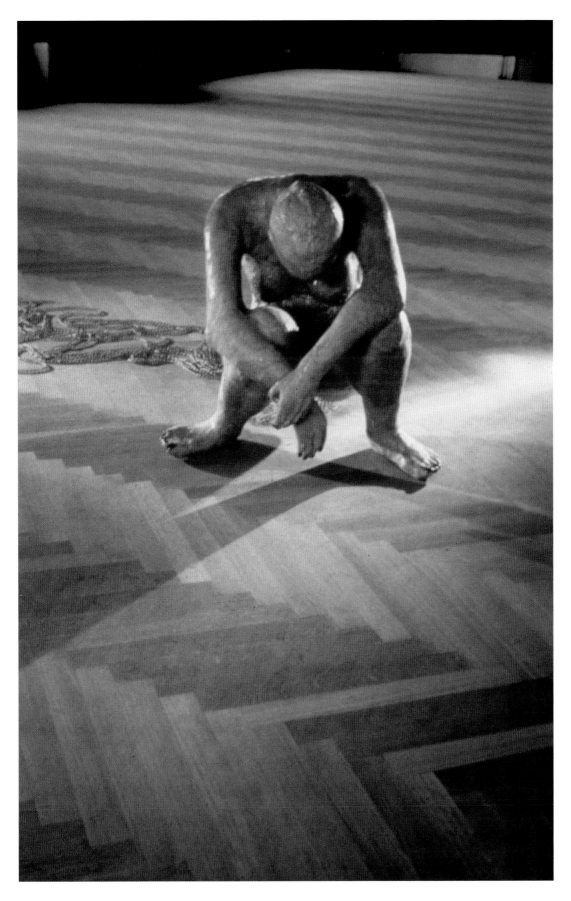

35 Kiki Smith, *Pee Body*, 1992, wax, glass and pigment, life size.

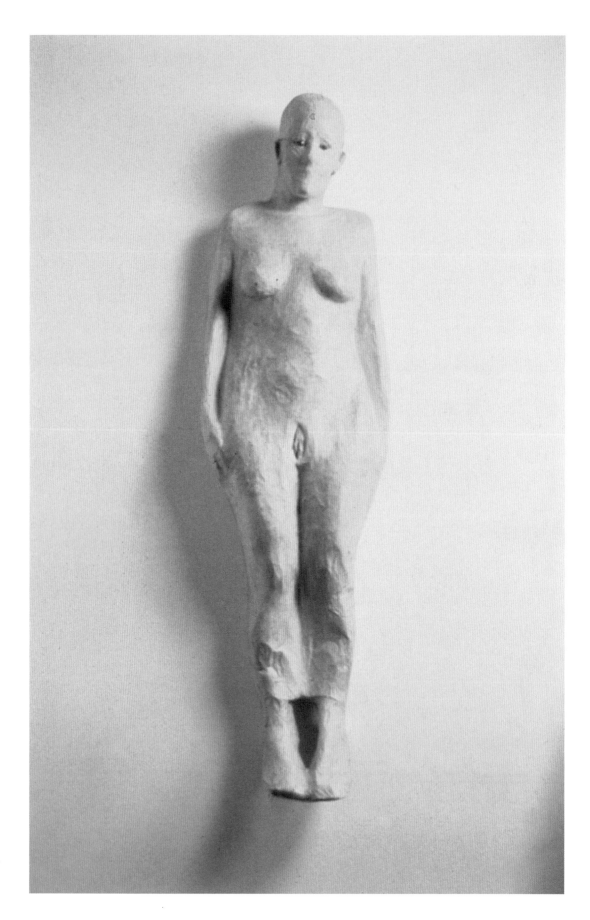

36 Kiki Smith,
Virgin, 1993, papier
mâché, glass and
plastic, life size.

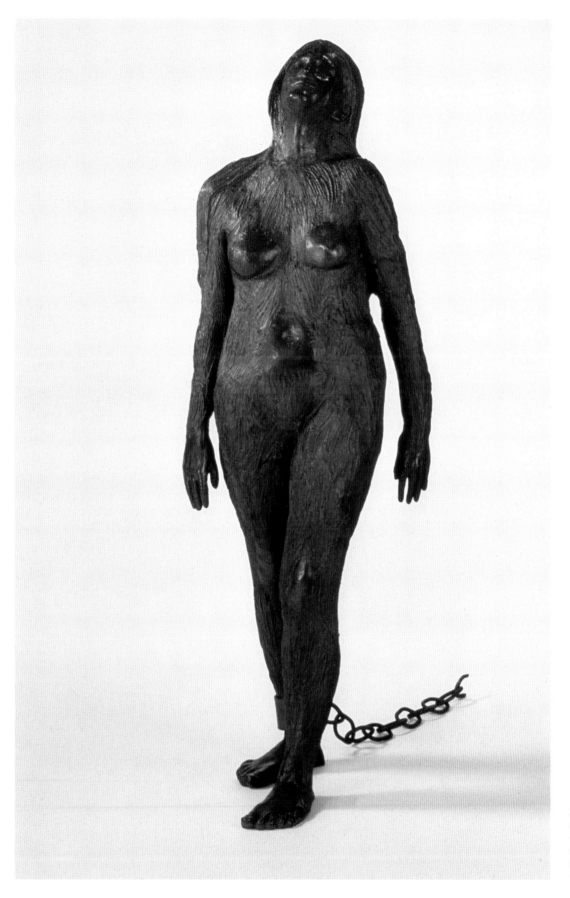

37 Kiki Smith, *Mary Magdalene*, 1994, cast silicon bronze and forged steel, 152.4 × 50.8 × 53.3 cm. (60 × 20 × 21 in.).

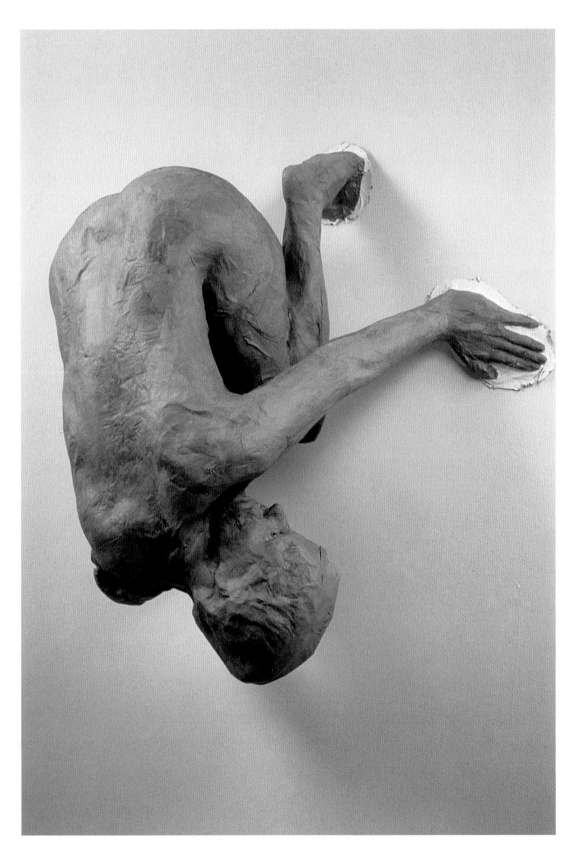

38 Kiki Smith,
Lilith, 1994, papier
mâché and glass,
43.2 × 78.7 × 81.3 cm.
(17 × 31 × 32 in.).

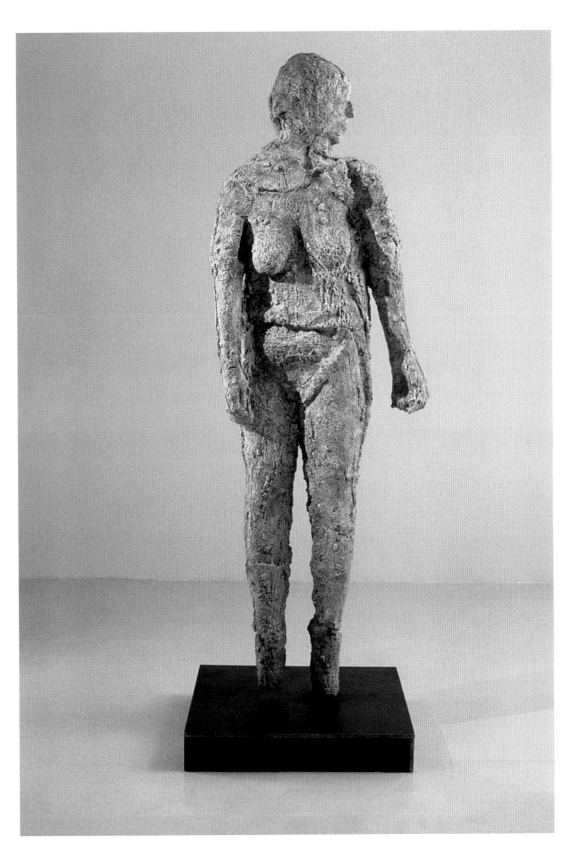

39 Kiki Smith,
Lot's Wife, 1996,
silicon bronze with
steel stand, 205.7 ×
68.6 × 66 cm. (81 ×
27 × 26 in.).

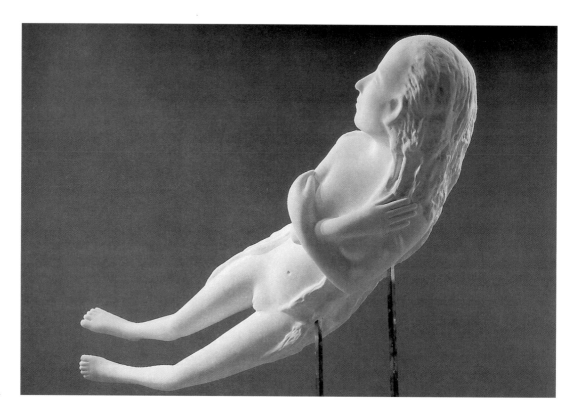

40 Kiki Smith, *Crescent Moon*, 2002, plaster over foam, 96.5 × 208.3 × 40.6 cm. (38 × 82 × 16 in.).

body seems weathered beyond what paper could endure, her shocking, blue glass eyes peer down upon the female figures below as if in horror at what her sex has endured. She too is mad.

Smith has a penchant for stories from the Old Testament, stories of women who led robust, sinful lives, rather than the more pious circumscribed lives of women in the New. *Lot's Wife* (1996; illus. 39), originally appropriately made of salt and plaster, stands more than six feet tall; her skin hangs from her body as she turns and drifts into dissolution. Smith wants stories writ on a grand scale, stories big enough to fit the female form.

Women's bodies, always being forced into some pre-existing form, could be thought differently, could be the model for representation as in ancient cosmologies. The Egyptian goddess – Nuit or Hathor – sky goddesses that eat the sun every night and give birth every morning.[19]

Narratives like these or narratives of her own fashioning are the basis of sculptures like *Reina* (1993; illus. 43), body parts mixed with stars that trail off into the sky; or *Crescent Moon* (2002; illus. 40), a new moon in the form of a slip of a girl cradled in the arms of the absent old moon; or *Milky Way* (1993), a dark-blue paper sculpture of a woman lactating, the milk forming silver stars spraying out into the galaxies; or *Siren* (1994), a fibre-filled muslin torso of a woman sprouting birds' heads and beads at its neck and genitals. In *Peacock* (1994) an enormous peacock tail fans out on the wall behind a figure of a woman crouched on the floor; the central jewel of the tail is formed by repeated drawings of blue vaginas, each as delicate as the eyelids to which they are attached by paper threads.

Smith's is a combinatory art. Throughout her career she has combined vegetation and animal and human body parts in intricate, intermingled and fantastical juxtapositions, leaving it up to us to create a variety of synaptic connections

between them. In the exhibition she includes a number of human bodies suspended in those fragile states where woman strays on to the territories of animal. *Serpent* (1999), a 2.27-metre (7½ ft) glass panel is just such a suspension; on it are painted two huge lizard-like creatures with human female heads, each clinging to a branch. *Standing Harpie* (2001; illus. 27), a 1.22-metre (4 ft) bronze sculpture of a small, delicately formed woman's body with enlarged head, sprouts feathers on her back and balances on bird's feet. *Sirens* (illus. 41) are cast bronze birds with human heads and female breasts. They were originally installed on a rock in Central Park as part of the Whitney Biennial of 2002. In *Rapture* (2001; illus. 50) an athletic-looking woman steps out of the overturned body of a wolf, as if the animal could metamorphose directly into the human.

'There's a lot of life that's been left out of art', Smith says. 'I always remember Lucy Lippard's remark that "art recalls that which is absent" because it's as if something needs to be brought into the arena, something that's being unspoken.'[20] While Smith explored the powerful symbolic repertoires at borders, margins and edges, her work became aligned with some of the central political issues of our times – violence against women, battles over abortion rights, the war against AIDS and breast cancer, even protests against environmental degradation. Her work has also served to destabilize the idealizations of the female body and realigned the mechanisms of desire. This may seem an odd development for work that is so much about loss and the liminal. But the movement of her work out into an overtly public arena was exactly the trajectory that Kristeva set out as she described Artaud's writing and, by extension, the work of any artist willing to go into that

underwater, undermaterial dive . . . where the black, mortal violence of 'the feminine' is simultaneously exalted and stigmatized . . . If a solution exists to what we call today the feminine problematic, in my opinion, it too passes over this ground . . . [I]t involves coming to grips with one's language and body as others, as heterogeneous elements . . . go[ing] through an infinite repeated, multipliable dissolution, until you recover possibilities of symbolic restoration: having a position that allows your voice to be heard in real, social matters – but a voice fragmented by increasing, infinitizing breaks.[21]

Smith speaks of the process she went through, 'My work has evolved from minute particles within the body, up through the body, and

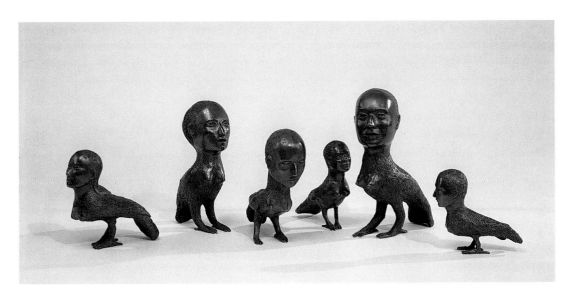

41 Kiki Smith, *Sirens*, 2001, bronze, various sizes.

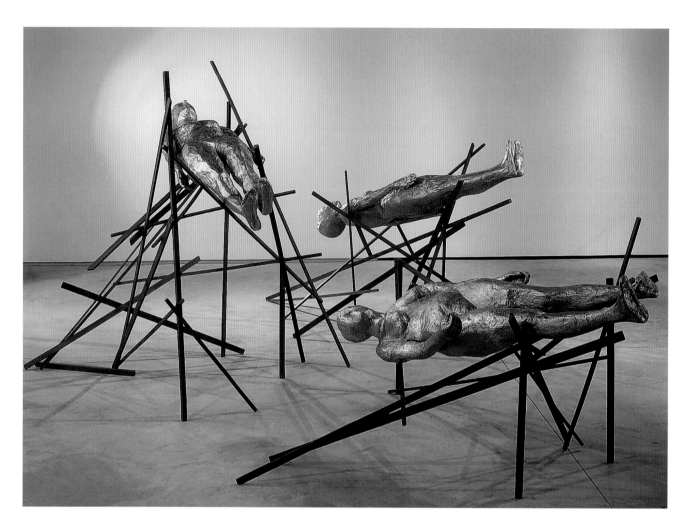

42 Kiki Smith, *Moon on Crutches*, 2002, cast aluminium and bronze, dimensions variable.

landed outside the body. In the last few years it's been inside and outside. Now I want to roam the landscape.'[22] Smith has, in fact, gone out into new fields – from the human body, to the world of animals and vegetation, to natural environments, the continents, the moon, the stars, the Milky Way and out into the galaxy. Her latest work is a series on the phases of the moon – female figures as embodiments of the blue moon, the red moon of the harvest, the yellow moon, the silver moon. They are held aloft on scaffolding. As if concerned that even celestial bodies may break, she gives them prosthetic supports and calls them 'Moon on Crutches' (illus. 42).

Although she does not make art with any

instrumentality in mind, her work has become important where rebellion and hope are concerned. Kiki Smith is now an internationally known artist. Her work is in major museums, galleries, libraries, public parks; it is out there, it is has a voice, it participates. Making images, fashioning new narratives produces change in the world; it is a political activity. If the images she fashions offer hope, it is not in their resolution, but in their latency. This is hope in the sense that Ernest Bloch recovered for us in *The Principle of Hope* – hope is process, that which is not yet, that which impels us into the future, an authentic anticipatory mode of working in the world, that needs, in fact, to be visualized.[23]

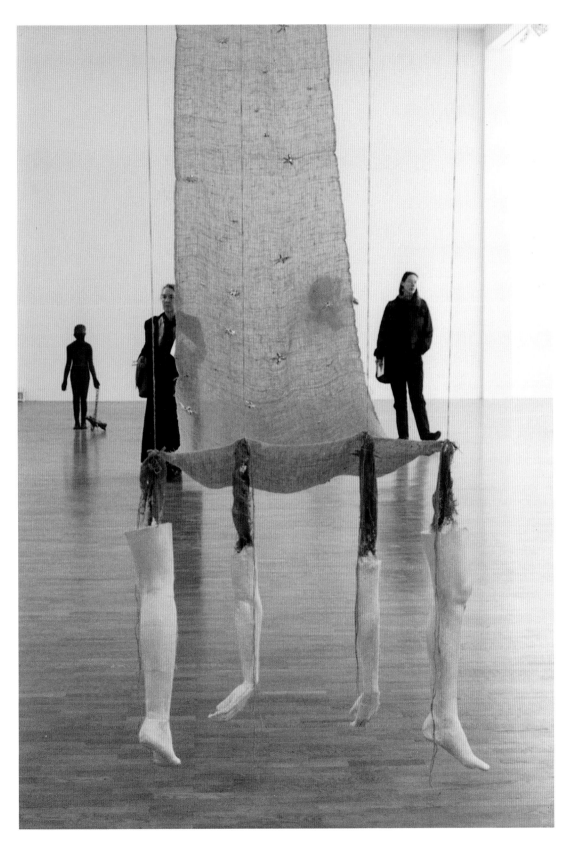

43 Kiki Smith,
Reina, 1993, burlap,
plaster and sequins,
dimensions variable.

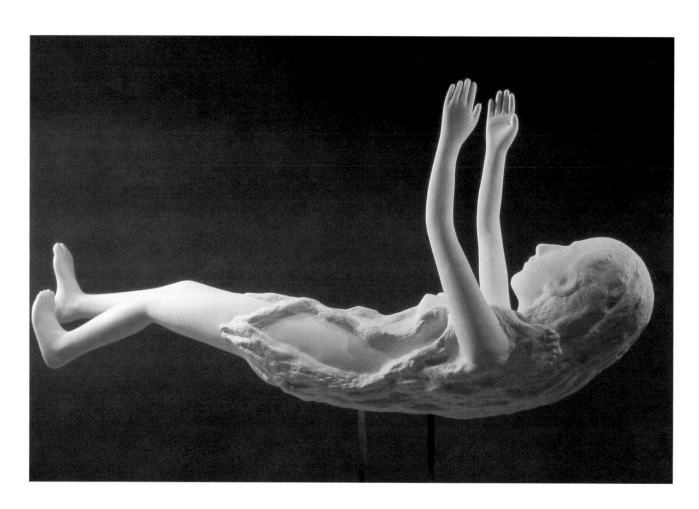

44 Kiki Smith, *Tied
to her Nature*, 2002,
plaster over foam,
106.7 × 223.5 ×
45.7 cm. (42 × 88 ×
18 in.).

Rapture: A Girl Story for Kiki Smith

MARINA WARNER

... that fair field
Of Enna, where Proserpin gathering flowers
Herself the fairer flower by gloomy Dis
Was gathered, which cost Ceres all that pain
To seek her through the world.
MILTON, *PARADISE LOST*, IV

I

Picture this: a field of flowers.

No, picture this: a meadow in spring, with young girls in flower.

Better still: spring, a flowery meadow, young girls gathering flowers, pulling petals one by one, chanting, 'He loves me, he loves me not'. Then, if the oracle says, 'He loves me', on she goes: 'Black-haired? Light brown? Redhead or blond?' When that answer comes, she picks another down to the cushion, 'Straight? Curly? Wavy or bald?'

Laughter splashes across the scene. Pinches. Squeals.

They're eleven, twelve, thirteen years old, children growing into their first girl shapes, the material of their bodies like loaves left overnight, bread rising to the mould. They have very little hair in their armpits, if any. The older ones have down in the small of their backs; a fuzz coming between their legs. One has more than the others; she has the darkest skin and hair, and she hides it from the others when they go swimming, in case they find it ugly. This is Lydia who's been included by Persephone's explicit permission into her loudmouth gang of friends. From this serious quiet one to the most hoydenish of all, Thaisa,

the girls have all reached the critical balance of flesh to height to bone to fluids that springs the switch on menarche. Flowers, so-called; anemones, blood-spotted.

This flowery meadow in spring where seven young girls are picking flowers: picture it in Sicily, on the slopes of one of the island's volcanoes, Mount Erice, a long time ago, around 450 BC, though they name the year after the reigning Greek emperor of the day, whose name I haven't quite established. They are jumping into their future feet first, squealing at the great draughts of the future they're inhaling with every breath they take. The leader of the gang, Persephone, will become Kore, a name that means, simply, Girl, and her little friends are korai, all of them resembling those straight-backed, high-bottomed, carved maidens in their fluted marble muslins that they say the sculptors damped down to reveal better the forms of flesh underneath. After this day, after the event that is waiting to happen swallows Persephone into a dark time and down in another world below this meadow, on the underside of the familiar ground on which the meadow lies, her band of korai will be changed into sirens, wailing against dangers, while her mother will be looking for her everywhere through a winter that never ends till she finds her.

45 Kiki Smith,
Fountainhead, 1991,
handmade book with
photo-engravings on
Abaca paper, 20.32 x
12.7 cm. (8 x 5 in.).

II

When I was a girl of about her age, I had a book with a reproduction of a painting showing Persephone rushing towards her mother from the dark depths of the Underworld with her arms outstretched and her whole body arched with longing to throw herself at her. For Demeter was standing at the top of some steps looking down into the darkness where Persephone had been held prisoner; the mother was leaning towards the daughter in expressive yearning too, against the light with her arms outstretched. The painter – Lord Leighton, I think – swirled Demeter in lots of apricot fluttering drapery in imitation of that delicate fluting and undercutting of marble relief carving, so that the goddess gave off a golden glow like my favourite night-light with the waxed lampshade, and these swathes of stuff whipping about gave me the feeling of the wind rushing out of hell as Persephone raced up the steps towards the light, the air, the world and her mother, who was summer, plenty, hot fresh bread, firm corn kernels, multi-grain cereals, all that goodness all together. Even the folds of two women's dresses were leaping, it seemed to me, into the young year that promised to burst into flower when mother and daughter found each other again.

I loved this painting, and the story it told. I knew I was a girl, too, as Persephone was, and that it wasn't impossible that I might even come to be like Persephone. Or so I wanted. More than anything, I wanted to belong in some kind of girl story. But how does a girl know what being a girl means? Putting such a question, framing it in all consciousness, seems to imply a failure to belong to the human species or to understand its most fundamental axioms. Ask almost anyone 'How did you know you were a girl? When did you know?' And nobody I can remember ever not knowing this, though I've read Jan Morris's *Conundrum* and interviews with transgendered third-sex people and so I know about feeling you're inside the wrong body, that your psyche is female, even if your body is male, and vice versa. But the taken-for-granted aspects of the girl story puzzle me now and they puzzled me then: the problem stuck: 'Be a girl' – how? Sharper still, how do you start to 'Go, girl'?

III

Now picture this: girls in the playground of a suburban day school, in a capital city that's never-the-less a backwater, Brussels in the 1950s. No flowers, no fields for that matter, but privet hedges, wooden fences, latched gates; on the asphalt, in the chain-link pen, some girls are playing hopscotch and skipping games, others are sharing secrets with each other, peeping behind their hands at others to make them feel left out. One of these, Natalia, has black curls on her head and thick black eyebrows that already meet in the middle. Two of her little classmates have been asking about her: she's strange because they know she hasn't got a father, or not at least one that comes to pick her up from school. She tells them, 'My Dad's in South America; he's got a ranch with lots and lots of cows like bulls. Not like our cows. Cows with big horns.' Her play-mates sing out a word she doesn't understand with a shriek of triumph and she knows she would be ashamed if she did. She doesn't under-stand because she's been brought up in another country far away, and speaks its language far better; the hubbub in the playground and the classroom out of hours defeats her. She has only just arrived, because her mother has taken a job as an interpreter employed in the new offices of the Common Market.

It is spring here too, and the new girl Natalia falls and scrapes her knees, quite badly, so that the stain of the tar from the asphalt ground will linger under the scarred skin decades after. She falls when the two girls holding the skipping rope miss a beat when she jumps in and she

comes down in a tangle. She hasn't yet the knack of it; at this stage, her body won't follow properly anything her mind tells it to.

IV

There were other examples for Natalia to observe, besides her new classmates. Older girls who wore stockings that made a kind of whispering sound as their legs rubbed together when they walked by the desks invigilating during the quiet reading time after lunch. Sometimes their petticoats hung down below the hem of their uniform, too. But she'd still prefer to be a boy, she thinks at night when she lies in her bed, imagining adventures involving a gang with herself as captain. She would watch the headlights of cars driving down the street outside first touch the drawn curtains into furrows of coloured light, then ripple across in a bright arc, then sweep on and leave them trembling and grey. Often it would take twenty cars or more before she fell asleep, and she'd imagine how she'd become a boy, specifically a boy of nineteen called something like Julian, who would be possessed of loads of Vim and Gumption, and would know how to make invisible ink and tie knots in 32 different ways, would stretch out long angular legs in tweed plus-fours, dash about with effortless ease, use a multiple penknife and discover the dastardly schemes of dark strangers just in time and long before any grown-up had even cottoned on to the presence of danger. Julian figured in lots of girl stories that Natalia was reading: he was the hero of a hundred books in which girls were soppy and drippy and weeds and crybabies and prissy and generally annoying. But tomboys only did a little better: somehow, after the first burst of energy, they lost their glow too. In the girl story that would undo all this uneasiness around her body and forestall the destiny of female character that loomed, this girl would make no apologies. She would fit the feel of the lithe and lissom me that Natalia sensed existed inside the clumsy casing of her growing outer she.

V

Persephone and her friends are playing in the meadow all in flower; around them, Lady's bedstraw, love-lies-bleeding, lords and ladies, orchids and asphodel, all in furls and spathes, with nectar-laden pistils, honey cups. Sky-blue buttons of scabious for staunching wounds, wild violets to give comfort (heart's ease), comfrey and balm and shabby dock leaves to soothe angry itching, as well as pharmaka which cooks use to season – parsley, sage, rosemary and thyme, like in the old song. Are the girls singing? A few lines of a love song. There's wild jasmine in clusters of white stars on one side of the field, and tufts of shrubby lavender in spires beside the papery rock roses growing out of glinting schist of the mountain slopes that rise above the meadow. They are telling one another things they've heard about . . . older people, and especially about men doing things to women. They've picked up odds and ends mostly in the family kitchens, from household servants who are even older than the grown-ups they're most curious about. They've learned about the body's holes, their variety and their uses and some of the bits that fit into them. There's some disagreement, however, about their number:

'Two ears.'

'One mouth.'

'Two eyes.'

'This part's easy.'

'Two nostrils . . .'

'No, that's really one hole.'

'It's not.'

'It is when you're dead.' This is Lydia; she is playing to her reputation for dark thoughts.

'We're not dead, so it's TWO nostrils, silly. We're not counting inside stuff. Insides are different.'

46 Kiki Smith, *Fountainhead*, 1991, handmade book with photo-engravings on Abaca paper, 20.32 x 12.7 cm. (8 x 5 in.).

'Makes six so far.'

'Plus one pee hole . . .'

'Then the other hole . . .'

They start all over again, clutching one another to stop bursting from the excitement.

'Don't forget your tummy button', says Chloe, lifting her top to stick a finger in her navel. 'Makes me feel sick.'

'That's where you come out of your mummy', says Thaisa.

'Ugh, right, disgusting', says Mintha, ' If you poke about too much, the knot'll come undone and you'll spill out of yourself all over the place.'

'No, stupid', says Persephone. 'It's the other way round. YOU come out of your Mother's bottom, and . . .' (to the sound of protests, even howls of derision), she goes on, 'and you're still attached to her by a long thread so you can't get mixed up with another baby when you're born and your mother is really so tired she can't keep track of everything that's happening and every one else is so busy they get a bit absent-minded.'

Her gang grows a little quiet and thoughtful. Each one is wondering, Did the system go awry in my case? Have I been tangled up with another baby, another girl child? Then, for one or two, the hope arrives on spread wings, Am I in fact someone else? Someone far more everything than what I now seem to be?

'No, no', says Chloe. 'You're not connected for long at all. Kittens come out of their mothers' bottoms too, I've seen them, and their shadows too come out after, a big red lump of stuff to start with, but it turns black and flat.' At this, Chloe looks a little uncertain and comes to a sudden halt in her report.

'The lump's *eaten*. It's not a shadow at all.' Thaisa is definite. 'Animals eat theirs.'

The group fell silent. It was a puzzle.

'That's how babies get out, but how do they get in?' Mintha frowns.

Lydia speaks up softly: as she reads the most, the gang listens. 'It's very easy and so you have be very careful. A baby can get in if you sit with your legs apart or if you sleep with your mouth open or if you stop to talk to a stranger and he gives you something to eat. You open your mouth . . .' (she demonstrates, closing her eyes). 'He pops something in . . .' (she made as if savouring something mysterious, delicious, and pantomimed gulping it down). 'He could be popping a baby between your lips . . .'. She screws up her face and spits. 'Ugh, yuck, yucky . . . Too late!'

'But you can stop the baby getting in', Thaisa declares firmly, for Lydia is playing too central a part in the conversation, 'I've been told how and it's true.' Her informant was Photis, daughter of her parents' cook. 'Photis says her mother has a sponge she puts inside her. She says it blocks the way at night and babies who are looking for somewhere to come and hide have to go somewhere else.'

The girls look about: there are flecks of light in the afternoon sun, motes in sunbeams, every one of them a miniature soul, waiting for flesh, expecting to grow full size, human scale.

'No, the right person has to breathe on you', says Persephone. 'Cows stand with their backsides to the wind and lift their tails and try and trap it inside them.' Her hand flies up to her mouth. 'I didn't say that', she says. 'You didn't hear me say that.' Her eyes are shining with mischievousness.

'And it has to be at the right time', Chloe adds, not picking up on Persephone's antic mood, for she has walked in on her mother and found her sitting down on the floor with a bloody cloth between her legs and crying that the new brother – or sister – that she wanted to come hadn't.

Persephone nods to her gang, announces with finality. 'Yes, it's not that easy where we're concerned, in fact. We're not like dogs or . . .',

her eyes looked away, to the slopes beyond the meadow. 'Or goats. Or cows. Girls like us have different bodies . . .', again she looked about them. 'No, even more than different. My mother says it's complicated . . .'. And she began to laugh as she listed all the most complicated phenomena in the world . . . They included wind and water and meteors and rainbows: unpredictable motions, mysterious relations, changeable temperatures, calibrated connections . . . oh, Persephone was shiny-eyed and intoxicated on the possibilities, and her friends listened to her, twisting their hair round their fingers and biting their lips as they followed her excitement and tried to imagine what they could not imagine. But they were full of love and envy and joyfulness and all these feelings were pouring into the mixture of possibilities for girls like them, girls like us.

VI

In the Fifties, in the ramshackle small home in the suburbs, Natalia doesn't remember now why the babysitter, Brigitte, who came when Natalia's mother went out, brought her son Christophe, who was six years older than Natalia and couldn't really be called a playmate. Though he was only fourteen Christophe was already as big as a man and had black hairs showing on his face and arms sparsely, like spiders crawling on him. Brigitte worked in the office of Natalia's mother, and she came from the same part of the world so they'd struck up an alliance. She seemed older than Natalia's mother, and she never seemed dressed up or scented; she never wore shiny stockings nor did she jingle with bracelets, though she did have a gold locket on a chain around her neck, with a picture of the Madonna on the case and, inside, a tiny photograph of Christophe when he was a baby with his father. His father was a chauffeur and he dropped Brigitte off with Christophe and sometimes

gave Natalia's mother a lift to wherever it was she was going, if he had the time.

Maybe Brigitte wanted to keep an eye on Christophe and make sure he did his homework, if his father was out waiting late for his bosses to come out of the restaurant where they were meeting.

In Natalia's memory, Christophe is sitting at the kitchen table, his sleeves rolled up or short for he was somehow always overheated, leaning on his elbows on the kitchen cloth that could be wiped clean, with its gay cherry-red and apple-green design of a hay cart and a procession of men and women and children and animals all going to market. Maybe Brigitte brought her boy so she could give him supper – yes, Natalia thinks now, Brigitte didn't want to make two suppers, one at home for Christophe and another for Natalia later. But where was she, when Christophe and Natalia were left alone? For in memory it seems they were always alone together at the table, especially the time when Christophe stood her up there, carefully folding back the cloth with the gay design of men and women going to market and put his nose under her skirt and smelled her.

They'd finished their fried eggs with melted cheese slices on top, and mopped up the runny bits of the yolk with toast cut into soldiers as Natalia's mother did, when they began playing a card game. The first time they played, Christophe and she traded chocolate: she cut up a bar that came from the larder and gave him half at the start. This time, he suggested forfeits, and when she said she had trouble thinking of any, he said he'd show her some good ones, and he took her arm and pushed up the sleeve of her school blouse, and twisted his hands in different direc-tions, laughing and saying: 'Here, this is a good one.' When she yelped and cried out, he told her he'd made a mistake and that wasn't what he'd meant to do and he'd show her another one, and he took her thumb and bent it back against her wrist.

It was difficult to understand now what it was about Christophe's bulk and temperature and metabolic rate that so pinned her down with anticipation that she couldn't take herself away to a safe place. Being near him was like being on the other side of the barrier with an animal on show at the zoo: he smelled, too, of wet hay and cheese and stale meat and the vulcanized canvas of his jacket, and his shape was loose all round his body, so that there appeared to be more of him than there was – every contour was expanding, grease smears and small yellow pustules lifting the contours of his skin and hair follicles sprouting. He was the first boy made visible and more than visible to her and all the features of this visibility etched her own edges till Natalia was bound to her nature with more puzzlement than she had ever known before.

At school the music teacher was a man, but Natalia didn't take extras. Of course men visibly filled the world outside school: men who drove the bus to school and took the money into worn leather pouches; who trundled the rubbish bins to lorries standing by, their engines grumbling while the driver hung out of the window shouting and smoking; other girls' fathers seen at mass, sometimes, and at school events; sometimes, the priest in his long lace dress; men in hats with dogs in the park where Natalia and her mother went for a walk on Sundays, in the lovely soft dapple under the beech trees; bald business men eating in the pavement cafés bowls of *frites* with apple sauce. Once a policeman called by and frightened Natalia's mother, demanding to see their papers, but all was well, it was just red tape. Once, a knife grinder rang the front door bell, and Natalia and her mother went out to watch him as he spun the wheel of his grindstone until sparks spouted outwards like dandelion spores on fire. And it so happens that this tight and unfamiliar capital city's inhabitants have adopted a little boy for a mascot, the Manneken Pis. In the Grand Place on Sundays, Natalia and her mother sometimes go and look at the birds on

sale in the market, tiny huddles of yellow and red and green all chirruping and chirring in the small wooden cages, and they usually go round the corner and join the crowd around the fountain, and watch the jet of water arc from the jaunty tap between the boy's chubby thighs into the basin.

Natalia's mother sometimes laughs with the rest, and sometimes she sighs, and wonders aloud what kind of country they have come to live in, where the people have chosen a peeing boy to be their emblem. Natalia's mother was a little prudish, she realizes now, and even humourless in her anxiety not to put a foot wrong and make her way: they both find the jutting Manneken Pis very rude, and it's not the rudeness that makes you feel funny and molten inside, or makes you giggle, or makes you want to wash your mouth out afterwards with soap. It's not really as rude as all that, just something you wouldn't do or want to watch someone do but a bit fascinating all the same.

When Christophe counted the tricks and then hands they'd played, he informed her with a big grin that she'd lost overall, and so she'd have to pay the forfeit. Even though she wasn't sure this was right, she let him pick her up and stand her on the table and though she tried to keep her legs really tight together the way she did when she didn't want to let out any pee if she was bursting, she felt she was going to explode all the same when he snuffled around under her skirt. He didn't hurt her this time, not as he had before when he showed her Chinese burns and other tortures; she only felt his nose, hot and a bit wet push under the elastic. But this contact seemed to do him harm, as he bent over afterwards on his chair making pants and groans, and began to twitch.

He was so doubled up that she climbed down off the table without his help and without him noticing and stood in the kitchen a little way away from him near the door because she was frightened something was going very very wrong

with him. But when he straightened up he looked all right and grimaced in her direction in a daze as if he didn't know who she was or what she was doing there. After that, he got out his homework, and began to shuffle an exercise book and a textbook, yawning. She went to look for Brigitte. On the stairs she found the light switch, but turned it quickly off again because Brigitte was lying on the sofa with her head back and her eyes closed. One of Natalia's mother's magazines open and drifting on her lap and the lamp on the side table was lit. Brigitte didn't notice anything, not even when Natalia came closer and was frowning hard to stop her face from pulling the other way into tears.

The main feeling was disappointment, really. It was sharper than the dirtiness, though this was confusing too. Having Christophe come over for an evening had filled Natalia with such anticipation, inspired in her a sense of occasion, as when her mother entertained a visitor, which was also a rare event. She'd been excited that Brigitte's son, who had been the baby in her locket picture but was now practically a grown-up, noticed her at all and so pleased he'd wanted to keep her company and play a game: but the inside her protested now against the outside that he'd investigated. The body he'd done things to and had done things to him was a stranger, a clumsy cast that enclosed her and masked her, stifled the living breath out of her as if someone had forgotten to make the right holes in it to let her see or think or eat.

VII

In the jasmine, above the meadow where the asphodel's tall spears are humming with bees, among the rock roses with blood-spotted throats rooted in the cracks in the tufa of the mountain, Dis the brother of Demeter, Kore's mother, is watching the band of girls. An old man, though not old to himself except in spirit, for he has

47 Kiki Smith,
Fountainhead, 1991,
handmade book with
photo-engravings on
Abaca paper, 20.32 ×
12.7 cm. (8 × 5 in.).

48 Kiki Smith,
plate 4 from
Fountainhead, 1991,
handmade book with
photo-engravings,
1.9 × 20.3 × 13.7 cm.
(0.75 × 8 × 5.375 in.).

band of girls and they shiver and one or two hug themselves and turn to pick up discarded things, the remains of their picnic, a few scattered flowers, a broken and wilted garland, and other items, of clothing, and of diversion . . . a gaily striped ball among the flowers.

The chill rears up, gathers itself into a shape, into a body of a man who's all lank and grey and shrouded, and he speaks, calling out to Persephone. He is greeting her, as if he knows her, but she still can't see him, only feel the shape of the dankness that approaches, so close now it touches her. He is referring to her mother by name, to her father too, he is claiming relation to her family. He is her long-lost uncle, it turns out, back from a long sojourn in his own kingdom, far from this lovely sun-drenched blooming island. He is so glad to see how she has grown up to be so lovely, how utterly charming she is.

'I can't see you', she says, helplessly. 'Where are you?'

Now he's almost touching her, and she smells the sulphurous sweat that clings to the dense shadow of his massed shape, bearing down. She turns towards it, wanting to turn away; her friends surround her but seem to slip off the edges of her vision, she can hear Lydia shrieking but she sounds really far away as the darkness takes her and catches her up against his long cold body. He stretches out his two long arms – the gesture her mother will repeat, a whole existence later – and folds them around her. Their clamminess passes through the cloth of her top as he squeezes down and fastens his hands around her ribs so that they almost meet again in a double knot. He's no shadow now, but substance, heavy water. He presses her down under him like the planing bulk of a raptor on the hunt with talons closing on a young hare that has been springing in a moon-bright field. Persephone feels hot pee squirt between her legs and down one thigh as he grips her and bundles her under his long arms and lifts her off the ground and begins to carry her away.

dark moods. He doesn't belong to the springtime in which the girls have their being, but, without knowing exactly why, he's emerged that afternoon into the sunlight, drawn by their laughter, their whispering, their earnest chatter, their questions. He has been listening in, crouched in the shadow of a boulder, unseen. Darkness provides him natural cover, for pitch night envelops him at home, though in one sense he has no home but the dingy, unlighted stretch of place and time on the other side of life. He comes closer to them, and they sense the proximity of chill and dark and they think the evening has fallen, suddenly. It is spring, after all, still unripe and not yet velvet rich and soft after the sun sets. The cold shadow stretches over the

First hard earth below, where he stamps and it gapes wide. They slither down through to the layers of riddled tufa below and then that cracks as he smites it and they fall deeper into the chasm, into the black, his mouth biting hers, his open forcing hers to follow and open too. She never imagined so much could exist inside another's mouth. His tongue is a lizard, kicking and whipping its way into her. He will force open every entrance. Untie her navel and turn her body inside out until she'll be flung from her own flesh.

Lydia is screaming now; Chloe sobbing; Thaisa howling, their jagged voices are calling out to her from a great distance, streaks of warmth in the cold that spreads from one end to the other of her life. She is screaming so hard she stops hearing anything at all except this, her fury at her ravishment.

This is the end of spring for Kore and, once her mother hears what has happened, for the entire world as well.

VIII

till she comes back.

IX

Her friends continue to cry out, they run about the meadow, they tread down the flowery pasture where they were playing till they fall to the ground where they stand, exhausted. Lydia swears to herself she will never let anyone forget this time, when Kore was snatched away from them, on that day that they never knew was going to be the last day for her of the time when she was a girl. Even years after, when against all the odds she has safely returned, overturning the grim news of all those police notices about missing children, missing girls, missing women, the girls who were her friends wake in the night with a jolt as they are revisited by the cold shadow that came down that evening in the field and swallowed up the spring.

The voices of the girls lifted in pursuit of Persephone and were caught up into the airwaves and started travelling. Towards us. The signals they emitted then turned into bird cries, into alarms of danger and lamentations for loss. They're beamed through time, they pulse in the intricate harmonic mesh that traverses our space-time present ever since the companions of Kore in the flowery mead implored the gods to lift them out of their bodies of heavy human flesh. They were heard and their wish was granted: lightness wrapped them and up they flew, mewing in the wind as they turned towards the sea and swooped down, skimming the earth still looking for their friend.

49 Kiki Smith, *Fountainhead*, 1991, handmade book with photo-engravings on Abaca paper, 20.32 × 12.7 cm. (8 × 5 in.).

I hear them in the wailing of ambulances and the clanging of fire engines, in the blare of the newspaper headlines when another schoolgirl was last seen . . . by a bus stop . . . on a railway bridge . . . taking a short cut across . . . in a café with . . . I have heard them in the tolling of buoys in the grey heave of a winter sea, rocking mournfully to a force eight rising to ten, turning cyclonic. They sound in the high screech of the fire bells in an office building when workers are drilled into leaving, swiftly, calmly, and I over-hear them in the faint boom of the air-raid warnings before the night attacks over the distant city on the TV where, as if in some disassociated fiery ballet, streaks of mortar fire and rockets flare and die, and I even catch their note in the shrill squeal of the anti-rapist personal alarm that, when I was young, was recommended for girls to carry in their bags.

X

In Hades, where he takes her, there are no living beings: she is the only one.

He is made of old cobwebs, soot and cinders, fog and methane, and when he sits her on his lap and tries to arouse himself with putting his fingers in her and his tongue, his smell changes to a charnel reek as his dead flesh warms a little, and gives off fumes of mortality, like hair caught in a flame.

No light, so no colour; no time either, because this realm on the other side of death belongs outside all of time and history and its flow, so no natural cycles of burgeoning and decay; no flowers, no birds, no breeze. No playing.

They do talk: she asks him why he wants her. But he finds it difficult to explain.

'A man on the point of death', he whispers in his choked voice, 'wants a girl beside him to warm his body: you are medicine with power to do more than any doctor's remedy.' He tries to laugh, and she turns in his lap from the stench rising from the funnel of his volcanic mouth.

Time does move along for her, unmetered, in the perpetual dark. The pomegranate, when the treacherous attendant produces it, glows and throbs with crimson and fertile vigour: she can't resist it. She breaks it open, and the glassy beads shine like flesh against the light, veined and juicy. She nibbles it: six seeds. Six seeds cost her half the year. They will introduce a measure, a limit on the bargain her mother is able to strike with Dis when at last she finds Persephone again and takes her away and brings her back to life for half the year, for her girl's springtime and future summer.

XI

Brigitte says she'll tell Natalia a story to help her not to be so scared before bedtime. Natalia curls up against her and sucks her hair (she's not allowed to suck her thumb or her fingers) as Brigitte fishes out of her handbag a small picture of her patron saint, and begins to list in a soft, languid singsong the terrible torments that she suffered during her long martyrdom. 'That expression on her face', says Brigitte, with great tenderness, 'So smooth and pure and beautiful – shows she never felt any pain at all, even when her father and all his friends were holding burning torches to her breasts and pulling out her tongue with pincers to force her and tying her to a wheel to break every bone in her body and chaining her to millstone to drown her and so make her marry the wicked pagan king they'd chosen for her . . .'.

Natalia puts the holy picture very close to her eyes in case the tiny figure of the saint tied to a wheel of fire might give her a sign.

Brigitte goes on: 'She can look like that, absolutely serene and perfect, because when you're being martyred, God gives you special grace. He's near you and he fills you with his fiery strength and so you don't feel anything but the power of his presence. It overwhelms every-thing else, even the most awful tortures, like hers. If you're a Catholic, you call it rapture'.

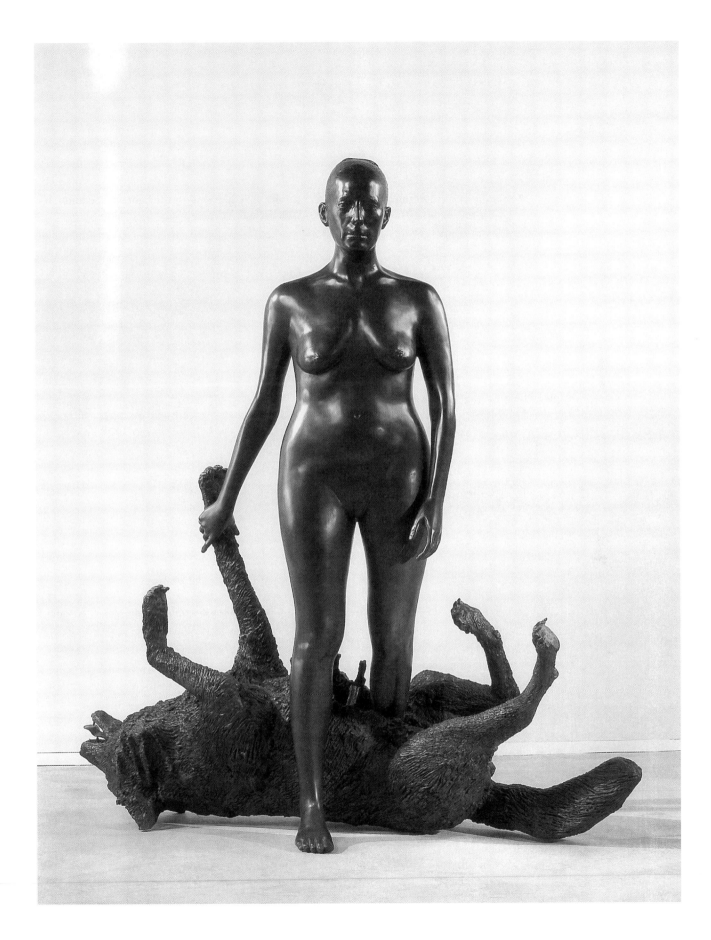

If Walls Could Talk

ROSETTA BROOKS

In the last videotaped interview before her death, the British writer Angela Carter said: 'As one gets older, the search for the beginning becomes more and more pressing because it is very nearly analogous to the search for the end.' Carter was referring to the importance of myths and the mythic in our daily lives. Throughout her career, embedded in every short story, novel and essay, Carter upheld the belief that the resurrection of the female in Western culture is a re-animation of the mythic: that it can lead to a re-enchantment of the world.

Nancy Spero and Angela Carter both share this eschatological desire for a re-animation of the mythic: a longing to re-enchant the world. For both women, it is a desire 'to return to the source; the space we know nothing about'. Indeed, Spero has described her art as an attempt 'to see what it means, to view the world through the depiction of women'. She doesn't claim to view the world through the depiction of women, only to see what it *means* to do so.

If she sounds tentative about the enterprise, it is because she wishes to emphasize its hypothetical nature. For Spero, the feminine is not a principle but a question.

Angela Carter would have understood this very well because the hypothesis embodied in all fiction (the 'what if . . .' and the 'as if . . .' suspensions of disbelief), together with a desire for the re-animation of myth in our lives, was the driving force of all her writings.

Both artist and writer recognize that the return of the feminine to our culture is, deep down, a mythic enterprise rather than a historical one: it is a deliberate regression set against progressive modernism. To engage with mythic history is to step outside historical consciousness, to find points *beyond* history, to tie up the loop of pre-history and post-history, to reach a point beyond anthropocentrism and linear time consciousness.

But for Spero, mythic consciousness is not some recoverable Arcadia of female consciousness. There is no nostalgia in her work. It is an art full of hope. Figures that dance across her scrolls are ciphers of archetypes that can never be fully suppressed and that can only be broached as myth or in the form of fiction.

Hope, though, has not always been an all-encompassing trait in her art. Earlier works, like the *War Series* in the 1960s and *Codex Artaud* in the 1970s, for example, were angry, defiant pieces, expressions of frustration about the world, about a woman's place in that world, and (equally important) about the role of the female artist in the rarefied atmosphere of the art world. However, by the mid-1970s, anger and disappointment were transformed into aggressive, positive resistance in her series entitled *Torture of Women*.

Strong, disturbing images of persecution and molestation arrested the viewer's attention. And yet, surprisingly, these powerfully unsettling works resisted despair. Instead, they were to pave the way for Spero's work in the 1980s in which celebration and confirmation of the female principle were to become the radical subtext underlying her art. And despite the sometimes dark and apocalyptic subject matter that she has always tackled, there was, and still remains, an overwhelming sense of glee in much of her work.

Midway through the 1980s, Spero embarked on an even more revolutionary path. Her

opposite page
51 Nancy Spero, 2003.

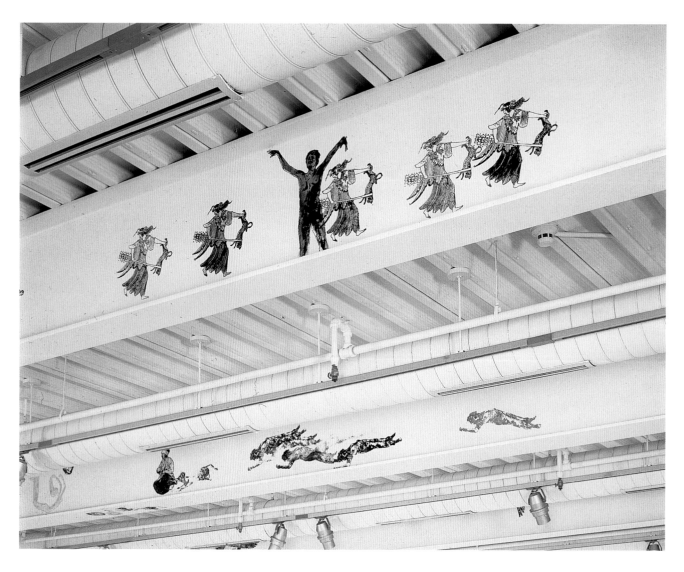

52 Nancy Spero, *Vulture Goddess*, 1991, hand-printing on beams (detail).

characteristic fragmented, pictographic goddesses, which had previously been consigned to the paper scroll and thereby condemned to the frame, were released into architectural space. Spero began working directly onto wall surfaces of museums and art galleries. Like genies let loose from their bottles, malevolent goddesses joined in an impish dance in an installation at the ICA in Philadelphia entitled *Devil on the Stairs*.

In this context, industrial girders became the frame and ground for Spero's printed imagery as she painted frieze-like assemblages directly onto the ceiling supports of the building (illus. 52). By

merging her printed figures with the structures and supports of the edifice, she awakened fleeting remembrances of the 'heroism' of the architecture. The building became an industrial garden and in its anonymous architecture we were able to envisage a temple to earlier technological achievements.

'Why not in every door a little threshold sod?' asks Gaston Bachelard. And, as if testing Bachelard's hypothesis, Spero's works are architectural musings. Why not a flying vulture goddess on every staircase? Why not a little door of the dead in every ventilation shaft?

A sarcophagus door as other-world plumbing? Spero prefers to use transitional spaces in her installation works – staircases, doorways, wall enclaves, ceilings – spaces we have been architecturally educated to perceive as peripheral.

The repeated figures of Minerva and the Sky Goddess, presented like fragments from a medieval, processional frieze and located on the wall above a small, anonymous service door, were enough to set off a reverie of spatial and temporal ambiguity in another installation work in Madrid entitled *Minerva, Sky Goddess* (illus. 53).

Spero has learned to exploit these threshold vantage points – these unexpected spaces designed to take spectators by surprise as they gradually become aware of the presence of a work of art. The onlooker's consciousness is altered in that moment of discovery. There is an unsettling feeling, an awareness of somehow having wandered beyond the ordinary indices of time and space, a mild sensation of having walked into the wrong place, or, even more disturbing, the wrong time. Somewhere between graffiti and Arcadian pre-Classicism, Spero's installations occupy an equivocal, intermediary time zone because, while the artist is attempting to create a post-historical image of the female, the dominant images in her work are determinedly pre-historical.

With each new installation in which the inner or outer facade of a building became her canvas, Spero became more daring. Most challenging in this respect was the juxtaposition of her fictional codices with truncated fragments of Classical antiquity in her installation at the Glyptothek

53 Nancy Spero, *Minerva, Sky Goddess, Madrid*, 1991, hand-printing on walls and floors.

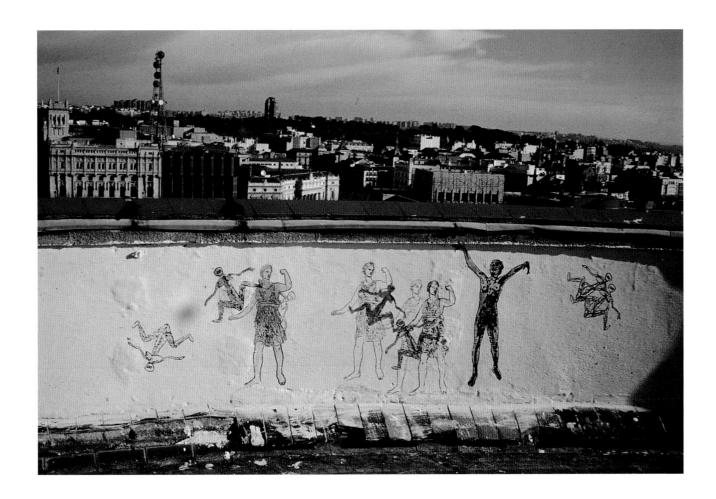

Museum in Munich in 1991. Creating an installation composed of works on paper along with cut-out figures scattered across the walls of the museum, all positioned around an existing assembly of Classical statuary, was a gesture on Spero's part to face the issue of authenticity head on. By placing the reproduction next to the original, by setting the ephemeral print medium up against the physical presence of stone, she created a surprising conversation between epochs of history.

Aboriginal Venuses were matched with a Greek Aphrodite and contemporary athletes posed next to Greek dildo dancers. Here Spero created a powerful, historically ambiguous space that curiously heightened the mythic quality of the permanent exhibition of Greek and Roman sculptural fragments by her gentle subversion of the context of historical objectivity that the museum provided. Spero's print fresco technique, which brought her imagery into immediate contact with the ready-made architectural features and objects of the museum, exploited the juxtaposition of archaic and post-historical 'fictions' to the full in the creation of a radically new vision.

Traditionally, the vertical dimension of space has always been linked to the idea of the transcendent. We are familiar with such visual representations in the underworld explored in Roman mosaics as well as in the vaporous above-worlds of the tradition of ceiling paintings, which reached its apotheosis in the eighteenth century with Tiepolo. This management of the threshold (this space of transition between the real and the imaginary) is a lost art of the fresco painter as well as being the forte of the ceiling painter.

It is a realm that has always been entrusted historically to the artist. Perhaps this is because the relation between everyday, secular space and that of the underworld and the above-world (the celestial or spiritual) can only be negotiated as images because they are absolute spaces.

Whatever the reason, the picturing of these spaces acts as symbolic representations of beginnings and endings, of Genesis and Apocalypse. They represented ascent into heaven or the gravitational pull of the earth: Origination and the Fall. Their co-existence as image and space in the marriage between architecture and painting is an Arcadian ideal – a balance of secular and sacred space.

When Mircea Eliade refers to the term sacred as 'a break in space and time revealed in a hierophany', he uses the metaphor of verticality as a form for interrupting the horizontality of everyday life. For Eliade, these sacred centres, lost through the dispersement of modern living, were to be experienced in the vertical. God, for example, sees from above. The abyss seeks its victims from below. People who have been resuscitated after near-death or out-of-body experiences talk about a sense of being at ceiling height, above the body. Gargoyles watch and protect from a high vantage point and, in the interiors of houses or churches, fertility symbols enclose the sanctity of the space from above, taking the form of cornice decorations.

Clearly Spero is acutely aware of this pictorial tradition and of the erosion of the vertical dimension in modern architecture and urban space. Her choices of imagery and location utilize these nether spaces to the full. And with this newfound freedom from the limits of paper or canvas, Spero finds her images mingling more and more with service ducts, lighting systems, standardized metal joints and overlooked paraphernalia – elements normally deliberately disguised or blocked out in contemporary settings for art in our modern museums and galleries. Interestingly, the ceiling seems to have become a favoured space for Spero's interventions. And yet it also provides a curiously appropriate form of encounter with Spero's iconography.

Spero's use of architectural space – especially her ceiling interventions – helps to restore a necessary balance between the material and

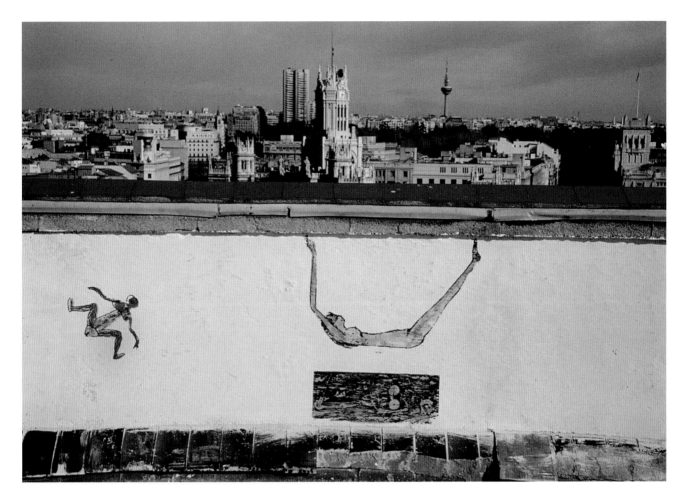

spiritual realms. They act as powerful reminders of the dictum that we are in the world and, equally, the world is in us: that to emphasize one aspect of life (like materialism) at the expense of something equally important (our spiritual life) can lead only to disaster, to disenchantment, to a world gone horribly wrong. That Spero's work can address such issues with both beauty and aggression is testament to the power that art still wields in a culture that steadfastly demeans its function.

Egyptian, Assyrian and Classical Sky Goddesses (especially the goddesses Nut and Artemis) abound in these installations. They take their place alongside contemporary fashion models, ancient Egyptian acrobats, modern-day athletes and gymnasts; a motley band of warrior women

– ancient and modern – occupy these physical and imaginary spaces. The over-arched, U-shaped Nut becomes a pattern of loops along the parapet of the roof terrace in the *Minerva, Sky Goddess* installation in Madrid in 1991 (illus. 54). In this work, Spero joins the Sky Goddess with the sky and tramples the aggressive figure of Minerva underfoot in the flora of the terrazzo. Printed skeletons of a pre-historic princess who had been buried wearing golden breastplates are repeated in the corner of the terrazzo. Elements of a gravesite mingle with the actual ruins of the real space.

Whether it is the aboriginal Uroboros or world serpent, the bent-over figure of *Nut*, or the warrior goddesses Minerva or Diana, the sky goddess in Spero's art represents the sovereignty

54 Nancy Spero, *Minerva, Sky Goddess, Madrid*, 1991, hand-printing on walls and floors.

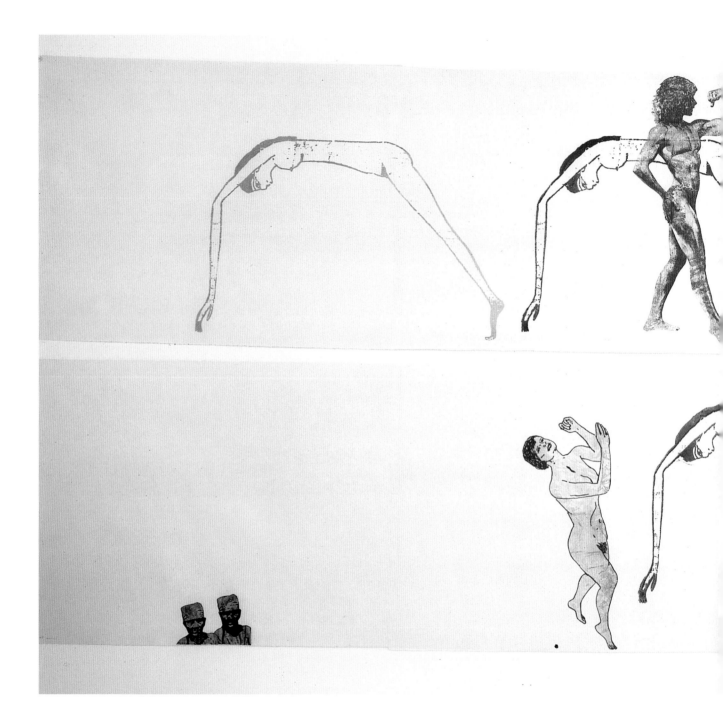

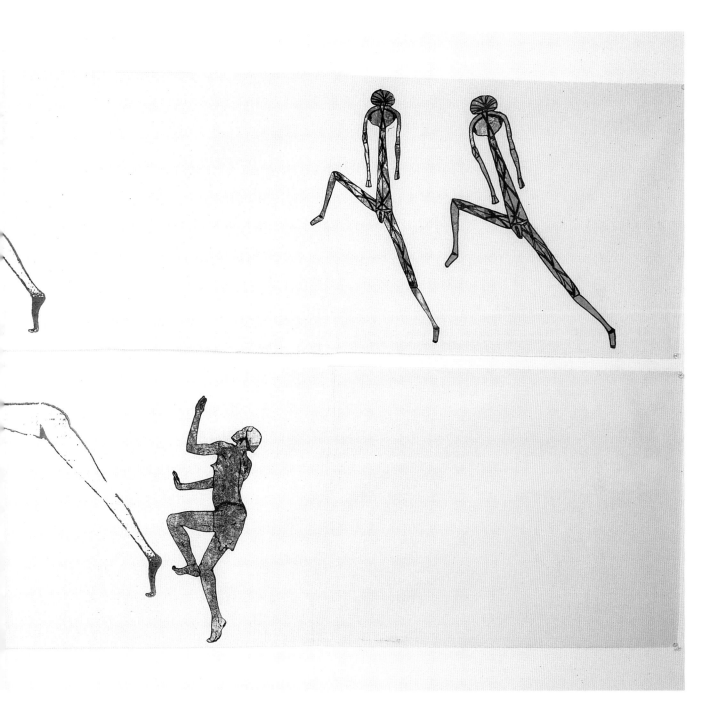

55 Nancy Spero,
The Goddess Nut,
1990, hand-printed
collage on paper,
106.7 x 279.4 cm.
(42 × 110 in.).

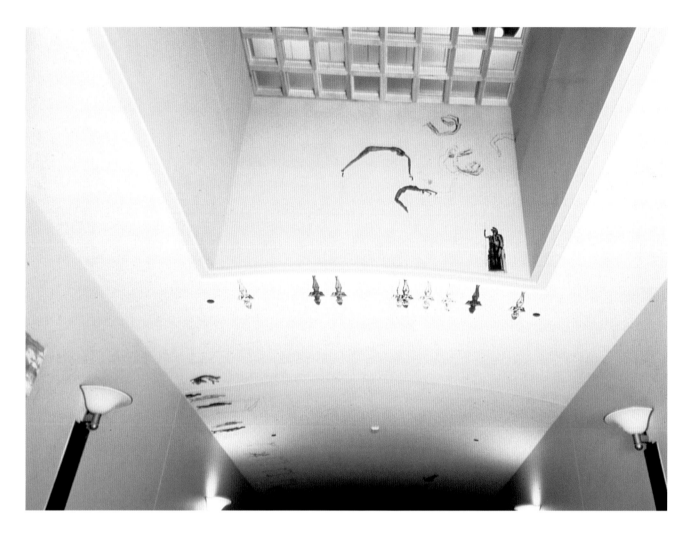

over the totality of the cosmos that is relinquished
to the Father Sky/Mother Earth dualism. Her
work is a gesture of reinstatement, a throwback
to the celestial goddesses of action and style who
commingle with images of contemporary athletes
and Greek dildo dancers (illus. 55). By using the
print medium, she restores a rhythm to them in
their vital dance of life and death.

In *To Soar* installed at the Harold Washington
R. B. Library in Chicago – and a work that
directly addresses ceiling space – the images
do indeed seem to float in the air (illus. 56).
Fragmented images of antiquity and the truncated
forms of athletes seem to be caught as if they
were scattering across the central ceiling in
migratory flight. The goddess *Nut* performs
cartwheels in a vaulted recess, and ancient
huntresses chase one another around the corner
of the heavens as if the ancient ideograms, burnt

into architectural decoration, have come adrift
from the gravitational pull of the architectural
scheme and are floating free in a skyward flight,
their arched flight an evasion of the rigid rectan-
gularity of their surroundings (illus. 57).

Flight is the central motif for this installation,
and repetition is its vehicle. Like the flying vulture
goddesses of her *Devil on the Stairs*, which are
overprinted in an arch of ascent like a study of
a bird in flight, *To Soar* attempts to recapture
some sense of the magic in the movement of the
image (illus. 58).

The intriguing feature of these installation
works (from the vantage point of artist, spectator
and institution alike) is that they are destined to
disappear, either by erosion through weather or
from redecoration. Their appearance likewise
is of spectral, spider-like figurines. They are
blurred, under-printed ghost images that are

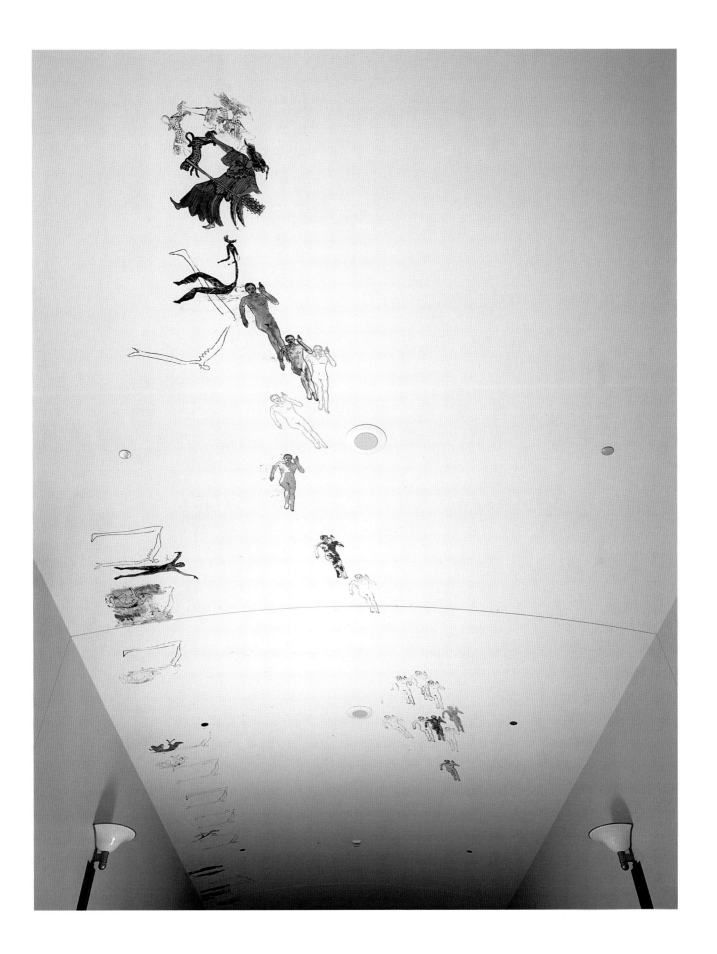

58 Nancy Spero, *Vulture Goddess*, 1991, hand-printing on beam (detail).

allowed to merge partially with their surroundings or to make their appearance out of it. So Spero pursues the image in flight and on the edge of disappearance: disappearance into its surroundings, into the physical surfaces of ceilings, walls and ground.

But she clearly enjoys this new found freedom of working outside the hard and fast limits of the frame and its concomitant centralized object of attention where the edges of the object of perception become insignificant. Indeed, for Spero, the edges are where discovery and regeneration take place. The progress of her entire oeuvre can be seen as a history of resistance to the enclosure of the frame. Her vertical and horizontal paper scrolls (the most characteristic form of Spero's art) create a similar spatial indeterminacy for the diminutive painted and collaged fragments dispersed within spatial voids.

This sense of potential endlessness is an essential part of the very nature of scroll

painting. Whether in the picturesque variety of a horizontal Japanese painting or in the sublime hierarchy of floating worlds in Chinese landscapes, the scroll invokes a sense of boundless, continuous space. Spero exploits the indeterminate through this relationship between the part to the whole and to the infinities that surround it in scroll paintings (illus. 59).

And yet, everything militates against such a way of seeing the world in this culture. Undaunted, Spero has developed a strategy that has always been about the suppression or evasion of the frame. In direct opposition to the modernist fetish with frames and limits that are designed specifically to create a sense of detachment from that which is contained within them, Spero seeks to implicate her spectators rather than disengage them. She confronts us with the uncontainable and challenges our desire for neat resolutions.

If the aesthetic attitudes of the recent past have denigrated into the indifference of window

shopping, Spero sees the necessity of operating outside the window spaces of the frame to function in the threshold space of peripheral vision – to insinuate space rather than to force spatial confrontation. In different ways and through different phases of her career, Spero has always sought out this ambiguous space of the threshold. Like the traditions of scroll paintings and architectural painting, Spero accepts that there is no sovereign vantage point: there is only a potential infinity of views. Like the older aforementioned traditions, the totality is uncontainable in her art. The edge between illusion and reality must be blurred.

Spero's return to this primordial space of painting (pigment applied directly to the wall) is radical precisely because it is taking place in the determinedly homogenous and non-hierarchical spaces of contemporary architecture. This poses the question of whether or not it is possible to recover that primordial relationship with space. Is it possible to re-enchant the world? It is a question that has become more and more important to contemporary art and that has always been central to Spero's art activity. Or has disenchantment taken over irreversibly in our spatial experience?

Spero's art provides no answer. Nor is it meant to. Rather it attempts to negotiate between the separated worlds of the mythic and the secular. The reanimation of a mythic dimension, a re-enchantment of space, a restoration of the feminine – all these goals are part of Spero's life work. And if the work has to negotiate with ventilation shafts, hi-tech lighting and postmodernist architecture as well as hundreds – if not thousands – of years of history and secular patriarchy so be it.

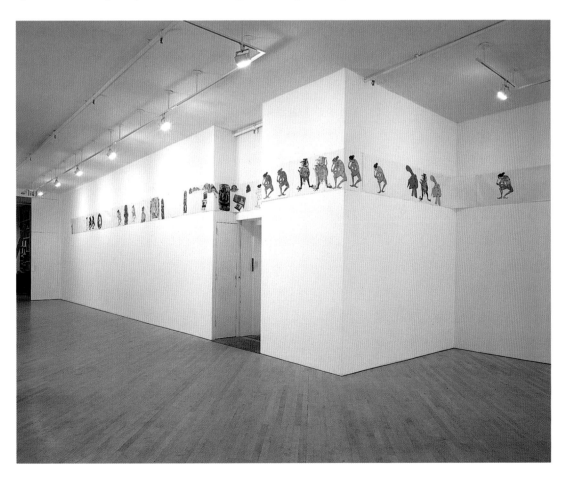

59 Nancy Spero, *Sacred and Profane Love*, 1993, handprinted collage on paper, 49.5 x 2,235.2 cm. (19.5 x 880 in.).

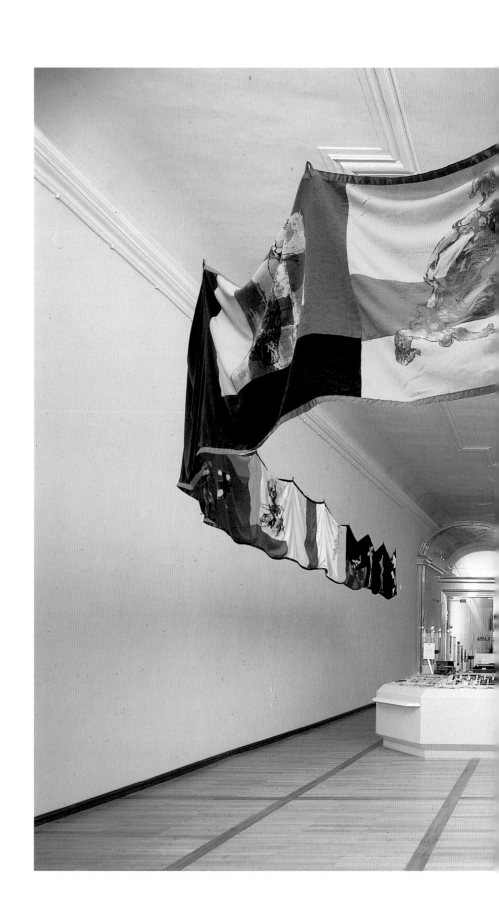

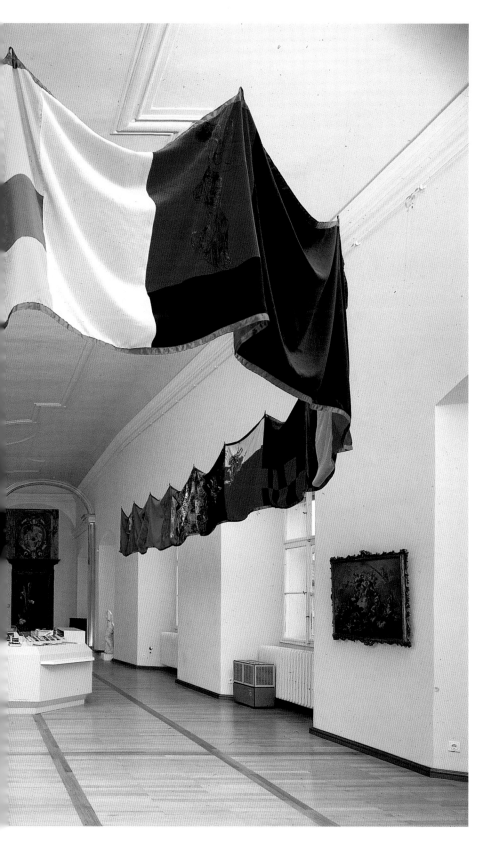

60 Nancy Spero,
A Cycle in Time, 1995,
hand-printing on
silk, 76 × 428 cm
(29.9 × 168.5 in.).

If Nancy Spero *does* provide an answer in her architectural interventions, it is a hypothesis: 'What if . . .'. But then, isn't that the way revolutions always begin?

PART 2: AN OPEN LETTER TO NANCY SPERO

Dear Nancy

It's ten years since I wrote the above article on your work. Coming across it after so many years, I find myself still 'agreeing' with much of what I said, despite the fact that your art has developed so much and you hadn't even begun working on your most public project – the mosaics for the Lincoln Center Subway. During the intervening years many young artists have arrived exploring new subjects in a variety of media. Additionally, the growth of cultural and critical theories have generated new art content and fresh ways of viewing and interpreting works of art. With this in mind, I decided to write you an 'open letter' in an attempt to discover for myself if my approach to your work has changed at all. So as you read through the pages of this letter, you'll find that I'm going to be riding roughshod, roaming around often blindly along a path somewhere between fantasy and reality, fiction and non-fiction, the imaginary and the pragmatic.

I want to use this structure, not because it's a form of funky art criticism but because presently there is an air of fantasy at work in our culture that's somehow informing our sense of 'reality'. I cannot yet give a name to it, or even describe it definitively or even clearly, yet it is shaping the cultural landscape as we know it. I'm not referring to Baudrillard's simulacrum or the current interest in digitization or virtual realities. Instead, what I'm talking about is a *space* where people knowingly enter into a realm of the imagination, self-consciously and deliberately in an attempt to use the imaginative as a means of transforming reality and then try and dream this new reality into being. It is a space where the worn old clichés

and myths surrounding cultural identities – for example, what it means to be a woman or what it's like not to be a white artist of European descent – are being turned on their heads; a space where the condition of 'otherness' that we've negotiated for the last four or five decades has somehow dissolved into something 'other', though it has not disappeared. There is a sense of fluidity rather than fixity to this space where amalgamated and multiple identities have become positive signifiers within a burgeoning narrative.

Most recently and most obviously, this space has been explored somewhat superficially in places like the *X Men* movies, *The Matrix* movies and even *Men in Black* and *007*, where mutated super-heroes are unapologetic about their unnatural capabilities. Even more interesting is that these characters are having fun with their differences and are creating comedy out of what often used to be a painful struggle for inclusion. Neither outsiders nor 'others', they exude a sense of belonging without carrying the baggage of self-loathing or victimization that seemed to be a badge of honor for their historical counterparts and predecessors.

As I write these partially formed ideas to you, Nancy, I feel as if I'm also describing precisely what I now think your art has been doing for almost 50 years. Your art practice has somehow instinctively preceded this cultural condition I'm alluding to, years before it rose to the surface and entered the popular arena. Consequently it has formed a foundation that many young artists have used as a springboard for their own art activity. I keep on thinking of some lines from Rainer Maria Rilke, that 'the future enters into us, in order to transform itself in us, long before it happens.' From this vantage point, I see your work as an invisible and radical precursor of so much of what we now take for granted as reality today.

Though I'm talking about media images and movies in particular, the concepts that you've

been exploring for so many years are embodied and embedded in some fashion in these cultural artifacts. I'll try to be more specific. In your earlier work, questions about women as outsiders who are marginalized and thus trivialized – though pertinent at the time – no longer seem to be the kinds of questions we now need to be asking. There are other questions, like: Who caused what the pictures show? Who is responsible? Is it excusable? Was it inevitable? Is there some state of affairs that we have accepted up to now that ought to be challenged?

I guess I *am* fumbling clumsily into the newer arenas of thought that spin endless theories about how a culture, whether local or global, is all about multiplicities. This forces us to rethink our positions about the subjective (what's *that* anymore?), questioning who we are: actors, performers, spectators, people who wear different masks constantly to – what? hide behind, play behind, escape from, travel into? This letter is just that – a letter not written to impress or provoke but to speculate, fumble around with some ideas unattached or even at odds with one another. And I'm also writing it to let you know that when I look at your art these days, as opposed to the way I looked at it in the 1980s when we first met and became friends, necessarily I see it and you differently. The world's changed, you and I have changed, and the issues have changed. I find this both exciting and scary. And yet, even if I come to the end of the letter having made little progress in advancing or bringing anything new to your art, one thing still remains constant, and that is my affective reaction to your art; an art that stands the test of time. Emily Dickinson knew when she was in the presence of great art/poetry because she would put it to a test:

If I read a book and it makes my whole body so cold no fire can ever warm me, I know this is poetry. If I feel physically as if the top of my head were taken off, I know that this is poetry.

These are the only ways I know it. Is there any other way?

That's close to how I often feel when I experience your art.

Keeping all this in mind, I want to go back to the idea of multiplicity because it seems to get to the heart of something I'm trying to figure out about my (and your own) relationship to your art today in light of the dominant cultural and theoretical concepts. For example, the notion of mutation that I referred to is a concept used most frequently in the cyber-space/technological/post-human theories that have abounded and proliferated during the last decade or so (illus. 61). Speaking about this, Katherine Hayles has said: 'Mutation is crucial because it names the bifurcation point at which the interplay between patterns and randomness causes the system to evolve in a new direction. It marks a rupture of pattern so extreme that the expectation of continuous replication can no longer be sustained.' In other words, she seems to be implying that mutation might well be a concept through which to begin to reframe familiar issues of cultural identity, subjectivity, etc. Clearly there has been a serious attempt to open up spaces for new interpretations of what makes us individual, what constitutes the subjective in a world in which fragmentation and multiplicity keep on pushing themselves into public awareness in more and more obvious ways.

As scholars explore these areas of identity, gender, the subjective and what constitutes the self, I find myself returning to your art from these different perspectives. What I discover is that when you moved to the 'other side' at the beginning of the 1970s, you were in fact, knowingly or unknowingly, questioning these very same issues. The originality, though, was in the way you chose to explore them. While other artists concerned themselves with precisely the same problems, they were still using the then current ideas about gender and the

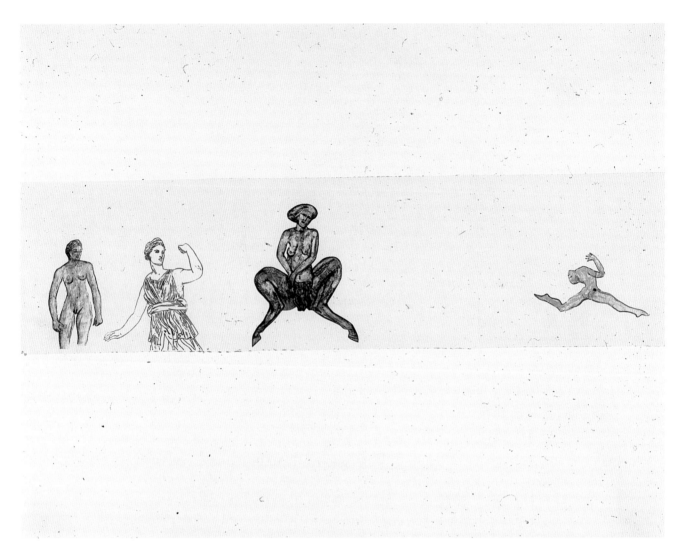

61 Nancy Spero,
The First Language,
1981 (detail of Panel
9), painting, collage
and hand-printing
on paper, 50.8 × 897.6
cm. (20 in. × 190 ft).

marginalization of women and women's art. The
result was one of ossification, dried-up ideas in
the act of breaking apart and breaking down,
rather than breaking through to potentially new
approaches through their images and their art.
The artistic end product, at least for me, resulted
in works that were ideologically dogmatic and
oversimplified.

Your art on the other hand, Nancy, has always
left me with a sense of hope (could that be
because your name, literally translated from the
Latin, is 'I hope'?) even in its darkest moments.
But the breakthrough came when you began to
mix mythological figures with historical realities.

In addition your move away from the traditional
forms of painting and image-making along with
your use of the scroll all combined to create a
new space for the exploration of meaning and
content in your work.

Whatever the current arguments surrounding
the idea of how we define a human being, let
alone a female human being, I've always believed
that what makes us human is that we are story-
telling animals. Every person has a story to tell.
That's what makes a person unique and it
defines the journey that we make through life.
And what is a myth if it isn't a story? Strictly
speaking, according to my extended dictionary

62 Nancy Spero, *Runway*, 2000, hand-printing and printed collage on paper, 497.8 × 50.8 cm. (196 × 20 in.).

definition, myth refers to 'an intricate set of interlocking stories, rituals, rites and customs that inform and give the pivotal sense of meaning and direction to a person, family, community or culture'. Myths organize culture, and they do so in ways that may be creative or destructive, healthy or pathological. What they do is provide a world picture and a set of stories that explain why things are as they are. They give us an authorized map for living life, creating a plotline that orders the diverse experiences of a person or community into a comprehensible narrative. By the same token myths can create a sense of limitation, selective blindness and rigid conservatism. They can enforce stasis where change is necessary, making the status quo appear inviolable.

So, given that each individual is a repository of stories, the legacy of the organizing myths of the culture resides within each person. I suspect, Nancy, that this is what you recognized all those years ago. And being the independent woman you are with that stubborn streak to make your own destiny instead of allowing others to create it for you, you threw down the gauntlet and accepted the challenge. You knew that change can only come by a process of sorting through the trash and treasures of the stories we've assimilated over the years. So you kept some, threw away others (by omission) and created new ones where you felt none existed before to create new narratives. I think we gain power over our worlds only when we imagine into existence a narrative of our lives that combines elements of our cultural, familial and individual experiences. As we know, the common root of authority and of 'authorship' tells us a great deal about power, so whoever authors your story authorizes your actions. Understanding this, Nancy, helped you gain personal authority and power over your art and its reception to the degree that you challenged the dominant myths, found them wanting, and thus created alternative visual narratives to inform your audience (illus. 62).

Knowing your art as well as I do now, it's interesting to trace the development of your imagery. From the early *Lovers* paintings and the *Black Paintings*, it didn't take you very long to realize your fragile position and the situation of most women in the art world as unfair, unequal, different, 'other than . . .'. Your frustrated attempts simply to be an artist, not a female artist, drove you to the edge pretty quickly (illus. 63). Even when you were in Paris in the early 1960s blithely tending your business of painting your *Mother and Child* and *Lovers* series, you suddenly made some works on paper, inventing serpentine figures with their tongues sticking out (they reminded me of Picasso's *Guernica* when I first saw them) screaming words like 'merde' and 'fuck you'.

Then it seemed that the anger just kept on building and building through the Vietnam War works and culminating in your *Codex Artaud* series. Now you embraced Artaud's anger with an almost frightening empathy. His violent language, his hatred and misogyny, his descent into the profound depth of language that finally became incoherent yet completely comprehensible, was your passport through the doors of convention and pretence, along with the desire to be heard the way male artists have always been heard. That series, followed by *Torture of Women*, brought you to the 'other side' where you've resided ever since. On this other side, issues of identity, both yours and women's in general, shifted radically and, without realizing it, you became a contributor to an area yet to be defined: an arena in which the realm of the imagination that I alluded to at the beginning of my letter is beginning to take on a new shape, quite at odds with other art movements of the past. Who could have suspected then that the doors you opened in your artworks would let out such strange creatures, such mutated monsters, while at the same time portraying with such honesty the crises and contradictions inherent in the issues of identity faced by women (illus. 65).

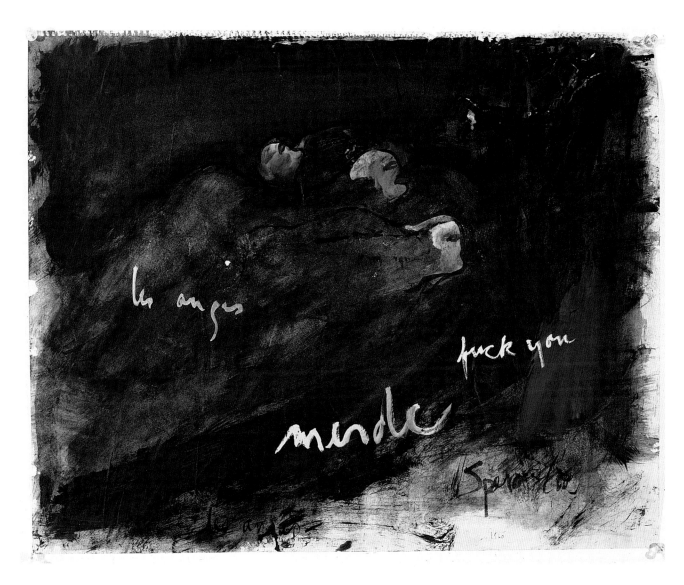

By the 1980s it was clear that there were limitations to an equal and universal identity structure that ultimately left women with a sense of their own identities as fragmented, liminal and partial.

What I now believe is that the breadth of the personal just might be the integrity of the work. I think this bears repeating, Nancy, because, looking back now from the vantage point of the twenty-first century at the complete body of your work since the beginning of your career, the struggle between the personal and the immediate needs of art world trends at any given time has created the greatest pain, anxiety, suffering and, yes, misunderstanding about the nature of your work.

The decision to stop using conventional forms of picture-making and to adopt the format of the scroll seemed to be a radical and important shift on your part to take control of your art instead of having it authored and thus authorized by a prevailing art world that, for the most part, distained and/or trivialized art made by women. It was a defiant step but one that reaped great rewards, both in terms of arresting the attention of the art world audience and returning images to a space of continuity where beginnings and endings are insignificant because the very form of the scroll suggests that we do not have to make our entrance into the art from a starting point already circumscribed by the artist, nor end our meditation of it simply because the scroll has been cut off (illus. 66). This sense of circumlocution always fascinated

63 Nancy Spero, *L'Anges, Merde, Fuck You*, 1960, oil on canvas, 43.8 × 55.9 cm. (17.25 × 22 in.).

64 Nancy Spero in
her New York studio,
1993.

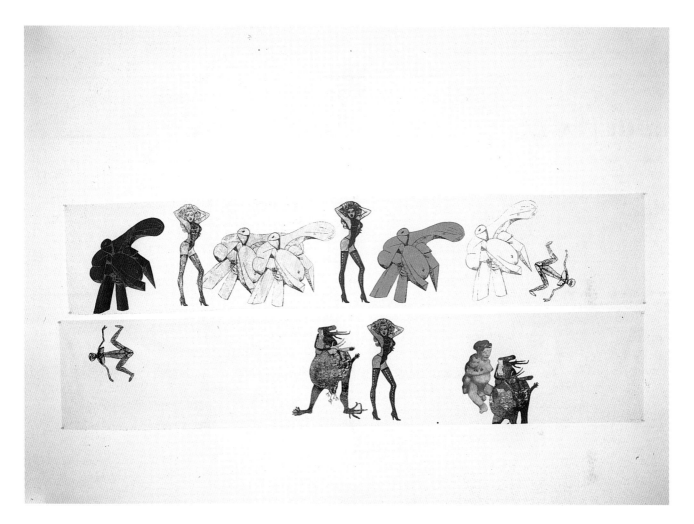

me because it allowed me to provide my own beginning and end even though the scroll had defined measurements. One never felt that the figures were confined by the frame (though formally of course they were); rather, I always felt that the formal structural limits were transcended by the content as it laid itself open to a mythical past and to an open-ended choice of futures.

Finally, Nancy, thanks for your work and your courage over the years – in friendship and love (illus. 64).

(Note: Part 1 of this essay was originally published in *Emry's Journal* as a catalogue essay accompanying an exhibition of the work of Nancy Spero at the Greenville County Museum of Art, South Carolina, March–May 1993.)

65 Nancy Spero, *Picasso and Fredricks of Hollywood*, 1990 (detail), hand-printed collage on paper, 50.8 × 548.6 cm. (20 × 216 in.).

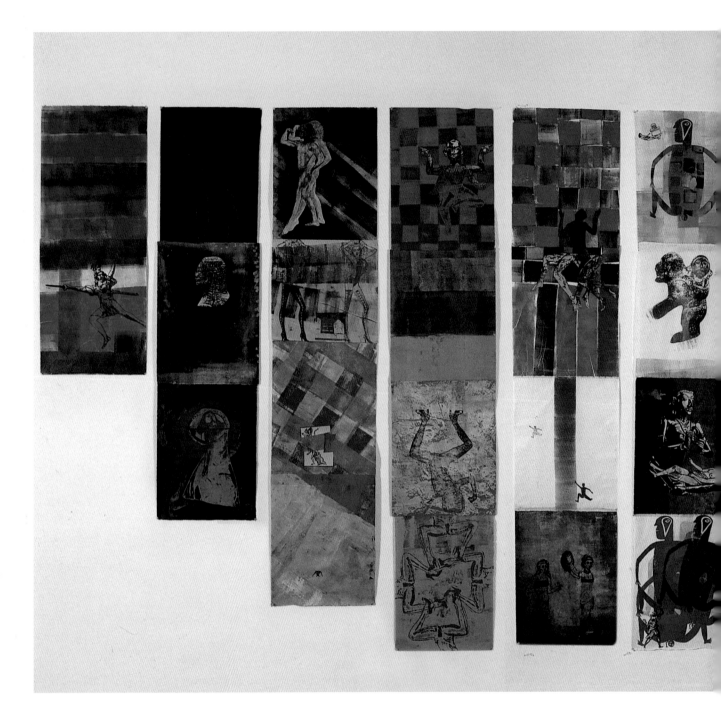

66 Nancy Spero, *The Hours of the Night II*, 2001, hand-printing and printed collage on paper, eleven panels, 2.74 × 6.7 m. (9 × 22 ft.).

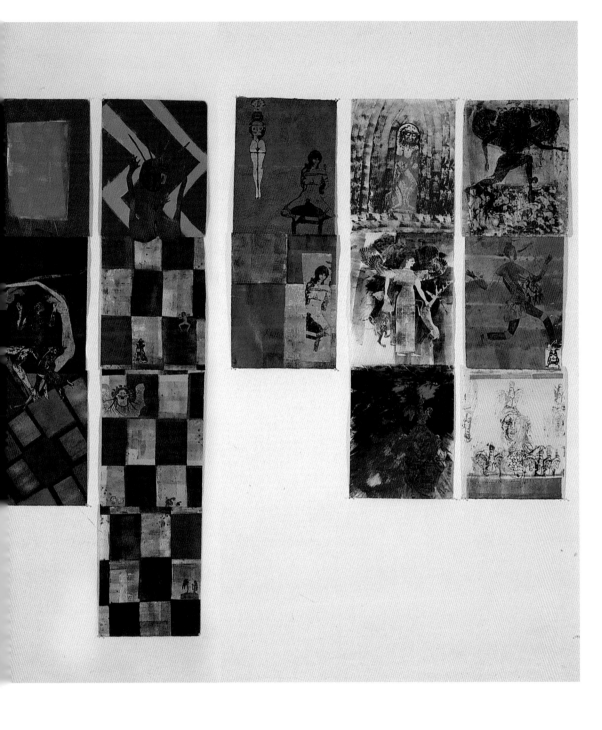

67 In Nancy Spero's
studio, New York,
1978: hand-printing
on paper, 1974.

Present Imperfect: Word and Image in Nancy Spero's 'Scrolls' of the 1970s

JON BIRD

That universal elements are irrevocably part of art at the same time that art opposes
them, is to be understood in terms of art's likeness to language. For language is hostile
to the particular and nevertheless seeks its rescue.
THEODOR ADORNO[1]

ARS SINE SCIENTIA NIHIL EST
(*Art without knowledge is nothing*)
(Nancy Spero: a hand-printing on paper in her
New York studio)

Over a twenty-year period I have returned time
and again to the work of Nancy Spero. In this
case, familiarity has bred not contempt but a
constantly reawakened curiosity (in its original
connotation of the 'rare' or 'strange') at the
complexity of her aesthetic imagination and
capacity for invention; at her willpower
undaunted by the restrictive and painful physical
effects of progressive arthritis; and at the ways in
which her practice continues to resist the trawl
of critical interpretations, my own included.
It's not that I now see another opportunity to
revise past attempts, rather that there is always
something to be found in her work that sets the
critical hares running again, often in new and
surprising directions. In this case it is another
text that has been the spur to revisit her formative
work of the 1970s – an essay written by Benjamin
Buchloh that first appeared in the exhibition
catalogue *Inside the Visible* (1996). I had long
wanted to write on Spero's monumental work
Notes in Time on Women, which she began shortly
after completing *Torture of Women* in 1976 and
completed three years later. In the 1980s, when I
was preparing her retrospective for the Institute

of Contemporary Arts in London, the intention
had been to include this work (displayed at
another venue and accompanied by a publica-
tion containing all 93 quotations that comprised
the textual element), only, because of its
extremely extended format of 64 metres (210 ft),
time, money and space – the constant demons
of curatorship – prevented the realization of this
aspect of the project. Nevertheless I remained
convinced of the historical significance of *Notes in
Time on Women*, which now, on the occasion of
the exhibition that this publication accompanies,
can be reassessed in relation to all Spero's major
scrolls of the past three decades.

> Paradoxically, 'writing' in Spero's work now
> also assumes a function opposing precisely
> the patent congruence of the 'writing' of
> Conceptual Art
> Benjamin Buchloh[2]

> I take from whatever – yes, geometry, but also
> Egyptian art, the Bayeux Tapestry, yoga figures,
> roller skaters, and so on. I was not unaware
> that Conceptual Art was going on, but I did it
> in my own fashion, you see.[3]

In 'Spero's Other Traditions', Benjamin
Buchloh argues that Nancy Spero (like Cy
Twombly) offered a challenge to 'Modernist

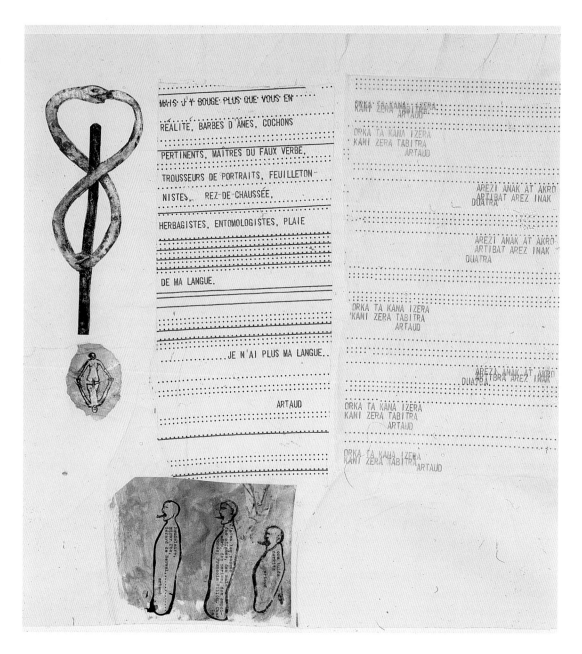

canonical criticism' through her particular use of language and collage techniques during the period that paralleled Conceptual art, taking her work *Codex Artaud* as indicative of an alternative tradition. *Codex Artaud*, her first scroll, was completed in 1972 after two years of exploring the writings of the French poet Antonin Artaud as a foundation for her own work. It included texts that referenced the literary as opposed to the purely linguistic, and expressed her belief in the pictorial possibilities of cultural myths and historical memory and of 'text', specifically the 'graffito', as a trace of the body and evidence of its corporeality (illus. 68). All this ran counter to the strand of Conceptual art, most clearly exemplified in the work of Joseph Kosuth, that proposed the analytical proposition as the inevitable 'reduction of the painting to the textual'.[4] (In 'Art

after Philosophy', after rehearsing the Kantian difference between synthetic and analytic propositions, Kosuth asserts: 'Works of art are analytic propositions. That is, if viewed within their context – as art – they provide no information what-so-ever about any matter of fact. A work of art is a tautology in that it is a presentation of the artist's intention, that is, he is saying that that particular work of art *is* art, which means, is a *definition* of art.'[5]) Recently a great deal of critical attention has been paid to the aesthetic histories of the 1960s and '70s, particularly the place of Conceptual art in a revised cultural history of post-war modernism. The rebuke made by Victor Burgin in his book *The End of Art Theory*, that this decade had been repressed as a time when 'nothing happened', has been thoroughly answered in the spread of publications and exhibitions that have precisely addressed this apparent lacuna.[6] This in turn has occasioned much debate over the explanatory status of the classification 'Conceptual art' and its relation to other critical discourses, particularly philosophy and theories of language, and the centrality of the visual in the making and interpreting of art. Consequently, much more attention has been paid to the aesthetic strategies of works of the period rather than simply accepting Conceptual art as primarily an innovative attack upon visuality, and as a challenge to criticism as a separate evaluative discourse. For example, Anne Rorimer, in one of the most recent reappraisals, introduces her research as being 'predicated on the idea that visual form and mental formulation are inextricably linked', and that 'Conceptual Art . . . never lost sight of its concern with the visual and the very nature of visualizing'.[7]

Through the process of historical rewriting, categories shift, positions are relocated, and what was deemed significant becomes background, and vice versa. Despite this, as Buchloh remarks, certain artists and artistic strategies have been consistently marginalized. Although Spero has been the subject of a great deal of critical production, some aspects of her practice remain relatively under-investigated in the context of these historical reworkings, particularly how the key elements of Conceptual art are articulated in her work; for example, the notion of institutional critique, word and sign; seriality and repetition; the grid; and her relation to, and incorporation of, the broader political and social issues and themes of the period. It is generally agreed that the years 1969–70 marked the emergence of art forms and exhibitions that emphasized the conceptual aspect of the artwork over its aesthetic or physical presence. Primary examples include *When Attitudes Become Form*, which opened in Bern and travelled to the Institute of Contemporary Arts in London in 1969; *Conceptual Art, Conceptual Aspects* at the New York Cultural Center; *Conceptual Art, Arte Povera, Land Art* at the Galleria Civica d'Arte Moderna, Turin; and *Information* at the Jewish Museum, New York, all in 1970. Nancy Spero had begun using text regularly from the late 1960s, first in her *Artaud* paintings and then systematically in the *Codex Artaud*. I have discussed these at some lengths previously, however, and here I will focus on two later works: *Hours of the Night* (1974) and *Notes in Time on Women* (1979).[8]

In his encyclopedic summary of Conceptual art, Peter Osborne distinguishes four categories that represent 'forms of negation' of what he takes to be the paradigmatic text of the dominant modernist aesthetic, Clement Greenberg's radio broadcast lecture of 1961, 'Modernist Painting'.[9] In this Greenberg expressed his philosophy of what constitutes significant contemporary art in the following terms:

the unique and proper area of competence of each art coincided with all that was unique in the nature of its medium. The task of self-criticism became to eliminate from the specific effects of each art any and every effect that might conceivably be borrowed from or by the medium of any other art. Thus would

69 Nancy Spero,
*Homage To New York
(I Do Not Challenge)*,
1958, oil on canvas,
119.4 × 78.7 cm.
(47 × 31 in.).

each art be rendered 'pure', and in its 'purity' find the guarantee of its standards of quality as well as its independence. Purity means self-definition, and the enterprise of self-criticism in the arts became one of self-definition with a vengeance.[10]

From this statement Osborne extracts 'material objectivity', 'medium specificity', 'visuality' and 'autonomy' as the areas for aesthetic contestation by the forms of Conceptual art and which resulted in particular genres sharing the strategy of 'drawing attention to the role of ideas in the production of meaning from visual experience'.[11] Spero had in fact offered her own succinct response to the hegemony of Greenbergian modernism in her painting of 1958, *Homage to New York (I Do Not Challenge)* (illus. 69). In this ironic commentary on the 'masters' of Abstract Expressionism, the initials of the primary male artists of the New York School are inscribed across a schematically rendered tombstone with, on either side, a rabbit-eared head with protruding tongue sporting a dunce's cap, a mocking negation of the words 'I Do Not Challenge'. (These words are taken from book Five of the poem by H. D. [Hilda Doolittle], *Helen in Egypt*, which Spero quotes extensively in *Notes*: 'No, I will not challenge / the ancient Mystery, / the Oracle . . .'.[12])

It is not my intention here to make a case for Spero's inclusion in the pantheon of Conceptual artists (other than in the expanded sense that all innovative art since Duchamp is conceptual in nature), or to minimize the critical situating of her work in relation to themes central to feminist art practices as they developed throughout the 1960s–70s. Rather, I intend to read her work as always engaged in a dialogue, sometimes as negation, sometimes as appropriation, with other aspects of the American and European post-war avant-garde throughout her long career and, furthermore, to argue that such readings reflect back upon the narratives of the modern

and postmodern in surprising and contradictory ways. In fact, Buchloh's observation on her marginalization is evidenced in any survey of the published histories of the period. Even Tony Godfrey's account, which includes a chapter 'Where Were They?', asserting 'very few women apparently made Conceptual art',[13] fails to mention Spero, despite including Ana Mendieta and Hannah Wilke who would appear to have a far more tenuous relation to the main currents of Conceptualism. However, as Griselda Pollock has frequently argued, paying careful and proper attention to alternative meanings – the signs of difference – challenges meaning per se.[14] Throughout the decade Spero experimented with the form and structure of her artworks, incorporating the textual with the figurative to prioritize the production of meaning as a semiotic process, drawing upon cultural, political and mythological themes to make works critically and reflexively addressing the historical and contemporary representations of women.

As Osborne argues, artists drew upon many definitions of linguistic meaning and varieties of language-use in the making of art. It was never, I think, Spero's intention to employ language as a negation of the visual, or visuality. Rather, her texts emphasize the linguistic basis of experience and the corporeality of language; of the subject (and for her, after 1974, this is the woman) produced through language, for example in her selection of texts by male authors for *Notes*, as language speaks the historical and situated subject – the excerpts from Amnesty International's documentation of torture: the body in pain. Besides this, however, is the attention that Spero pays to the material properties of the work, not only the delicacy of the handmade paper that provides the ground for text and image and which signifies as both support and absence – the space between forms or the silence of a void – but also the text's physical presence, hand-printing from wood-block alphabets, the typeface of a bulletin typewriter, graphic qualities

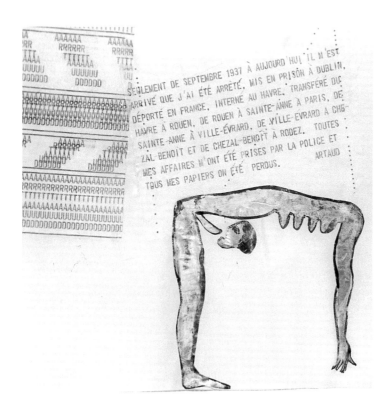

that frequently correlate with the content of the linguistic message:

> And in the *Artaud* the narrative is the kind of staccato and already fractured language of Artaud, and in this kind of rhythm, or lack of rhythm, a kind of scattering in the space of the language. And with the images it sets up a certain uneven rhythm, perhaps analogous to a pulse rate or heart beat . . .[15]

Thus in a detail from panel VI of the *Codex Artaud*, a densely ordered geometric area on closer inspection reveals the repetition of the poet's name in a visual form that collapses the syntactical nomination into the phonetic equivalent of a shout or scream (illus. 70).[16] In this and other examples, particularly *Hours*, Spero

70 Nancy Spero, *Codex Artaud*, 1971 (detail of panel VI), 52 × 316.2 cm. (20.5 × 124.5 in.).

employs typography to introduce a plastic element to the work; the variety and distribution of letters and words negate the normal spatial regulation of text and introduce another realm of signification – the embodied viewer moving in space. And, in addition to her form of semantic play with the linguistic elements, there is always a politics of representation inscribed in their use within a much wider system of social meanings that are inextricably implicated in questions of power.

From the date of her return to New York in 1964 after a five-year stay in Paris with her husband, the artist Leon Golub and their three sons, Nancy Spero was actively engaged in the major social movements of the period and increasingly in the Women's Movement and feminist politics. As the burgeoning political movements defined their respective agendas and alliances under the general rubric of the 'New Left', the cultural legacy of McCarthyism still impacted on the contested terrain of post-war modernism, an arena dominated by, in Francis Frascina's formulation, 'critics' persistent adherence to art/cultural emphasis on the canon, reliance on the hegemonic market and institutional attention, replication of male white supremacy in visual high culture and celebration of individual oeuvres over collaborative achievements.'[17] Some of the most radical alliances were formed as breakaway groups from the male-dominated activities of the New Left, which had been central to the Civil Rights and Anti-War movements. (There was an important aspect of New Left thinking, however, that was to become central to feminist politics, besides the belief in the authenticity of human relations and participatory democracy, and that was the place accorded to the body as an emotional guide to social relations.[18]) Spero joined Women Artists in Revolution, which resulted from a schism within the Art Workers Coalition, contributed to the Ad Hoc Women Artists Committee, and was one of the founder members (along with Barbara

Zucker, Dotty Attie, Sue Williams, Mary Grigoriadis and Maude Boltz) of the first women artists alternative gallery space in New York – AIR (Artists in Residence), which opened in SoHo in September 1972. The early 1970s was also a time of actual interventions by feminists in the institutional policies and structures of major museums and galleries, which included demonstrations at the Metropolitan Museum of Art, the Whitney Museum of American Art, the Los Angeles County Museum of Art and the Corcoran Museum of Art in Washington, DC. Spero contributed an essay on the exclusion of women artists from the Whitney Annual to *Art Gallery Magazine*, where she not only attacked their exhibiting practice but also pointed out that there were 'ninety-two male artists in the Whitney's permanent collection for every eight females.'[19] These protests continued; in 1976 Spero was a member of the MoMA and Guggenheim Ad Hoc Protest Committee demonstrating against two museum exhibitions: *Drawing Now* at MoMA with five contributions by women to forty-one by male artists, and *Twentieth Century American Drawings* at the Guggenheim with only one women included amongst the twenty-nine artists exhibiting. The ideological and social contradictions characterizing conflicts over issues of gender and representation are clearly demonstrated in the fact that the curator for the MoMA show was a woman, Bernice Rose, who employed the familiar defence of aesthetic quality '. . . I can't consider a work good on the basis of whether it was done by a man or a woman. I just have to look at the work as work.'[20]

Eric Hobsbawn, in his history of the twentieth century – *The Age of Extremes* – sees the 1970s as the start of the 'crisis decades' marking the gradual slide from the post-war period of continual economic and technological development, a 'golden age' during which the primary capitalist economies of the West were responsible for 75 per cent of global production and 80 per cent of

manufacturing exports. The mid-1970s were not only recessionary years marked by a significant slump in industrial production and international trade, but also a period of considerable political upheaval with America's eventual humiliating withdrawal from Vietnam and a heightened tension between the two superpowers as they supported opposing factions in a revolutionary zone that spread across Southeast Asia, Africa, Latin America and the Middle East. Watergate, followed by Nixon's resignation, created a situation in which conspiracy theories, protest movements and the radical political and sub-cultural legacies of the 1960s were played out across the social and cultural spheres and provided the context for increasingly politicized art practices. At the start of the decade an issue of the journal *Artforum* registered the growing questioning of the role of artists in response to repressive social and military agendas by publishing replies by artists to the question 'What is your position regarding the kinds of political action that should be taken by artists?'.[21] A few years on, for many artists and intellectuals, the reactionary politics of the 1970s were contained in the Report of the Trilateral Commission of 1976, a consortium of right-wing thinkers and politicians from America, Europe and Japan, in which the Harvard professor and government advisor Samuel Huntington suggested that the public expression of civil rights and anti-war feeling represented a dangerously liberatory dynamic. In response, the Federal Government introduced a range of repressive measures that impacted on the arts and academic communities as a retrenchment from the gains in social representation and equalities made by women and ethnic groups. The general disillusionment that grew as the cultural and political utopianism of the 1960s either faded away or was transformed into its oppressive opposite provided fertile ground for the reactionary cultural politics to come. Daniel Bell's assault upon the countercultural tendencies of the 1960s and early 1970s, the *Cultural Contradictions of Capitalism*, was

published in 1976 and did much of the ground-work for the 'culture wars' of the following decades. The imagined threat of 1960s radicalism provided a constant object of suspicion and jus-tification for the economic restrictions on Federal and State funding for the arts and humanities, a position consistently represented by the Right's primary cultural publication in the USA, the *New Criterion*, founded in 1982. Although these and other factors contributed to the politi-cization of art practice and practitioners during this period, a major force for change came from the various activities of the Women's Movement and the theoretical discourses of feminism that suggested a range of positions from which to think and act 'differently' across the social form-ation. It is in this context, and in relation to the post-war avant-gardes, that Nancy Spero's formal and conceptual visual poetics of word and image should be assessed.

LA FATIGUE DE LA COMMENCEMENT DU MONDE

> There is a quote I used in some of the small works around 1970 which refers both to the attitude I have towards my work and to my physical condition – 'La fatigue de la com-mencement du monde', the fatigue of the beginning of the world. How to relay the world, get at it and have the energy necessary to make art.[22]

If one of the main aims of Conceptual art was, in Michael Newman's words, 'for the conditions and limits of spectatorship to become a reflexive part of the work',[23] then Spero's scrolls clearly meet this requirement. Her eleven-panel work, *Hours of the Night*, combines hand-printing, gouache and collage on paper, each individual vertical section measuring approximately 300 by 50 centimetres, giving an overall dimension of 284.5 × 660.4 cm. (112 × 260 in.) (illus. 71). The presentational format is that of the book – in Spero's words, 'like a visual manuscript spread flat on the wall'[24] – the page merging with its support to become not simply the ground for the text but a material entity, the sequence of panels analogous to the act of reading from page to page. However, the scale and spread of the text and the variations in print size literally turn spectatorship into an embodied action of moving along the panels, coming closer and retreating, backtracking, glancing up, down and across – in fact, the viewer is encouraged to read performa-tively. Spero's scattering of words and images across the surface of the paper contradicts the familiar reading pattern of linear narrative and the normative viewing relationship of Western pictorial art. The fragmented, collaged elements of *Hours* more closely resembles graffiti, or, given the derivation of the title from the Egyptian *Book of the Dead*, hieroglyphic tablets, while the repetition of key words confounds narrational logic: the eleventh and final hour also carries the words of the first – 'Smoke Lick' (an autobio-graphical reference to a fire in Spero's apartment in 1973) and 'The first hour of the night'.

The structure of Spero's work of the 1970s correlates with other artists' experimentations with language as a communicational and aesthetic device, for example, the early work of Vito Acconci before he turned to live performance, treating the page as a performative arena, Carl Andre's *Poems* (1958–74), employing mechanical modes of inscription in repetitive and grid-like arrangements, or the work of Marcel Brood-thaers, particularly his appropriation of the poetry of Mallarmé in its spatialization of the word and emphasis upon its ideographic value. Lyotard's discussion of the poetry of Mallarmé in the context of his elaboration of the concept of 'figure' bears relation to Spero's experimentation with the plastic element of text. Describing Mallarmé's text, 'Un coup de des jamais n'abolira le hasard', Lyotard writes:

The book-object contains two objects: an object of signification (made of signifieds linked together according to the rules of syntax) . . . And then, an object of *signifiance*, made up of graphic and plastic signifiers (gaps, typographical variations, use of the double page, distribution of signs across the surface), made in fact of writing disturbed by considerations of sensibility (of 'sensuality').[25]

There is also the highly influential presence of John Cage, whose performances allowed for chance, repetition and silence, and whose musical notations incorporated diagrams, directions and linguistic elements. Certainly *Hours* affirms the importance of the gaps between words and letters, and in this and subsequent scrolls space frequently signifies silence. But it is the legacy of Artaud that dominates: language is enigmatic, allusive, provocative and material (in *Notes in Time on Women* the first two functions are performed by the image/text relationships), endowed with political, cultural and institutional meanings, and the quality of fragmentation so central to literary modernism and present in the *Codex, Hours* and *Notes* is never simply a reductive device but a means of reintroducing the corporeal into the textual. Perhaps 'dispersal' is a better term for Spero's aesthetic strategies (in fact she is now using this as a descriptive title for her most recent work as she breaks from her familiar horizontal or vertical format into asymmetrically collaged sheets), although, as Buchloh has argued when discussing Brood-thaers, fragmentation also has a mimetic function reflecting the contingent and dissonant nature of experiences of modernity.

The aesthetic of the fragment in modernity has a long and complicated history. Linda Nochlin argues that the fragmented or mutilated body was central to the visual rhetoric of the French Revolution, signifying the acts of destruction that preceded social transformation, of which the guillotine represented the 'archetype

of human dismemberment . . . a specifically contemporary instrument of state-sanctioned death'.[26] For Nochlin, the most dramatic examples of the 'body-in-pieces' in the history of French art are to be found in Théodor Géricault's depictions of body parts, dramatically lit and scientifically observed paintings that represent the actual impact of historical reality upon the subject. These abject still lives contribute to the iconography of dismemberment that traverses the conflicts of the last two centuries. In Rainer Maria Rilke's wartime correspondences, the literature of early modernity as a response to metropolitan city life (for example in Baudelaire or Nietzsche as an aesthetic of loss, insecurity and ethical relativism) is reconfigured through the experiences of trench warfare as a moment of rupture that shattered conventional terms of periodization and disorientated the sequence of time, effects upon the human body and psyche that reoccurred in the Second World War trauma of the Camps.[27] In many first-hand accounts, what most characterizes the experience of battle is a fragmented mentality resulting from long periods of inactivity, boredom and repetitive drilling interrupted by the chaos, fear and unbearable tension of being under fire. Taken to extremes, the Camps reproduced this contrast of the bureaucratic administration and segmentation of what passed for daily life with the obscene ergonomics of sudden death.[28] Spero draws upon this material for her own visual language in *Torture of Women*, *Hours* and *Notes*. Having studied briefly in Paris in the late 1940s and then lived there from 1959 to 1964 she would have been familiar with the art-historical references. In fact, a connection can be inferred from the Revolutionary iconography of the fragmented body, through castration theory, to her 'Dildo dancer', or from Géricault's *Severed Heads* (1818) to the rows of decapitated heads spread across panel 19 of *Notes* (illus. 72). Similarly, the violence of war is figured across the semantic structure of *Hours* in the debased vocabulary of conflict, the

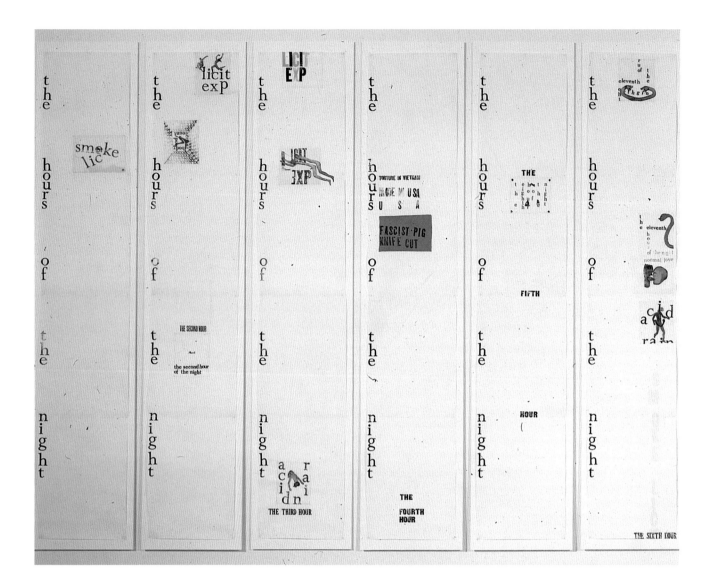

unpredictability of image / text relationships, pockets of intensity contrasted with areas of non-activity, abrupt changes in the size of typeface and an internal movement interrupting the vertical dynamic of the panels; each isolated word, phrase or image ruptures the surface in incremental bursts of signification. As the critic Lawrence Alloway observed, 'Her works are patterned, not on the basis of formal unity, but on antagonistic relationships and evasive action.'[29]

Spero's raiding of cultural archives and social histories suggests that here is a practice of art-making emphatically about memory. She returns obsessively to figures of mythology, scripture and history not in order to expose, in the Barthian sense, myth as the naturalization of the historical – the work of ideology – but rather to record the trace of the sacral and the archetype in the narratives of history and the formation of identities. Writing on modernity, Baudelaire attributed the draughtsman's skill to memory rather than perception, an echo of the legend of the origins of painting in Butades' tracing of her lover's shadow as an aide-memoire against his impending absence. In both accounts representation is conceived as an act of memory, of re-presentation.

71 Nancy Spero, *Hours of the Night*, 1974, hand-printing and painted collage on paper, 284.5 × 660.4 cm. (112 × 260 in.).

In the narratives that Spero draws upon and the interplay of past and present, fiction and documentary that structure her iconography, the act of remembering is neither simply an exercise in archaeological retrieval nor the unreflexive expression of a Romantic sensibility; rather, she asks how the entwining of myth and history have constructed the cultural representations of women and how these constructs might be undone, or done differently. And as memory comes into play so does time. In my introduction to this book, 'Imagining Otherworlds', I introduce the distinction made by Julia Kristeva between two temporalities – the event time of social and historical change and 'women's time', a temporality of the feminine ordered by the maternal body as both process and trace. Spero's scrolls are marked by the temporal as her dominion of women is summoned to testify against the political and cultural amnesia that has accompanied their activities and achievements across histories and geographies, and in the demands made upon the viewer in their expansive unfolding. They unapologetically take your time as they offer meditations upon time's victims and survivors. (In *Notes* it is the conjoining of

the figures of mythology with real social beings that can be read as an allegory of the struggle against what Adorno termed 'mythic nature', a dialectic of reason and truth but with the addition of an openness to the play of the phantasmagoric [illus. 73].)

For her title *Hours of the Night*, Spero consulted the Egyptian *Book of the Dead*,[30] a series of papyrus scrolls depicting magical spells to aid the dead in their journey through the underworld towards the afterlife. Also of interest to Artaud, this pre-Dynastic myth recorded the movement of the sun god Ra from dusk to dawn, a cyclical journey whose completion, the rising of the sun, symbolized the resurrection of Osiris, the first king of Egypt. As with many of Spero's borrowings from mythology, it is the narrative interpretation of a natural event – in this case the rise and fall of the River Nile transcribed into a story of origins and consciousness expressed as the transition from darkness to light – that provided the literary basis for her own translation. With *Hours of the Night* an allegory of resurrection, the sun reborn each day, is reinterpreted as a sequential visual poem signifying in allusive and cryptic collaged texts the 'terrors of the night and the [Vietnam] war',[31] each 'Hour' aphoristically connoting conflict and its effects: 'smoke lick', 'body count', 'acid rain', 'knife cut', 'shoot out', 'firefight' . . . The repeated coded message 'Licit Exp', which reappears constantly in later works, is an abbreviation of the medieval phrase 'Explicit Explanation', which frequently ends manuscripts of the period, and many of these phrases and images are reappropriated from the *Codex* and subsequently become part of Spero's visual language.[32] In this work images function as an appendage to language; visually letters dominate, the tiny figures overwhelmed by the printed texts both formally and conceptually as 'acid rain' dissolves a dancing figure, falling figures, arms outstretched, spiral away from a 'shoot out', 'explicit' and 'knife cut' assault two figures; each hour brings its own special

nightmare via the recoil of one element against another (illus. 74). Like the work of the dream, condensation and displacement are the processes veiling the meaning of these truncated phrases and image fragments. (The use of abbreviation and expressions that are intended to hold the viewer's attention can also be traced to American Pop Art and the incorporation of mass media signifying systems, particularly advertising.)

Spero had already employed radically different forms of language in the *Codex Artaud*, setting image against text to extend the connotational range of the visual and linguistic registers, and this continues in *Hours*. In the *War Drawings* of the 1960s she parodied the debased and deceptive rhetoric that the military establishment uses to disavow the real effects of war upon its victims, and something of that still persists, but here the cold pragmatism of 'Body Count', printed boldly across panels 7 and 8, is in stark contrast to the collaged expletive on panel 4: 'Fascist Pig; Knife Cut'. Artaud haunts this work as writing is made to signify beyond its literal content, functioning as a physical presence impressed across the page in the disposition of words horizontally and vertically, in variations of scale and emphasis produced by the size of the printing block and hand pressure, in upper- and lower-case lettering, and in flashes of colour and scattered imagery interwoven with words and phrases opening associational chains of meaning. However, there is another aspect to *Hours* immediately apparent to the viewer and that is that, despite the dispersal of fragments of text and image across the extended format of the eleven panels, compositionally the work coheres.

There is in this, I think, a further art-historical reference – to the function of wall-sized painting within post-war American modernism and, in particular, to Jackson Pollock and his achievement in creating paintings of a density and evenness that distributed optical intensity across the total surface area. This is the tradition that Spero struggled with and against in her early work and

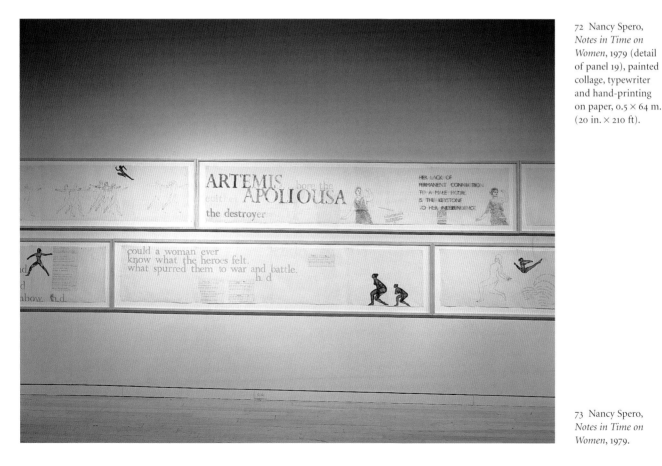

72 Nancy Spero, *Notes in Time on Women*, 1979 (detail of panel 19), painted collage, typewriter and hand-printing on paper, 0.5 × 64 m. (20 in. × 210 ft).

73 Nancy Spero, *Notes in Time on Women*, 1979.

74 Nancy Spero,
Hours of the Night,
1974 (detail of panels
6/7/8).

which she pilloried in *I Do Not Challenge*. The
dimensions of Pollock's largest works – *One:
No. 31* (1950) is 269 × 531 cm., *No. 30* (1950) 270
× 538 cm. and *No. 32* (1950) 269 × 457 cm. –
correspond to the scale of salon History Painting,
and *Hours* at 284 × 660 cm. exceeds this some-
what. In both scale and content, *Hours* is a History
Painting, but conceived through a critical
engagement with Minimalism and Conceptual
art's demythification of gesture and opticality.
As Spero's irregular seriality mocks the pseudo-
order of analytical Conceptual art, so she
reinvests her work with paintings' antecedents –

a recognition that the persistence of myth and
the literary can become metaphors for contem-
porary experience.

It is this experimentation with forms of
language and modes of address, a re-engagement
with memory in the formation of an embodied
subjectivity, and the possibility of a transgressive
pictorial counter-narrative, that was to be further
developed in *Torture of Women* (1976; illus. 75)
and her monumental 24-panel scroll, *Notes in
Time on Women*.

LAURA RAGGIO
20 years old
SILVIA REYES
19 years old
d: 21 april 1974 both
students and left wing
militants, they were
arrested during a
house search in monte
video. in the same
operation another girl,
DIANA MAIDANIK, received
35 shots when she oper
ed the door. although
the authorities claimed
the three girls had
died in cross fire,

URUGUAY

75 Nancy Spero,
panel 8 from *Torture
of Women*, 1976,
painting, collage and
hand-painting on
paper, 50.8 × 3,810 cm.
(20 in. × 125 feet).

1

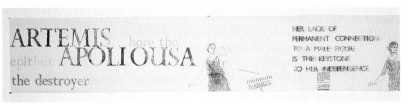

4

6

7

8

9

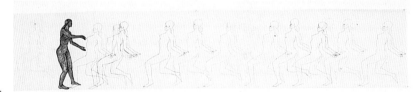

10

11

76 Nancy Spero,
*Notes in Time on
Women*, 1979 (16 of
24 panels), painted
collage, typewriter
and hand-printing
on paper, 0.5 × 64 m.
(20 in. × 210 ft.).

I use language in my work to point out facts, opinions, history, hostilities, etc., concerning women. How they are used and have been used. Part of the title is called 'active histories'. This is the active action-oriented analysis and portrayal of a range of conditions and situations that women operate under.[33]

The original title for the work for which Spero began compiling references and quotations early in 1976 and finally completed as a 24-panel scroll (illus. 76) combining painted collage, bulletin-typed blocks of text and hand-printing on paper in January 1979 was *Notes in Time on Women Part II: Women, Appraisals, Dance and Active Histories*. Sometime during the mid-1980s (the artist is not clear as to the precise date) this was shortened to *Notes in Time on Women*. Her original intention had been for *Torture of Women*, completed in 1976, to comprise 'Part I', but as *Notes* expanded in length, finally ending up at a little over 64 metres (210 ft), she decided that the two together would present the viewer (and any exhibiting space) with a work of such complexity and proportion that it was preferable to split into two distinct scrolls. Even as it stands, *Notes* is her second largest scroll, later exceeded only by her 39-panel work *Azure* (2002). *Notes* also represents the closure of a period of art-making from the late 1960s, during which Spero combined texts and images in almost every work and at the end of which she determined to focus solely on cross-cultural and trans-historical visual representations of women.[34] After *Notes*, until she embarked upon another significant innovation in her artistic practice of printing directly onto interior and exterior wall surfaces to create site-specific and spatially expansive installations, text is absent apart from some small one and two panel works.[35]

Notes in Time on Women was first exhibited as a 'work in progress' at AIR Gallery, SoHo, New York, in January–February 1979, immediately after its completion, then at the Peachtree Center Gallery in Atlanta and also, later that year, at the Picker Art Gallery of Colgate University, Hamilton, New York. The original AIR Press Release described the work as

a continuous linear band inscribed with a range of opinion, history and myth referring to the status of women . . . Painted and printed images are collaged into and counter the information. The work is related to cinematic impressions of fragmented and fleeting movement.

The AIR exhibition received a generally positive critical commentary; Ellen Labell, in an otherwise primarily descriptive but thoughtful review for the *SoHo Weekly News*, concluded that 'the work may be too powerful for many viewers'.[36] Corinne Robins, in a longer assessment of Spero's scrolls of the 1970s for *Arts Magazine*, also responded to the challenge of the content and scale of the work for audiences and institutions:

Nancy Spero's work remains a problem. It belongs in a museum, but under what heading would a curator put it? How could one make it appropriate for children over eight and under twelve to see and perhaps even read. How could one explain to them Spero's monsters . . .[37]

Robins's recognition of the innovative formal and conceptual structure of *Notes* constantly inflects her critique. She describes the spectatorial relationship as a 'struggle between seeing and reading', of 'images and words . . . telegraphed simultaneously making the work difficult to take in' and, in a reference to Ad Reinhardt's statement of 1963 (which also appears in Joseph Kosuth's manifesto for analytical Conceptual art, 'Art after Philosophy'), 'Art is art and everything else is

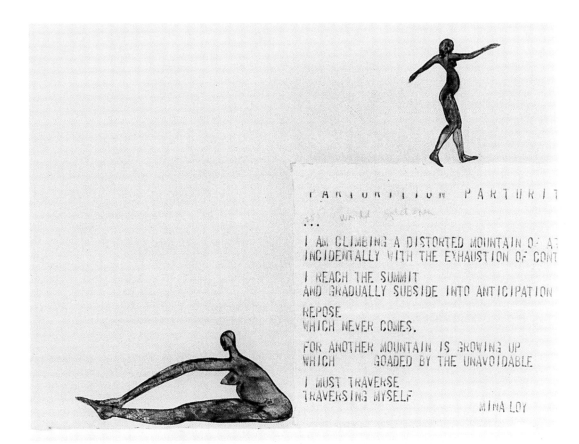

everything else', she responds: 'Spero's art contains "everything else", demands that we see, read, walk past and around in it and refuses to be put in an appropriate art category'.[38] Or, as Benjamin Buchloh later put it, '. . . they both [he is referring to Nancy Spero and Cy Twombly] reinvent painting with a consideration of painting's profound entanglement not just with myth but with historical and cultural memory'.[39]

The 93 hand-printed and bulletin-typed quotations that are distributed across the panels of *Notes in Time on Women* catalogue, in linguistic and typographic variety, the hegemonic force of patriarchal language, a symbolic order traversing history and lived experience mediated through the discourses of science, philosophy, literature, myth, law, medicine, journalism and the media. Spero has mapped the traces of an encyclopedic discourse of power to assemble an archive testi-fying to the linguistic violation of women with 'facts', statements and 'truths' that are blind to the discriminatory structure that always and already frames its propositions. As with *Torture of Women*, *Notes* represents parallel worlds: an imaginary universe populated with goddesses, heroines, athletes, pregnant women, dancers and body parts, and a universe all too real in its cataloguing of abuse, misogyny, neglect and the rebellious murmur of dissenting voices. This is a world both challenging and enticing, a drama-turgy of the body traversing the hidden and forbidden spaces of torture and taboo, a tension between bodily pains and pleasures – sexuality, dance, reproduction, dialogue – and the emascu-lating tentacles of patriarchal language.

Notes begins with childbirth and ends in divorce. The opening panel is unevenly hand-printed with a text from the Aztec *Sahagun*,

book 11: 'Certainly childbirth is our mortality, we who are women, for it is our battle.' Panel 24, the final panel (although, as I have already observed, there is no necessity to read from left to right; this is not a narrative in the linear sense), combines a letter to the artist from a friend describing her recent experience of divorce, 'certainly a horizon expander', with excerpts from poems on the same theme including lines from a poem by the little-known American poet Mina Loy entitled 'Parturition', which could serve as a codicil to the work as a whole: 'I am climbing a distorted mountain/Incidentally with the exhaustion of control/I reach the summit/And gradually subside into anticipation of/Repose/Which never comes./For another mountain is growing up/Which goaded by the unavoidable/I must traverse/Traversing myself' (illus. 77). Sandwiched between the first and final panel is a history of oppression and resistance where words of hate are turned against themselves through the expressive actions and gestures of libidinal female bodies: an erotics of the body-in-space negating this discourse of power.

Mostly these are the texts of men, but other voices interrupt the flow; women answer back, tell a different tale and a tale of difference. The poet H. D. recounts the narrative of Helen of Greece who 'was rapt away by Hermes/at Zeus' command', wondered at the actions of men: 'what spurred them to war and battle/what fire charged them with fever', and who, in H. D.'s interpretation, recognized that, for a woman 'the law is different/if a woman fights/she must fight by stealth . . .'. Across another section, on panel 8 amidst the documentation of black women's experiences of racism and resistance, Spero prints the words of the ex-slave Sojourner Truth addressing the 4th National Women's Rights Convention in New York in 1853: 'But we'll have our rights, see if we don't, and you can't stop us from them; see if you can. You may hiss as much as you like, but it is comin . . .' (illus. 78).

In between *Hours of the Night* and *Notes in Time on Women*, Spero made *Torture of Women*, a fourteen-panel scroll of hand-printed images and bulletin-typed accounts of women's pain taken from the documents of Amnesty International, and some of this material, and the pictorial relationship between image and text, is continued into *Notes*. *Torture of Women* is a work of witness, a testament to the extraordinary capacity for survival under the most extreme assaults upon the body; against the torturer's acts of negation of the self the voice attests to the possibility of being. From the broken and anguished notations and records of female victims of torture, *Torture of Women* testifies to the effects upon utterance of the deracinated subject, of language at the limits of what it is to be human (illus. 79). Giorgio Agamben, writing on the enigma of Auschwitz, sees in the aporia of the

78 Nancy Spero, *Notes in Time on Women*, 1979 (detail of panel 8).

Camps, 'the very aporia of historical knowledge: a non-coincidence between facts and truth, between verification and comprehension'.[40] The discordancy in *Torture of Women* between the image – a fantastical frieze of hybrid animal and human forms adapted from mythology and history – and the scattered texts, the words of survivors, points to a lacuna at the core of the testimonies of witnesses and victims of horrors, of 'something it is impossible to bear witness to'.[41]

It is Agamben's belief, following Primo Levi, that the 'true witnesses' could not, in fact, bear witness – that, in the presence of the utter darkness of absolute evil, there are no survivors. Some other form of utterance must stand in, for the non-place of the subject becomes desubjectified, thus 'language, in order to bear witness, must give way to a non-language in order to show the impossibility of bearing witness'.[42] With *Torture of Women* the records of female victims of torture are accompanied by another language, the imaginary and adapted figures who bear witness to the trace of the body's violations, a silent but watchful community commemorating the survivors of trauma. Similar accounts resurface across panel 9 of *Notes*, which immediately proceeds the section on black women. Here the hand-printed and typed descriptions – first-person narratives and excerpts from Amnesty files from Argentina, Indonesia, Brazil, Turkey and other repressive regimes – assume a mimetic function as the typefaces darken and alter in scale and texture, collaged texts are over-printed, words jump of the page: 'Electric Shock . . . Beat . . . Fist . . . Rape . . . Subjection of Women . . .', an anonymous murmur of statements whose visual and emotional density squeezes space and, metaphorically, life out of the frame (illus. 80). In this company it is appropriate that a later section, panel 18, names the goddesses of blood sacrifice: Artemis, Kali and the Gorgon whose death-inducing gaze reflects the contradictions of witness, the impossibility of vision, of living to tell the tale. 'Torture', as Elaine Scarry observes, 'is itself

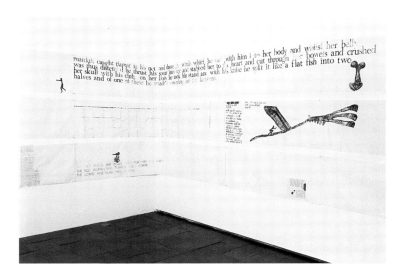

language-destroying',[43] and *Torture of Women* and sections of *Notes* produce the ruination of language as the fundamental expression of anguished corporeality; the subject as witness to their own subjection. Dis-identification in *Codex Artaud* becomes de-subjectification in *Torture of Women*; both constitute the search for a position in language replaced by the unsayable, an aporia also figured in *Notes* but as the limit position in the Babelic inventories of lived experience, myth and historical knowledge.

Reviewing Spero's scrolls of the 1970s, *Codex Artaud*, *Hours of the Night*, *Torture of Women* and *Notes in Time on Women*, what is evident is that her linguistic turn is to the statement, not the proposition; to enunciation as the affirmation and contextualization of the place of the subject in the production of meaning. Unlike the propositional mode of much Conceptual art, Spero repetitively emphasizes the subject's relation to the linguistic event, to the moment and place of utterance – of what is at stake in speech when the subject speaks. In this she shares in the interest, current at the time, in the role of linguistic 'shifters', those signs common to all languages (for example, the pronouns 'I', 'you', 'me', 'this', or adverbs, 'here', 'then', 'now', etc.) whose meaning is fixed in relation to the discursive context in which they occur: 'The subject is caught in the

79 Nancy Spero, *Torture of Women*, 1976, hand-printing and painted collage on paper, 0.5 × 38.1 m. (20 in. × 125 ft).

moment of enunciation, and is in some way constructed by it, put in place by it.'[44] In 1970s film theory, shifters and the 'subject of enunciation' were important elements for theories of cinematic language in understanding how the spectator is caught up in the film narrative and positioned in relation to it.[45] Shifters are empty markers of position and subjectivity and, for Spero, the 'here' and 'there', the 'now' and 'then', are grounded in the body, the body, that is, in its relation to other bodies, their histories and experiences that engage the spectator as both eye and body. Looking at a Spero is an embodied activity that relates to the movement of the eye as it scans the expanded pictorial field and to the body's mobility, moving in relation to the work, a process that, in the case of multiple panel scrolls, can involve traversing a considerable distance over a period of time. A number of temporalities are invoked then: the historical referent – from pre-history to the present, what might be termed 'reading time', which again, in certain works (*Codex, Torture, Notes*) can be prolonged and demand varying levels of attention and memory; and experiential time – the physical action required to encompass the work in its entirety.

Reading and seeing are both visual acts but

80 Nancy Spero, *Notes in Time on Women*, 1979 (detail of panel 9).

different kinds of experience. In Spero's scrolls, the text resists dissolution in the dominance of the signified; it is visible and material, full of graphic value, the linking of signs exceeds mere horizontal contiguity to emphasize weight, volume, tactility: presence. Reading the texts of *Notes in Time on Women*, the spectator is drawn into multiple worlds of individual experience and social reality, incremental narrations that linger and coalesce in consciousness and which, in their totality, metonymically invoke the social and cultural histories of women's oppression. These readings are interrupted and inflected, reinforced or contradicted by images that sometimes appear to be the visual correlates to the literary text, at others to operate as an independent signifying system entirely. The image operates through a double articulation: as a receptor for the texts' connotations, or as the supplement that undoes meaning, introduces difference and value and opens the discourse of power to the world. (Like the 'fragment', the distinction between the discursive and the visual has a long philosophical history going back to Gotthold Lessing's *Laokoon*. In this tradition the literary is privileged over the visual, the temporal over the spatial, and strict boundaries had to be

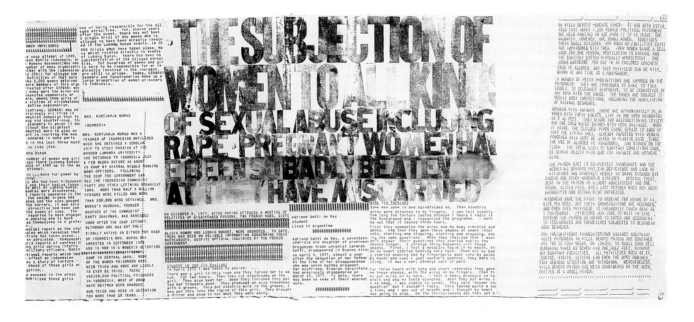

81 Nancy Spero, *Notes in Time on Women*, 1979 (detail of panel 17).

drawn between the arts, a foundational aesthetic that leads eventually to the definition of art through criteria of self-identity, the bedrock of Greenbergian modernism.)

When Spero began to appropriate the fractured prose of Artaud it was partly as a response to the limited and oppressive subject positions available to a female and nascently feminist artist in the 1960s. Artaud offered Spero a provisional position from which to perform her own identity, visually encoded in the image of the head with protruding tongue with its connotations of irreverence and expulsion. It is as if, in the works of the late 1960s through to *Notes*, Spero is intuitively tracking the moves in theory that were coming from the conjunction of structuralist and semiotic theories of the sign, psychoanalysis and feminist politics of the historical and situated subject. From a position constructed out of parody, anger and resistance, raiding the archives for whatever might aid her in creating an artistic identity, to the considered and complex scripto-visual relationships of *Hours* and *Notes*, Spero develops a dialectical practice of art-making that enables her to combine visual and textual narratives of the mythic and the everyday, personal memory and cultural archetype, the sacred and the profane.

This is decidedly not an art of closure but of disjunction, fragmentation, contingency and parody. Every example of the holistic human body is countered by its repetitive figuring, analogous to the sequential movement of time-lapse photography, or through textual interruptions to the imagery from collaged and printed blocks of typeface creating random patterns, clusters and grids. In addition, meaning is negated or resignified through the contrast of painting and writing as in the figure on panel 17 (illus. 81), leaping, arms akimbo over a quotation from Derrida on the feminine as absence, or the Dildo dancer, a familiar Spero motif, gigantic phallus tucked securely under one arm, who separates the words 'Défense d'uriner' in boldly printed block capitals from a misogynistic quotation from Juvenal on women's debauchery and another from Tacitus on the punishment of adulterous women (panel 21).

The combination of multiple voices, fragmented and schematized figures and body parts (panel 19 is partially composed of rows of collaged heads, both actual portraits and generalized and abstracted depictions) exposes the fiction of ego-centred identity. What Spero presents are psycho-sexual bodies divided and traversed by the currents of memory, history, culture and

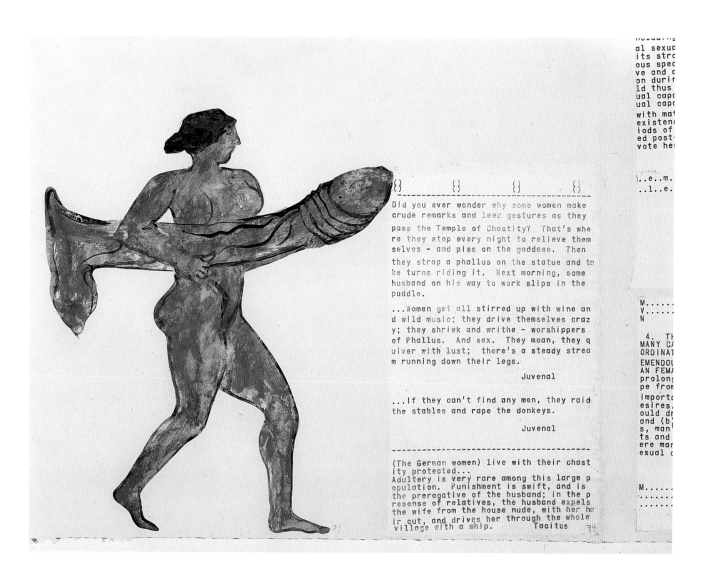

Did you ever wonder why some women make
crude remarks and lewd gestures as they
pass the Temple of Chastity? That's whe
re they stop every night to relieve them
selves - and piss on the goddess. Then
they strap a phallus on the statue and ta
ke turns riding it. Next morning, some
husband on his way to work slips in the
puddle.

...Women get all stirred up with wine an
d wild music; they drive themselves craz
y; they shriek and writhe - worshippers
of Phallus. And sex. They moan, they q
uiver with lust; there's a steady strea
m running down their legs.

 Juvenal

...If they can't find any men, they raid
the stables and rape the donkeys.

 Juvenal

(The German women) live with their chast
ity protected...
Adultery is very rare among this large p
opulation. Punishment is swift, and is
the prerogative of the husband; in the p
resense of relatives, the husband expels
the wife from the house nude, with her ha
ir cut, and drives her through the whole
village with a whip. Tacitus

82 Nancy Spero, *Notes in Time on Women*, 1979 (detail of panel 21).

language. Throughout the 1970s her art is a heterogeneous act of appropriation and synthesis, annexing elements from a diverse range of visual and lexical archives for her aesthetic vocabulary, borrowing from the current avant-gardes – from Pop iconography and the introduction of mass cultural icons into the discourse of 'high' art to the emphasis upon the spectatorial relation and linguistic presence in Minimalism and Conceptual art, whilst maintaining a dialogue with the pictorial, narrative and the potential for art's engagement with the social world in all its variety and contradiction. However, unlike much of the 'appropriation art' of the next decade, generally falling under the rubric of the 'postmodern', Spero maintains the legibility and specificity of her source material: the feminine is signified as historically and culturally determined, resistant and, despite all obstacles, empowered (illus. 82).

Invisible in Plain Sight

ANN REYNOLDS

Throughout her career, Nancy Spero has called attention to forgotten or unseen images of women and, more recently, she has placed them in relatively inaccessible institutional spaces, such as a military base in Innsbruck, Austria, or in neglected areas of more public architectural spaces, such as in her installation at the Festspiel-haus at Hellerau near Dresden.[1] Spero's mosaic design for the Lincoln Center Subway Station in New York continues these interests, but in terms of a space with a long history of visual and social unconsciousness.

Putting art in public, being in public with art, generating a public and a public presence for art are actions that are reflexively subsumed into a single, unifying term: 'public art'. Significantly, a problem with much contemporary art defined as 'public' is that discrepancies have tended to emerge between location and the intended or presumed effect, because a public location does not guarantee a public or a particular kind of 'public' type of experience. This may occur because a given physical location is infused with its own discrete rhetoric that public art often fails to address.

In her project for the Lincoln Center Subway Station, *Artemis, Acrobats, Divas and Dancers*, Nancy Spero addresses the discrepancy between public space as a formal physical location and its rhetoric of representational forms, publics, experiences and shared history. She brings female images from her personal artistic repertoire into a public space, the walls of the eastern and western platforms of the Lincoln Center Subway Station at 66th Street and Broadway. Many of her chosen images are historical figure types: Athena, Artemis, ancient Graeco-Roman and Egyptian dancers and musicians, aboriginal figures, the

opera diva, or, from more recent history, the female athlete. Spero did not invent any of these figure types. A variety of versions of many of them have appeared in numerous public contexts and media before, and they are probably familiar to many New York City Subway users.

Because of the stipulations of the commission for the 'Arts for Transit' programme of the Metro-politan Transit Authority (MTA) and its intended permanence, Spero's figures were rendered in the ancient medium of mosaic by a professional mosaicist.[2] This medium was new to her, but it has a long association with the public spaces of the New York City Subway system. Thus neither her images nor her chosen medium are new or unfamiliar to public space in general. However, together in their present public location they constitute a contradiction to the extent that Spero's images and the female figure types on which they are based are not usually found in the New York City Subway. Instead of the advertising images of interchangeable, young, beautiful women and men, often minimally clothed, selling commodities: alcohol, music, television shows or the latest film, Spero offers heterogeneous images of goddesses, divas and athletes (illus. 83), which she folds into the Subway environment through mosaic: 'As raw as I sometimes want these things to be, they get mediated into art. For instance, I want woman as the protagonist in the Subway – the feminine entering Lincoln Center – it's highly stylized, but the principle is activist.'[3] This activism derives from the discrepancies between the different aspects and histories of public experience subsumed in a particular public space, the Subway, and a particular set of 'public' images of women – and how these discrepancies can generate a feminist experience and perhaps a

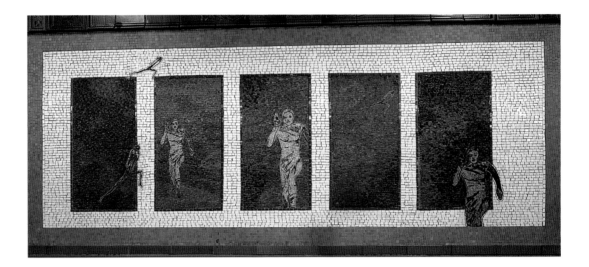

83 View of panel, *Artemis, Acrobats, Divas and Dancers.*

feminist public. It is not so much what Spero invents – since many of her figure types and particular images are borrowed from other sources – but where she puts her figures; their location, medium and their history; where they have been before and how they have been viewed before. Through her arrangement of these figures, she rewrites a historical narrative of women that is familiar and yet unfamiliar at the same time. Its location in this particular public place, a place with its own history, permits it to be both things at once.

In order to equate public locations with a specific type of experience or set of images, one must take for granted that these locations are closely regulated, and that they are experienced by uniformly attentive and impartial subjects. But such expectations are idealizations that are based on a desire for a particular type of coherence and the privileging of particular types of subjects and not on the realities of actual public spaces, how they are used, and the heterogeneity of the individuals who pass through them. Rosalyn Deutsche has argued:

Art critics who advocate a return to an ideal of a unitary public sphere try to recuperate the masculinist subject and, in so doing, hide from the very openness of public space that

they ostensibly champion. To this end, they cast art informed by feminist critiques of subjectivity into privacy, dismissing it as inimical to political public space.[4]

Associating critiques of masculine subjectivity with private artistic practices and locations safely 'out of sight', and consensual, naturalized subjectivity with public artistic practices and locations clearly 'seen', is the most fatal assumption of all to make about experience in the public sphere, since many components of public space are so familiar and ubiquitous that they often escape notice. Such invisible visibility can generate its own surreptitious feminist political power by exploiting an obvious contradiction prevalent in the experience of presumably public spaces and public art forms: invisibility in plain sight.

SUBMERGED SPACES, SUBMERGED IMAGES
(TRADING PLACES)

And I remember I tenderly imagined how, at this very moment, my mother would be moving slowly about the narrow bedroom I had left behind forever, folding up and putting away all my little relics, the tumbled garments I would not need any more, the

scores for which there had been no room in my trunks, the concert programmes I'd abandoned; she would linger over this torn ribbon and that faded photograph with all the half-joyous, half-sorrowful emotions of a woman on her daughter's wedding day. And, in the midst of my bridal triumph, I felt a pang of loss as if, when he put the gold band on my finger, I had, in some way, ceased to be her child in becoming his wife.[5]

Even the most public of spaces possesses secret or forgotten histories. The historian Lewis Mumford has described the subway as a residual urban form of the fundamental condition of the Industrial Revolution: mining. He calls mining 'un-building' or *Abbau*, and claims that its 'slavish routine, whose labor was an intentional punishment for criminals, became the normal environment of the new industrial worker'. By the third quarter of the nineteenth century the railroad had extended the mine's un-building process into almost every industrialized community.[6] He elaborates:

Few of us correctly evaluate the destructive imagery that the mine carried into every department of activity, sanctioning the anti-vital and the anti-organic. Before the nineteenth century the mine had, quantitatively speaking, only a subordinate part in man's industrial life. By the middle of the century it had come to underlie every part of it. And the spread of mining was accompanied by a general loss of form throughout society: a degradation of the landscape and a no less brutal disordering of the communal environment. Agriculture creates a balance between wild nature and man's social needs . . . The process of mining, on the other hand, is destructive: the immediate product of the mine is disorganized and inorganic; and what is once taken out of the quarry or the pithead cannot be replaced.[7]

Eventually, Mumford argues, this un-building began to spread to the urban environment in the form of the 'underground city ideal' of bundling together all the city's necessary services, such as plumbing, electricity, communication lines and transportation, and burying them underground in a network of tunnels. This network provided a new kind of urban environment and life, based on an extension and normalization of the conditions initially forced on the miner.[8] Once accepted, the conditions of this underground environment – mechanically produced and controlled light and ventilation and choreographed movements – emerged from the underground and began to dictate the design of buildings – sealed skyscrapers – erected above ground as well, and so, according to Mumford, un-building defeated aesthetic experience at every turn.[9]

Mumford's conception of the city's network of tunnels both above ground and below as pervasive yet invisible historical continuations and material extensions of the Industrial Revolution and eventually capitalism's repressive terms had not been appreciated as such by many artists until the 1980s. Act-Up, Keith Haring and Alfredo Jaar, to name just a few well-known artists and one activist group, chose the walls of New York City Subway platforms as sites for their public interventions because of the latter's 'underground' location and peripatetic conditions. Jaar's Spring Street Subway Station project *Rushes* actually inserted images of a mine and miners in Brazil to its contemporary urban counterpart, the Subway.[10] However, none of the MTA's commissioned mosaic projects for the city Subway stations that preceded Nancy Spero's project make reference to the subway as an unconscious historical form or location. For the most part, their artists acknowledge the location of their assigned station in terms of its correlative above ground by providing vignettes of its local culture, buildings or institutions, or they base their designs on their own previous art with little regard for its new material conditions or location.

84 Nancy Spero,
*Artemis, Acrobats,
Divas and Dancers*,
1999–2000, glass and
ceramic mosaic.

85 Nancy Spero,
Artemis, Acrobats,
Divas and Dancers,
1999–2000, glass and
ceramic mosaic.

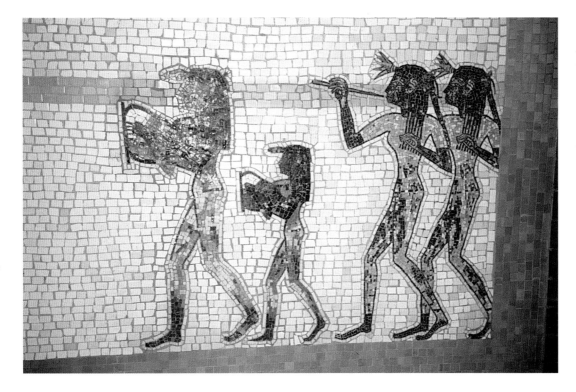

Spero's imagery makes reference to her station's geographical and cultural location *and* to her own art. Location and her artistic practice dovetail nicely. Her dancers, acrobats, skaters, goddesses and Egyptian figures have all been stock figures in her own art for years (illus. 84 and 85), and, for New Yorkers, evoke a chain of associations that resonate between the city streets, the stages of Lincoln Center and the walls of the Metropolitan Museum of Art. Spero developed the diva figure specifically for the Lincoln Center project; she is the star of Spero's eastern platform cycle and an embodiment of the culture of the Lincoln Center (illus. 86).[11]

She calls the figures that she bases on the art of the past 'faux antique'. Obviously, they are not true Antique figures, just representations of Antique images or forms.[12] She invents some of these images herself, but she also copies or traces many of them from books or photographs. Simple linear drawings or outlines of two-dimensional images of Antique figures result. Over the years Spero has transformed most of

these simple figure drawings or tracings into rubber stamps or metal plates on a variety of scales, which she then prints in an array of colours on paper and cuts out or prints directly onto the wall in her installations. For the Subway project, her assistant, Samm Kunce, scanned Spero's figures onto a computer so that the artist could select from them, determine the scale and colour of each one, assemble the chosen figures into groups for each panel of the mosaic, and arrange these panels into a particular sequence on the computer screen.

Spero feels that 'mosaics are decorative', and that her designs for the Lincoln Center Subway project needed to reflect that fact.[13] Therefore flatness became absolutely necessary to the design of both the individual figures and their groupings in the individual panels. But her comment also refers to the necessity of reconciling the two extremes of decoration and figural representation, always an issue in her art. She must render a three-dimensional figure on a two-dimensional surface, not through illusionistic

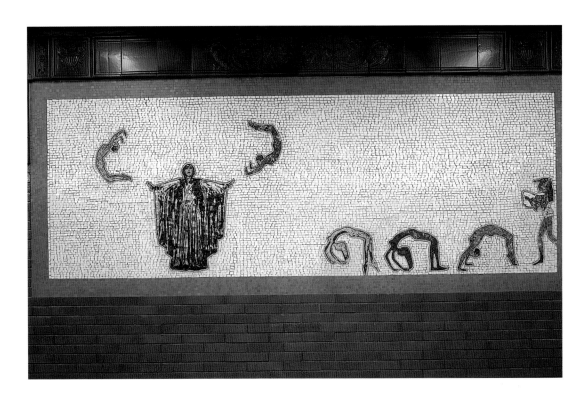

88 View of panel, *Artemis, Acrobats, Divas and Dancers*.

89 Detail from panel, *Artemis, Acrobats, Divas and Dancers*, western platform.

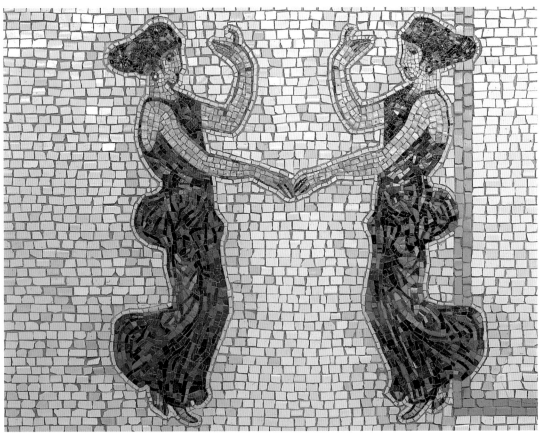

fold-out
90 *Artemis, Acrobats, Divas and Dancers*. Details and computer generated plan of entire mosaic

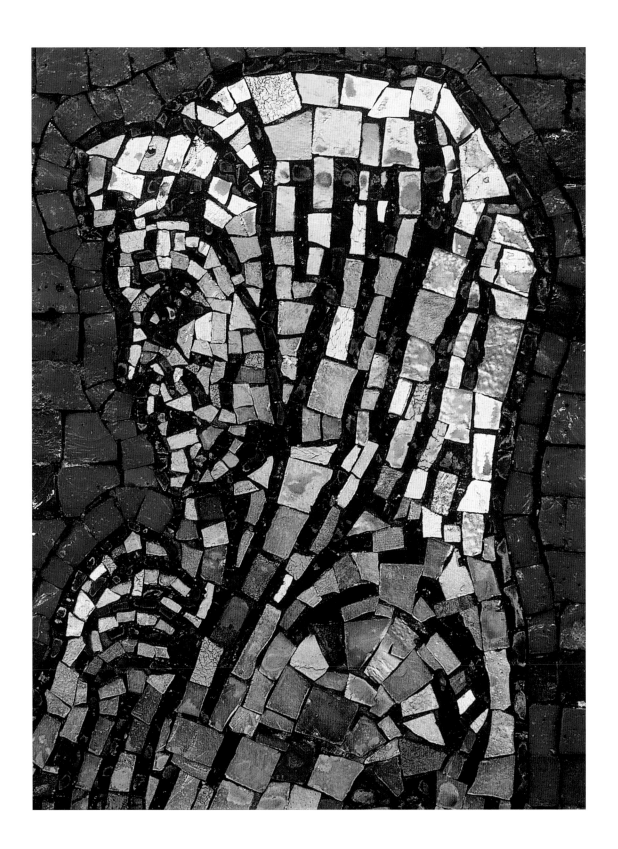

91 View of panel, *Artemis, Acrobats, Divas and Dancers.*

tricks or analogies, but by transforming this figure, which often already exists as a two-dimensional image in its drawn or traced source, into a calligraphic ideogram of that figure type. Spero has described her role as 'a courier, carrying these images from the past and present, a kind of a scribe'.[14] In a way they are all historical ideograms, repeated bits of figural language; and they are all basically silhouettes.

In the process of installing the figural images, the mosaicists for the Subway project reduced them to true silhouettes (illus. 87). They marked out their edges – where the field of tesserae would abut with the figure's profile – and filled in the shape with white ceramic tiles. Once they completed the individual figures in the studio, they removed the white tiles from the wall and lifted each figure, which was surrounded by an outline of smaller tesserae, up into its proper place inside the silhouetted space.

Spero's economy of form in her design also underscores the fact that her figures are two-dimensional silhouettes. She often rotates the same figure to create leaping, diving and back-bending acrobats in different colours (illus. 88). She flips figures to create dancing partners (illus. 89), and when she pulls these figures closer together (illus. 91), they do not embrace the same three-dimensional space but exist in separate yet overlapping two-dimensional planes, because she has superimposed two of the same two-dimensional figures, one flipped on top of the other.

92 Detail from panel, *Artemis, Acrobats, Divas and Dancers.*

All Spero's figures are resolutely two-dimensional; each one is sealed off in a silhouette outline of tesserae. None of them share a uniform three-dimensional space, just a sequence of two-dimensional spaces, a flat continuum along the walls of the Subway platform. But this continuum is historical as well as spatial (illus. 92). Spero reiterates: 'The female principle has entered the New York Subway system, women who are active in the world, and I've brought antiquity into it because of this continuum from time past to time present.'[15] By presenting these figures in such a spatial sequence, she is able to bring female figure types from different historical periods in line with each other without losing a sense of their temporal differences or constructing a strictly historical narrative. They become place-markers for the actions of women, not representations of individual actors in history.

Many of the active 'female protagonists' that Spero chooses to represent 'the female principle' are shadow figures in the history of art, figures such as Egyptian musicians, which are often viewed as merely decorative, the antithesis of action. Spero brings them to consciousness in a space of unconsciousness, the underground space that, according to Mumford, defeats art at every turn. Her placement of these figures in such a space thus illuminates the balance between aesthetic consciousness and aesthetic repression. Freed at once from historical context and cultural obscurity, Spero's figures evoke a continuum that runs both parallel with and counter to Mumford's continuum between the mine and the urban underground. Spero states: 'I intend all my work to be "open ended" – interconnected, a continuous movement through time.'[16]

93 View of *Artemis, Acrobats, Divas and Dancers* downtown western platform.

SUBMERGED SPECTATORSHIP:
IN-LIFE WATCHING

Yet the skull was still so beautiful, had shaped
with its sheer planes so imperiously the face
that had once existed above it, that I recog-
nized her the moment I saw her; face of the
evening star walking on the rim of night. One
false step, oh, my poor, dear girl, next in the
fated sisterhood of his wives; one false step
and into the abyss of the dark you stumbled.[17]

Nancy Spero designed her Subway mosaic cycle
for partial viewing.[18] Conditions of ideal viewing
– seeing all of the cycle's mosaic panels as an
uninterrupted continuum on either the eastern
or western sides of the Subway station – exist
only in reproductions: photographic views of the
long perspectival sweep of an empty station
taken in the early morning hours (illus. 93) or
computer print-outs of the layout of the entire
design (see foldout). Yet even these images are
not ideal because they necessarily deeply distort or
eliminate the spatial terms of the site. Complete
on-site views are impossible because of the con-
stant presence of other people and the relative
narrowness of the viewing space; one cannot
back up enough to see the entire sequence of
mosaic panels on either side because the Subway
platform is not wide enough to permit it.

Partial viewing is also inherent to such a site
because most of the potential spectators of
Spero's work are transitory or inattentive ones.
They pass rapidly when travelling by train, and
when on foot, often hurriedly; even when not in
a rush, they barely give the mosaics a sideways

on that side are randomly framed by the supporting piers of the Subway's infrastructure (illus. 94). The MTA improved the viewing conditions on both platforms by not placing benches in front of any of Spero's images and by eliminating the rectangular panels for mounting advertisements, which are usually interspersed along the platform walls. But old viewing habits die hard regardless of the removal of a few distractions.

Although the Subway platform is a space in which viewing occurs, because of the physical terms and habits endemic to the space, Spero's mosaics could remain relatively spectator-less. The challenge for an artist working in such a space is to acknowledge these a priori spectatorial conditions and habits and to encourage viewers to become aware of them as well, so that they can not only see the images she presents within these conditions but also see how she presents them in terms of these conditions and a much earlier underground condition, the ancient Egyptian tomb.

Spero has described her mosaic design for the 66th Street Subway Station as analogous to an Egyptian tomb and her figures as offerings akin to the offerings and objects that would be needed by the deceased in the afterlife. Although Spero's intended spectators are not dead, they are rarely present in the sense that they are often inattentive. She describes the situation this way:

> The tired and the hungry, the New Yorkers with a pallor from sitting in offices all day long are confronted (if one chooses to look) with these exuberant figures. Utopian offerings to the daily commuters of the number 1 and 9 subway . . . This is not a Utopian scheme for a better society, it is a Utopian ideal of the human body depicted by female images able to move, dance and sing unfettered. It is an ideal play – if you will – a perpetual moment. The contradiction of Utopia underground in the bowels of the earth.[19]

95 *Ti Watching a Hippopotamus Hunt*, mastaba of Ti, Saqqara, *c.* 2500–2400 BC, painted limestone wall relief, approximately 114.3 cm. (45 in.) in height.

glance. Such behaviour is the result of three things: again, the relative narrowness of the viewing space, the conditions under which people move through the space and visual habituation. Few are accustomed to seeing anything of interest on the walls of such a space. Mostly they expect to be accosted by advertisements or graffiti, which can be visually aggressive but rarely reward close, sustained viewing. Or, when waiting for a train, their attention can also be drawn away from the confines of the platform to fellow travellers who also wait, out into the darkness of the tracks, or toward the other side of the platform where fragments of the mosaic cycle

Egyptian private tomb reliefs depict few situations that the living spectator is meant to share, since the principle if not sole intended spectator of every image in the tomb is the deceased who owns these images. He or she was believed to have passively watched 'in death' the activities of daily life either from outside these images or from within them via an image proxy. When represented within the image, he or she is always depicted a bit larger and apart from the activities that he or she watches. For example, in an Old Kingdom relief from the Tomb of Ti at Saqqara (illus. 95), Ti, the owner of the tomb and the deceased, is represented by the figure that stands in his own boat and, according to the relief's inscription, 'watches' a hippopotamus hunt taking place in the adjacent boat. All the figures in the relief and in the tomb as a whole are depicted in the conventionalized composite view and canon of proportions typical of ancient Egyptian art: feet, legs and head rendered in profile; torso, arms and eye rendered frontally. The artist or artists indicates Ti's status through his larger scale relative to the other figures, through his inactive pose, neither standing nor walking, which suggests no movement or the potential for future movement, and through the repetition of his image on a similar scale relative to the other figures and in the same stance in almost every relief in his tomb.

The art historian H. A. Groenewegen-Frankfort states that such a depiction indicates the deceased's simultaneous resignation to death and clinging to life through watching and concludes:

We must acknowledge that an effort was made to bridge the gap between the worlds of the living and the dead, only our interpretation can account for the fact that while there is frequent mention in the accompanying texts of the activities of others, never once is any reference made to the dead man's actions other than 'watching' . . . It is this persistent passiveness which corroborates our interpretation of the term 'seeing' and it is the combination of both which makes us feel justified in considering the original scheme both subtle in meaning and restrained in purpose.[20]

Thus the images do not record the dead man's activities in life but provide an image of him in death watching life's daily manifestations. They have no temporality but an ongoing present.

Spero frequently uses figures from Egyptian tombs in her art, and *Artemis, Acrobats, Divas and Dancers* is no exception (illus. 96). These figures are depicted in the conventionalized

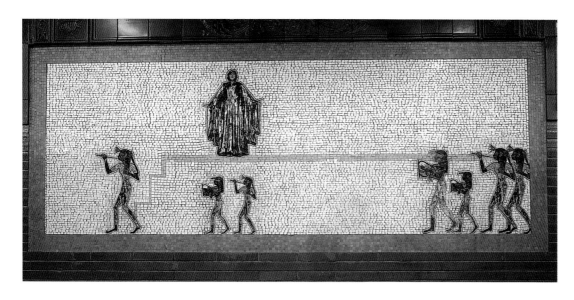

96 View of panel, *Artemis, Acrobats, Divas and Dancers*.

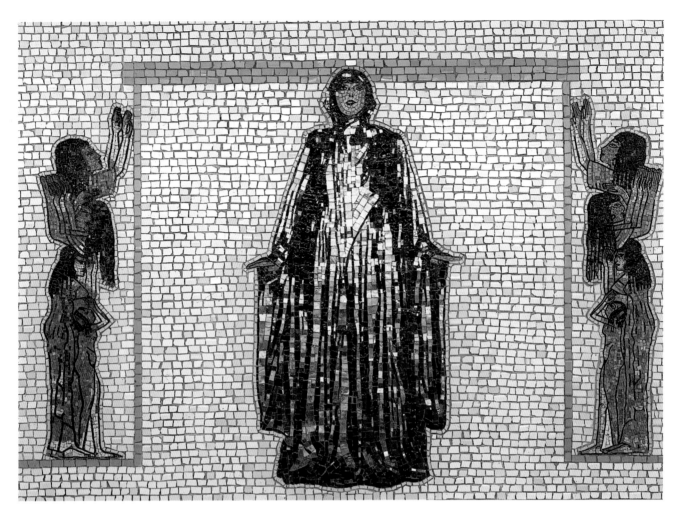

Egyptian composite view and usually mirror
the directional movement of the Subway train
through the station and the direction that most
travellers take once they leave the train and make
their way to the exits to the street level. Thus
these figures reiterate the everyday life of the
Subway. Interspersed amidst these and other
figures moving toward the exit, but usually set
slightly apart on a different register or within a
separate architectural frame, the diva figure faces
outwards in a full frontal depiction (illus. 97).
She is not significantly larger than the figures
that surround her, but she stands out primarily
because of her anomalous frontality and the
shimmering gold tesserae that constitute her
costume. Each manifestation of her figure in the
sequence of mosaic panels is a repetition of the
previous one in every sense but one: the positions
of her arms, which slowly rise and lower in each

successive image. This subtle gestural transfor-
mation and her frontal address and colourful
grandeur are directed to the Subway riders who
pass by in the express trains and do not stop at
the local station at 66th Street. The artist hoped
to achieve the visual effect of a cinematic flicker
of animated movement as the figures flash by
like the pages of a flip book or successive frames
of a film projected on a wall. This cinematic
sequence generates a visual experience that
could be considered to be analogous to a kind of
distanced 'in-life watching' of images in action.
Like the figures in Egyptian tomb reliefs, the diva
figures and the progressing musicians, acrobats
and dancers have no specific temporality but
enact an ongoing present.

In a conversation with Jo Anna Isaak, Spero
remarked:

Once you and I were talking about the printing process I use in which the same figure appears and reappears in an extended narrative format. You mentioned Gertrude Stein's use of repetition and her term, the 'continuous present.' That is a very good term for what I am doing. The history of women I envision is neither linear nor sequential. I try in everything I do – from using the ancient texts, to the mythological goddesses, to H. D.'s poems on Helen of Egypt – to show that it all has reverberations for us today. And then it makes sense.[21]

In light of its affinities with an ancient Egyptian convention of representing a reassuring, if not utopian, ongoing present, Spero's creation of a 'continuous present' in *Artemis, Acrobats, Divas and Dancers* makes even more sense.

SUBMERGED STORY-TELLING

On her eighteenth birthday, my mother had disposed of a man-eating tiger that had ravaged the villages in the hills north of Hanoi. Now, without a moment's hesitation, she raised my father's gun, took aim and put a single, irreproachable bullet through my husband's head.[22]

Each section of my essay begins with a quotation from Angela Carter's 'The Bloody Chamber', a feminist rewriting of the familiar fairytale 'Bluebeard'. Carter's most dramatic change to the traditional telling of the tale comes at the end of the story when she describes the mother's sweep up the narrow roadway to the castle on horseback:

You never saw such a wild thing as my mother, her hat seized by the winds and blown out to sea so that her hair was her white mane, her black lisle legs exposed to the thigh, her skirts tucked around her waist, one hand on the

reins of the rearing horse while the other clasped my father's service revolver and, behind her, the breakers of the savage, indifferent sea, like the witnesses of a furious justice. And my husband stood stock-still, as if she had been Medusa, the sword still raised over his head as in those clockwork tableaux of Bluebeard that you see in glass cases at fairs.[23]

Here Carter transforms Freud's dreadful image of the feminine into a powerful heroine and in so doing reveals, among other things, that the dread that the image evokes is only in the eyes of men. For the daughter, who in this tale as commonly told is usually rescued by her brothers, her mother's image was one of deliverance from her fate. Carter has simply expanded the points of view from which the powerful feminine is seen, rearranged the narrative roles and positions of the already established characters and substituted a female protagonist for a masculine one. The thrill for me, and it comes every time I read the story, is the surprise at the substitution. It always seems so unexpected and fresh because the point of view, the traditional heroes and most of the contextual narrative are so familiar. This familiarity grounds the surprise and the power of Carter's rearrangement and substitution and the ensuing transformation of the meaning of the feminine.

Nancy Spero has spoken about how context shifts the meaning of an image:

A few other examples of shifting meaning are the image of a contemporary woman athlete with her hands above her head – triumphant, but in other circumstances it seems as if she could be mourning or imploring. And an ancient Egyptian musician could be trumpeting a celebration, or playing for a funeral procession, or dance [see illus. 96].[24]

Substitution can dramatically alter the meaning of a narrative, but changing the sequence and

location of the figures and/or characters does the job just as well. Because of her manipulation of scanned images on the computer for this project, Spero has become more of a composer of image sequences than ever before. She also added ground lines and some architectural framing for most of her figures to give them some grounding and weight (see illus. 96 and 97); usually her figures float in the wide open white space of the gallery wall or on their paper background.[25] Spero's decision to add these elements serves to emphasize the sequencing and the point of view of the spectator as well. When describing her design process for *Artemis, Acrobats, Divas and Dancers*, Samm Kunce noted that the total sequence was not planned beforehand. An image was chosen because the previous one seemed to call for it to balance and maintain the rhythm and energy of the design. The arrangement, not the characters, with one exception, is what was created anew.[26]

In his widely influential text, *The Uses of Enchantment: The Meaning and Importance of Fairy Tales*, Bruno Bettelheim notes that fairy tales teach little about the specific conditions of life in the modern mass society. They address archetypes of the human psyche and provide ideas on how to bring one's inner house into order.[27] The nature of the fairy-tale genre is heterogeneous both in terms of where and when it has developed, but according to Marina Warner:

the thrust towards universal significance has obscured the genre's equal powers to illuminate experiences embedded in social and material conditions. These are subject to change over time and ultimately more capable

of redress than the universal lessons of greed, lust and cruelty which fairy tales give us; in one sense, the historical interpretation of fairy tales holds out more hope to the listener or the reader than the psychoanalytic or mystical approaches, because it reveals how human behaviour is embedded in material circumstances . . . and that when these pass and change, behaviour may change with them.[28]

Artemis, Acrobats, Divas and Dancers is Spero's story, her characters, her history, not because she invents them but because she puts familiar images into play in a specific social space and in relation to particular historical conditions of spectatorship. In response to the question: 'Do you think art ever does effect significant social change? Is that asking too much?' Spero responded:

It's never too much to ask and never too little to ask. But who knows? There are few artists – like Picasso – who have been powerful in instituting what a century might look like. But who can tell what it might mean to have my female images surviving through time? What does this mean in terms of entering the consciousness of society or of women's consciousness of themselves and their place in society? What does it mean to bring a feminine protagonist into the subway environment?[29]

Rather than the question often put to the storyteller, 'How will it all turn out?', one might ask who is turning up to watch and . . . possibly to save the day.

References

JON BIRD: 'IMAGINING OTHERWORLDS'

1 Jacqueline Rose, *On Not Being Able To Sleep: Psychoanalysis and the Modern World* (London, 2003), p. 48.

2 This is a complex and recurring issue that revolves around the interpretation of 'difference', in the expression 'different from . . .'. Since the 1960s this has shifted from attempts to decipher gender specificity in formal and compositional elements to reading the work of women artists for 'some system to the patterning of signs into meanings' (Griselda Pollock), and the recognition of sexual difference coded into 'the relations between spectator and text' (Lisa Tickner). See, for example, Griselda Pollock, ed., *Generations and Geographies in the Visual Arts: Feminist Readings* (London and New York, 1996); Lisa Tickner, 'Nancy Spero: Images of Women and *la peinture féminine*', in *Nancy Spero*, exh. cat., Institute of Contemporary Arts, London (1987).

3 Thomas Crow, *The Rise of the Sixties* (London, 1996).

4 Sylvère Lotringer, 'A Conversation with Kiki Smith', in *Antonin Artaud: Works on Paper*, ed. Margit Rowell, exh. cat., Museum of Modern Art, New York (1996), p. 147.

5 Griselda Pollock ' The Politics of Theory: Generations and Geographies in Feminist Theory and the Histories of Art Histories', in *Generations and Geographies in the Visual Arts*, p. 6.

6 Michel Foucault, *Discipline and Punish: The Birth of the Prison*, trans. Alan Sheridan (London, 1979).

7 Anne Baring and Jules Cashford, eds, *The Myth of the Goddess: Evolution of an Image* (London, 1993), p. 502.

8 Theodor Adorno, *Aesthetic Theory*, quoted in Josh Cohen, *Interrupting Auschwitz* (New York and London, 2003), p. 61.

9 For a discussion of the politics of 'cultural feminism', see Simon Taylor, 'The Women Artist's Movement: From Radical to Cultural Feminism, 1969–1975', in *Personal and Political*, exh. cat., The Museum Guildhall of East Hampton Inc. (2002).

10 Kiki Smith was included in the exhibition *The Uncanny*, curated by Mike Kelly at the Gemeentemuseum, Arnhem, and the Fred Hoffman Gallery, Los Angeles, 1993.

11 'Women's Time', in Julia Kristeva, *New Maladies of the Soul*, trans. Ross Guberman (New York, 1995).

12 Jon Bird, 'Dancing to a Different Tune', in Jon Bird, Jo Anna Isaak and Sylvère Lotringer, *Nancy Spero* (London, 1996).

13 Elaine Scarry, *The Body in Pain: The Making and Unmaking of the World* (Oxford, 1985), pp. 179–85.

14 Clement Greenberg, *Art and Culture: Critical Essays* (Boston, MA, 1967), p. 200.

15 *Ibid.*, p. 64.

16 Nancy J. Troy, *Modernism and the Decorative Arts in France: Art Nouveau to Le Corbusier* (New Haven, 1991); Gill Perry, 'The Decorative, the Expressive and the Primitive', in *Primitivism, Cubism, Abstraction*, ed. Charles Harrison, Francis Frascina and Gill Perry (New Haven, 1993).

17 This is discussed in some detail in an as yet unpublished essay by Elissa Auther, 'Clement Greenberg's Theory of the Decorative and the Modernist Hierarchy of Art and Craft' (2002).

18 Andreas Huyssen, *After the Great Divide: Modernism, Mass Culture and Postmodernism* (London, 1988), p. 47.

19 For an example of this, see Donald Kuspit, 'Betraying the Feminist Intention: The Case against Feminist Decorative Art', *Arts Magazine* (November 1979). The attack on the decorative was also a significant aspect of modernist design, the architect and theorist Adolf Loos even going so far as to write an essay entitled 'Ornament and Crime'.

20 Peter Wollen, *Raiding the Icebox: Reflections on Twentieth-Century Culture* (London, 1993).

21 See Rozsika Parker, *The Subversive Stitch: Embroidery and the Making of Femininity* (London, 1984), and Charlotte Robinson, ed., *The Artist and the Quilt* (New York, 1983).

22 Julia Kristeva, 'Giotto's Joy', in *Desire in Language: A Semiotic Approach to Literature and Art*, ed. Leon S. Roudiez, trans. Thomas Gora, Alice Jardine and Leon S. Roudiez (Oxford, 1980), p. 22.

23 For example, see Derrida's observations on the supplementary nature of colour in Western aesthetics in *Of Grammatology*, trans. Gayatri Chakravorty Spivak (Baltimore and London, 1976).

24 Alexander Theroux, *The Primary Colours* (New York, 1994), p. 1.

25 Derrida, *Of Grammatology*, p. 35.

26 Michael Fried, *Absorption and Theatricality: Painting and Beholder in the Age of Diderot* (Los Angeles and London, 1980).

27 *Ibid.*, p. 108.

28 Hélène Cixous used the expression 'l'écriture féminine' to describe a form of writing inscribed with the pulsions of the female body in her essay 'The Laugh of the Medusa', in *New French Feminisms*, ed. Elaine Marks and Isabelle de Courtivron (Amherst, MA, 1980). For a period during the 1980s Spero adapted this to *la peinture féminine*: 'There is no other way to go but for a new direction. The French feminists are talking "L'écriture féminine", and I am trying "la peinture féminine"' (Nancy Spero interview with Nicole Jolicoeur and Neil Tenhaaf, 'Defying the Death Machine', *Parachute*, no. 39, July–August 1985). Lisa Tickner and I both discuss this in our essays in *Nancy Spero*, exh. cat. for the ICA, 1987.

29 Baring and Cashford, *The Myth of the Goddess*, p. 488.

30 Helaine Posner, *Kiki Smith* (Boston, 1998), pp. 19–20.

31 Mieke Bal, 'Sexuality, Sin and Sorrow: The Emergence of Female Character (A Reading of Genesis 1–3)', in *The Female Body in Western Culture: Contemporary Perspectives*, ed. Susan Rudin Suleiman (Cambridge, MA, 1986).

32 Baring and Cashford, *The Myth of the Goddess*, p. 511.

JO ANNA ISAAK: 'WORKING IN THE RAG-AND-BONE SHOP OF THE HEART'

1 Angela Carter, *Nights at the Circus* (New York, 1984), p. 69.

2 Sylvère Lotringer, 'A Conversation with Kiki Smith', *Antonin Artaud: Works on Paper*, exh. cat., The Museum of Modern Art, New York (1996), p. 146.

3 Michael Boodro, 'Blood, Spit and Beauty', *Art News* (March 1994), p. 131.

4 Kay Larson, 'The Big Apple', *Mirabella* (November 1999), p. 20.

5 *Ibid.*

6 Kristen Brooke Schleifer , 'Inside and Out: An Interview with Kiki Smith', *Print Collectors Newsletter* (July–August 1991), p. 86.

7 Jean-François Lyotard, 'One of the Things at Stake in Women's Struggles', *SubStance*, 20 (1978), pp. 11–12.

8 Jane Weinstock, 'A Lass, a Laugh and a Lad', *Art in America* (Summer 1983), p. 7.

9 Schleifer , 'Inside and Out', p. 87.

10 Deirdre Summerbell, 'Marrying Your Own Personal Nutty Trips with the Outside World', *Trans Magazine* (Fall–Winter, 2001), p. 208.

11 Joanne Kesten, ed., *The Portraits Speak: Chuck Close in Conversation with 27 of his Subjects* (New York, 1997), p. 590.

12 Susan Sontag, *Under the Sign of Saturn* (New York, 1972), p. 67.

13 Carey Lovelace, 'Weighing in on Feminism', *Art News* (May 1997), p. 145.

14 Lotringer, 'A Conversation with Kiki Smith', p. 146.

15 Larson, 'The Big Apple', p. 20.

16 Julia Kristeva, *Powers of Horror* (New York, 1982), p. 4.

17 Jo Anna Isaak, 'Love Calls Us to the Things of this World', *Kiki Smith*, exh. cat., Whitechapel Art Gallery, London (1995), p. 25.

18 *Ibid.*, p. 22.

19 *Ibid.*, p. 26.

20 Summerbell, 'Marrying Your Own Personal Nutty Trips', p. 208.

21 Julia Kristeva, *Desire in Language: A Semiotic Approach to Literature and Art*, trans. Alice Jardine, Thomas Gora and Leon S. Roudiez (New York, 1980), p. 165.

22 Boodro, 'Blood, Spit and Beauty', p. 131.

23 For Ernest Bloch's view of hope and this emotion's relationship to the visual, I am indebted to Peter Schwenger, *Fantasm and Fiction: On Textual Envisioning* (Stanford, CA, 1999).

JON BIRD: 'PRESENT IMPERFECT: WORD AND IMAGE
IN NANCY SPERO'S "SCROLLS" OF THE 1970S'

1 Theodor Adorno, *Aesthetic Theory*, quoted in Josh Cohen, *Interrupting Auschwitz* (New York and London, 2003), p. 31.

2 Benjamin Buchloh, 'Spero's Other Traditions', in *Neo-Avantgarde and the Culture Industry: Essays on European and American Art from 1955 to 1975* (Cambridge, MA, and London, 2000), p. 438.

3 Nancy Spero in conversation with Margit Rowell and Sylvère Lotringer in *Antonin Artaud: Works on Paper*, ed. Margit Rowell, exh. cat., Museum of Modern Art, New York (1996), p. 138.

4 Buchloh, 'Spero's Other Traditions', p. 438.

5 Joseph Kosuth, 'Art After Philosophy', in *Uber Kunst*, ed. Gerd de Vries (Cologne, 1974), p. 148. Heavily indebted to the logical positivism of A. J. Ayer, Kosuth nevertheless retained the psychologism of artistic intention and the notion of 'context', despite the resolutely anti-contextual model of meaning he was citing. For a full discussion of Conceptual art's relation to philosophy, see Peter Osborne 'Conceptual Art and/ as Philosophy', in *Rewriting Conceptual Art*, ed. Michael Newman and Jon Bird (London, 1999).

6 Victor Burgin, *The End of Art Theory: Criticism and Postmodernity* (London, 1986). Recent work on Conceptualism includes the catalogue to the exhibition *Global Conceptualism: Points of Origin, 1950s–1980s*, ed. Luis Camnitzer, Jane Farver and Rachel Weiss, at the Queens Museum of Art, New York (1999); Tony Godfrey, *Conceptual Art* (London, 1998); Peter Osborne's compilation of texts, works and documents, *Conceptual Art* (London, 2002); Alex Alberro and Blake Stimson, *Conceptual Art: A Critical Anthology* (Cambridge, MA, 2000); Anne Rorimer, *New Art in the 60s and 70s: Redefining Reality* (London, 2001); and *Rewriting Conceptual Art* cited above.

7 Rorimer, *New Art in the 60s and 70s*, p. 9.

8 Jon Bird, 'Dancing to a Different Tune', in Jon Bird, Jo Anna Isaak and Sylvère Lotringer, *Nancy Spero* (London, 1996), pp. 40–97.

9 Osborne, *Conceptual Art*.

10 Quoted in Francis Frascina and Jonathan Harris, eds, *Art in Modern Culture* (London, 1992), p. 309.

11 Osborne, *Conceptual Art*, p. 18.

12 H. D. [Hilda Doolittle], *Helen in Egypt* (New York, 1961), p. 64.

13 Godfrey, *Conceptual Art*, p. 281.

14 See Griselda Pollock, 'The Politics of Theory: Generations and Geographies in Feminist Theory and the Histories of Art Histories', in *Generations and Geographies in the Visual Arts*, ed. G. Pollock (London and New York, 1996), and her *Differencing the Canon: Feminist Desire and the Writing of Art's Histories* (London and New York, 1999).

15 Nancy Spero interview with Jon Bird (New York, 1996).

16 I discuss this fully in 'Dancing to a Different Tune', *Nancy Spero*, p. 48.

17 Francis Frascina, *Art, Politics and Dissent: Aspects of the Art Left in Sixties America* (Manchester, 1999), pp. 109–10.

18 Daniel Belgrad, 'Into the Sixties', in his *The Culture of Spontaneity: Improvisation and the Arts in Postwar America* (Chicago, 1998).

19 *Art Gallery Magazine* (1971). It should be noted that the Whitney Museum of American Art, New York, still does not own any of Spero's works. In fact, the only major scroll in an American Museum, *Notes in Time on Women*, was donated to the Museum of Modern Art, New York, by a private collector.

20 *World Trade Community News* (13–27 April 1976).

21 'The Artist and Politics: A Symposium', *Artforum*, IX/1 (1970).

22 Nancy Spero interview with Jon Bird (New York, 1996).

23 Michael Newman, 'Conceptual Art from the 1960s to the 1980s: An Unfinished Project', *Kunst und Museumjournaal*, VII/1–3 (1996), p. 98.

24 Nancy Spero interview with Jon Bird (New York, 1996).

25 Quoted in Geoffrey Bennington, *Lyotard: Writing the Event* (Manchester, 1998), p. 68.

26 Linda Nochlin, *The Body in Pieces: The Fragment as a Metaphor of Modernity* (London, 1994), p. 10.

27 Andreas Huyssen, 'Paris / Childhood: The Fragmented Body in Rilke's *Notebooks of Malte Laurids Brigge*', in his *Twilight Memories: Marking Time in a Culture of Amnesia* (New York and London, 1995).

28 Visarut Phungsoodara, unpublished PhD.

29 Lawrence Alloway 'Nancy Spero', *Artforum* (May 1976).

30 This is more accurately translated as 'The Chapters of the Coming Forth of the Day'; see E. A. Wallis Budge, *The Book of the Dead* (London, 1974), p. 17.

31 Nancy Spero interview with Jon Bird (New York, 1996).

32 Spero's appropriation of trans-cultural images has been the subject of critical debate as an 'orientalizing' tendency in her work. This has, I believe, been more than adequately answered (e.g., by Bird, Tickner, Isaak) and, in her essay for the catalogue for the Cairo Biennale, Nazli Madkour addressed her own doubts on this, arguing that 'the appropriation of vernacular images does not raise a serious issue', and concluding that 'Spero's rites of passage . . . draw from a variety of ancient sources delicately reassembled in a highly personal aesthetic approach'. Nazli Madkour, 'Spero's Hieroglyphs', exh. cat., *7th International Cairo Biennale* (December 1998–February 1999).

33 Nancy Spero, notes for a panel on 'Expressionism: Artists Talk on Art' (New York, 1982).

34 The work that immediately followed *Notes in Time on Women* was the 22-panel scroll *The First Language*, completed in 1981, composed entirely of images of the female body in movement, a visual narration recording an experiential history from violence and brutality to athleticism, dance and the erotic.

35 The development of her technique of printing directly onto walls came from her discovery that images could be transferred onto rubber plates without significant loss of quality, thus allowing the possibility of printing onto uneven surfaces.

36 Ellen Labell, 'Notes on Women', *SoHo Weekly News* (25 January 1979).

37 Corinne Robins, 'Words and Images Through Time: The Art of Nancy Spero', *Arts Magazine* (New York), December 1979.

38 *Ibid.*

39 Buchloh, 'Spero's Other Traditions', p. 435.

40 Giorgio Agamben, *Remnants of Auschwitz: The Witness and the Archive*, trans. Daniel Heller-Roazen (New York, 1999), p. 12.

41 *Ibid.*, p. 13.

42 *Ibid.*, p. 39.

43 Scarry, *The Body in Pain*, p. 20.

44 Rosalind Coward and John Ellis, *Language and Materialism: Developments in Semiology and the Theory of the Subject* (London, 1977), p. 62.

45 This was the subject of many articles in the film journal *Screen* during the 1970s. For example, see the Special Double Issue on 'Cinema Semiotics and the Work of Christain Metz' (Spring–Summer 1973), and XVII/3 (Autumn 1976).

1 For a detailed discussion of Spero's use of architectural space in these installations and in her Lincoln Center Subway Station installation, see Susanne Altmann, 'Nancy Spero – Site-Specific Military Hospital of the Innsbruck Garrison – Festspielhaus, Dresden-Hellerau – Subway Station, New York', in *Nancy Spero: A Continuous Present*, ed. Dirk Luckow and Ingeborg Kähler (Kunsthalle zu Kiel, 2002), pp. 77–94.

2 Spero was invited by the Metropolitan Transit Authority's 'Arts for Transit' programme to compete with five other artists for the commission.

3 Robert Enright, 'On the Other Side of the Mirror: A Conversation with Nancy Spero', *Border Crossings*, xix/4 (November 2000), pp. 18–33.

4 Rosalyn Deutsche, *Evictions: Art and Spatial Politics* (Cambridge, MA, and London, 1996), p. xxiv.

5 Angela Carter, 'The Bloody Chamber', *The Bloody Chamber* (London, 1979; reprinted New York, 1993).

6 Lewis Mumford, *The City in History: Its Origins, its Transformations and its Prospects* (New York, 1961), pp. 446, 451.

7 *Ibid.*, p. 450.

8 *Ibid.*, pp. 479–80.

9 *Ibid.*, p. 480.

10 *Rushes* consisted of posters made from blown-up photographs that the artist took of miners in an open Brazilian mine. The posters, mounted in the spaces normally reserved for advertisements, were on view from 1 December 1986 to 31 January 1987. The title, *Rushes*, was meant to refer to the fact that viewers would see the mining images from a moving subway. A selection of these same images was also exhibited in light boxes in Galerie LeLong, New York, under the title *Gold in the Morning*.

11 This figure is based on a photograph of an internationally known Austrian singer, Friederike Massaryk (Fritzi Massary), from the 1920s. Spero had to promise not to use this image again in her art. Nancy Spero, interview with author, 18 February 2003.

12 Nancy Spero, interview with author, 18 February 2003.

13 Nancy Spero, interview with author, 18 February 2003.

14 Enright, 'On the Other Side of the Mirror', pp. 18–33.

15 *Ibid.*

16 Anne Barclay Morgan, 'From Victim to Power: Women across Cultures and Time: An Interview with Nancy Spero', *Art Papers Magazine*, xxv/6 (November–December 2001), p. 32.

17 Angela Carter, 'The Bloody Chamber'.

18 Nancy Spero, interview with author, 18 February 2003.

19 Nancy Spero, 'Utopia is a Morphine Dream I Had', statement for Vassar Utopian Conference, 13 February 2003.

20 H. A. Groenewegen-Frankfort, *Arrest and Movement: An Essay on Space and Time in the Representational Art of the Ancient Near East* (London, 1951; reprinted New York, 1972), pp. 31–2, 33.

21 'Jo Anna Isaak in conversation with Nancy Spero', in Jon Bird, Jo Anna Isaak and Sylvère Lotringer, *Nancy Spero* (London, 1996), p. 24.

22 Angela Carter, 'The Bloody Chamber'.

23 *Ibid.*, pp. 39–40.

24 Morgan, 'From Victim to Power', p. 32.

25 Nancy Spero, interview with author, 18 February 2003.

26 Samm Kunce, interview with author, 5 June 2003.

27 Bruno Bettlelheim, *The Uses of Enchantment: The Meaning and Importance of Fairy Tales* (New York, 1977), p. 5.

28 Marina Warner, *From the Beast to The Blonde: On Fairy Tales and their Tellers* (New York, 1994), pp. xxii–xxiii.

29 Enright, 'On the Other Side of the Mirror', pp. 18–33.

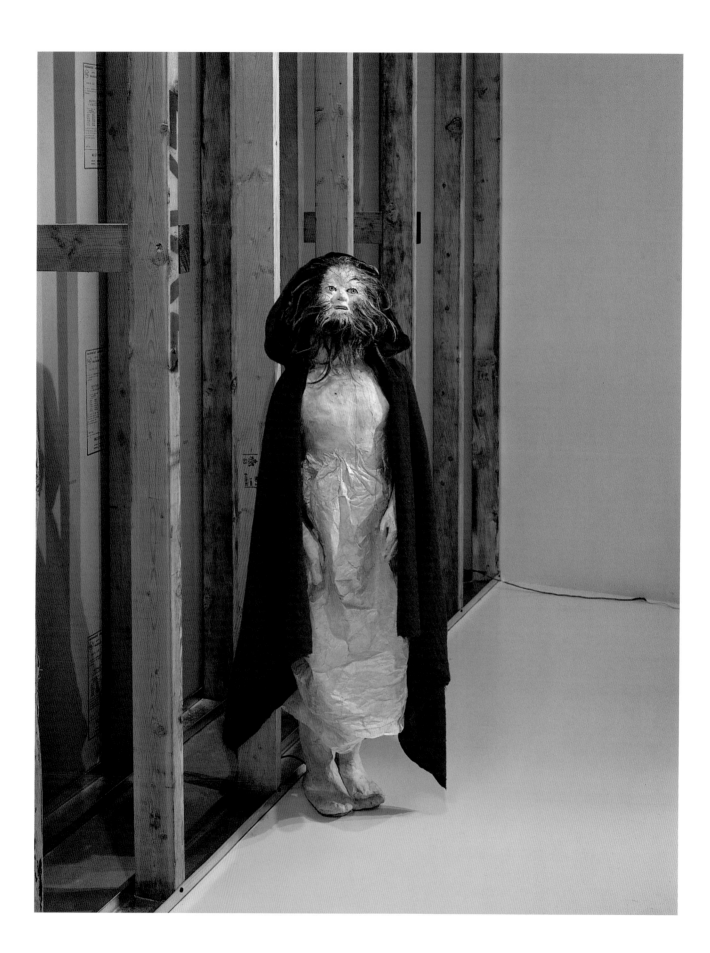

Selected Bibliography

KIKI SMITH
SINCE 1990

Aagerstoun, Mary Jo, text in *Terra Firma*, exh. cat., Art Gallery, University of Maryland, College Park, MD (1997)

Ahrens, Carsten, text in *Kiki Smith: All Creatures Great and Small*, exh. cat., Kestner Gesellschaft, Hanover (1998)

Bonami, Francesco, 'Kiki Smith: Diary of Fluids and Fears', *Flash Art* (January–February 1993), pp. 54–5

Boodro, Michael, 'Blood, Spit and Beauty', *Art News* (March 1994), pp. 126–31

Causey, Andrew, *Sculpture Since 1945* (Oxford, 1998)

Close, Chuck, 'Interview with Kiki Smith', *Bomb* (Fall 1994), pp. 38–45

Dannatt, Adrian, 'The Art Newspaper Interview: Kiki Smith', *Art Newspaper*, November 1999, p. 37

—, essay in *The Smiths*, exh. cat., The Palm Beach Institute of Contemporary Art, Lake Worth, FL (2002)

David, Catherine, text in *Désordes*, exh. cat., Galerie Nationale de Jeu de Paume, Paris (1992)

De Duve, Thierry, *Voici, 100 ans d'art contemporain* (Brussels, 2000)

Deitch, Jeffrey, text in *Post-Human*, exh. cat., FAE Musée d'Art Contemporain, Pully/Lausanne (1993)

Greenstein, M. A., 'A Conversation with Kiki Smith', *Artweek*, 7 January 1993, pp. 23–4

Guenther, Bruce, text in *The Essential Gesture*, exh. cat., Newport Harbor Art Museum, Newport Beach, CA (1994)

In the Lineage of Eva Hesse, exh. cat., Aldrich Museum of Contemporary Art, Ridgefield, CT (1994) [contains texts by Mel Bochner and Elizabeth Hess]

Isaak, Jo Anna, 'Love Calls Us to the Things of this World', in *Kiki Smith*, exh. cat., Whitechapel Art Gallery, London (1995)

—, *Feminism and Contemporary Art: Revolutionary Power of Women's Laughter* (New York, 1996)

Jahoda, Susan E., text in *This is my Body, This is my Blood*, exh. cat., Herter Art Gallery, University of Massachusetts, Amherst (1992)

Jones, Amelia, '"Presence" and Calculated Absence', *Art in America* (January–February 1995), pp. 101–5 and xvi

Kalina, Richard, 'Real Dead', *Arts Magazine* (December 1991), pp. 47–53

Kertess, Klaus, 'Kiki Smith: Elaborating a Language of the Body', *Elle Décor* (February–March 1996), pp. 52–3, 56, 58

Kiki Smith, exh. cat., Institute of Contemporary Art, Amsterdam (The Hague, 1990) [contains texts by Paolo Colombo, Elizabeth Janus, Eduardo Lipshutz-Villa, Kiki Smith and Robin Winters]

Kiki Smith, exh. cat., Wexner Center for the Arts, Ohio State University, Columbus (1992) [contains texts by Claudia Gould and Linda Shearer]

Kiki Smith: Silent Work, exh. cat., MAK Österreiches Museum für angewandte Kunst, Vienna (1992) [contains texts by Peter Noever, Kiki Smith and R. A. Stein]

Kiki Smith, exh. cat., Montreal Museum of Fine Arts (1996) [contains texts by Mayo Graham and Christine Ross]

Kimball, Roger, 'Oozing Out All Over', *Modern Painters* (Spring 1995), pp. 52–3

Kuspit, Donald, 'The Decline, Fall and Magical Resurrection of the Body', *Sculpture* (May–June 1994), pp. 20–23

Landi, Ann, 'Kiss & Tell', *Art News* (February 1995), pp. 116–19

—, 'Who Are the Great Women Artists?', *Art News* (March 2003), pp. 94–7

Levin, Kim, 'Voice Choices', *Village Voice*, 8 November 1994, p. 8

Lucie-Smith, Edward, and Judy Chicago, text in *Women and Art: Contested Territory* (London, 1999)

Lyon, Christopher, 'Kiki Smith: Body and Soul', *Artforum* (February 1990), pp. 102–6

McCormick, Carlo, 'Kiki Smith', *Journal of Contemporary Art* (Summer 1991), pp. 81–95

opposite page
98 Kiki Smith, *Daughter*, 1999, paper, bubble wrap, cellulose, hair, fabric and glass, 121.9 × 38.1 × 25.4 cm. (48 × 15 × 10 in.).

Musgrave, David, 'The Quick and the Dead', *Art Monthly* (December–January 1997–8), pp. 40–41

Myoda, Paul, 'Kiki Smith', *Frieze* (January–February 1996), pp. 64–5

Netzer, Sylvia, '3 New York Artists Use Glass: Judy Pfaff, Kiki Smith, Nancy Bowen', *Neues Glas / New Glass* (Spring 1995), pp. 1–29

Otto, Libby, 'RE: Production – Art and Medical Images of the Pregnant Body', *Queen's Feminist Review*, IV (1996), pp. 79–86

Pohlen, Annelie, text in *Uber Leben* (Bonn, 1993)

Pollack, Barbara, 'Leaping Off the Pedestal', *Art News* (June 1998), pp. 106–10

Posner, Helaine, *Corporal Politics*, exh. cat., MIT List Visual Arts Center, Cambridge, MA (1992)

—, *Kiki Smith*, interview with the artist by David Frankel (New York, 1998)

Raymond, Zizi, and Kiki Smith, *The Body Electric*, exh. cat., Corcoran Gallery of Art, Washington, DC (1991)

Regarding Beauty: A View of the Late Twentieth Century, exh. cat., Hirshhorn Museum and Sculpture Garden, Smithsonian Institution, Washington, DC (1999) [contains texts by Neal Benezra, Olga M. Viso and Arthur C. Danto]

Reinhardt, Brigitte, *Kiki Smith: Small Sculptures and Large Drawings*, exh. cat., Ulmer Museum, Ulm (2001)

Rian, Jeff, 'What's all this Body Art?', *Flash Art* (January–February 1993), pp. 50–53

Schwendener, Martha, 'The Body Returns', *Art in America*, 1–2 (1995), pp. 92–100 and XV–XVI

Sheets, Hilarie M., 'The Mod Bod', *Art News* (June 2001), pp. 98–105

Skestos, Stephanie, 'Modern and Contemporary Art: The Lannan Collection at The Art Institute of Chicago: Kiki Smith', ed. Jeremy Strick, *Museum Studies*, XXV/1 (1999), pp. 64–5

St-Gelais, Thérèse, 'Kiki Smith: la mélancolie de l'anatomiste', *Parachute*, 70 (1993), pp. 5–9

Stoops, Susan, text in *Kiki Smith: Unfolding the Body*, exh. cat., Rose Art Museum, Brandeis University, Waltham, MA (1992)

Tallman, Susan, 'Kiki Smith, Anatomy Lessons', *Art in America* (April 1992), pp. 146–53, 175

—, 'The Skin of the Stone: Kiki Smith at ULAE', *Arts Magazine* (November 1990), pp. 31–2

Tanguy, Sarah, 'Kiki Smith: Night', *Sculpture* (September 1998), pp. 64–5

Taplin, Robert, 'Dead or Alive: Molds, Modeling and Mimesis in Representational Sculpture' *Sculpture* (May–June 1994), pp. 24–31

Vicente, Mercedes, 'Un mundo natural', *Lapiz* (February 1998), pp. 62–73

Weber, John S, text in *Dissent, Difference and the Body Politic*, exh. cat., Portland Art Museum, Portland, OR (1992)

Williams, Gilda, 'Young Americans Part 2', *Art Monthly* (May 1996), pp. 27–9

Wilson, Andrew, 'Out of Control', *Art Monthly* (June 1994), pp. 3–9

Young, Dede, text in *Ethereal and Material*, exh. cat., Delaware Center for the Contemporary Arts, Wilmington (2000)

NANCY SPERO
SINCE 1986

Bird, Jon, Jo Anna Isaak and Sylvère Lotringer, *Nancy Spero* (London, 1996).

Board, Marilyn Lincoln, 'To the Revolution: Nancy Spero's Art as a Site of Transformation in the Context of French Feminist Theory', *Selected Essays: International Conference on Representing Revolution*, ed. John Michael Crafton, West Georgia College International Conference (1991)

Bonito Oliva, Achille, 'Art is a Gynacaeum of Images', *Sky Goddess, Egyptian Acrobat*, exh. cat., Galleria Stefania Miscetti, Rome (1991; reprinted in *Nancy Spero: Woman Breathing*, exh. cat., Ulmer Museum, Ulm, 1992).

Dobie, Elizabeth Ann, 'Interweaving Feminist Frameworks', *Journal of Aesthetics and Art Criticism*, XLVIII/4 (Fall 1990), pp. 381–94

Edelman, Robert G, 'Report From Washington, DC: The Figure Returns', *Art in America* (March 1994), pp. 39–43

how she was rapt away
by hermes, at zeus' command,
how she returned to sparta,
how in rhodes she was hanged
and the cord turned to a rainbow. h.d.

99 Nancy Spero, *Notes in Time on Women*, 1979, hand-printing and typewriter collage on paper, detail of one panel; whole work 40–50 cm. × 6,400 cm. (15–20 in. × 210 feet).

Fehlemann, Sabine 'Bildwelten aus Buchstaben', in *Buchstäblich: Bild und Wort in der Kunst heute*, exh. cat., Von der Heydt-Museum, Wuppertal (1991)

Flynn, Barbara 'Interview with Nancy Spero' (New York City, August 1986), *Nancy Spero*, exh. cat., Galerie Rudolf Zwirner, Cologne (1987)

—, 'Interweaving Feminist Frameworks', *Journal of Aesthetics and Art Criticism*, XLVIII/4 (Fall 1990), pp. 381–94

Fraser, Kathleen 'Letter From Rome: H. D., Spero and the Reconstruction of Gender', M/E/A/N/I/N/G, 10 (November 1991), pp. 40–42

Garb, Tamar, 'Nancy Spero', *Artscribe* (Summer 1987)

Gómez Reus, Teresa, 'Nancy Spero', *Canelobre*, 23–4 (Winter–Spring 1992), pp. 126–37

Hanak, Werner, and Mechtild Widrich, *Nancy Spero: Installation der Erinnerung*, Museum cat., Jüdisches Museum der Stadt Wien, Vienna (1996), pp. 44–9

Harris, Susan, 'Dancing in Space', *Nancy Spero*, exh. cat., Malmö, Sweden (1994)

—, *Of Joy and Despair*, exh. cat., Hiroshima City Museum of Contemporary Art (1996)

Hellman, Mimi, 'Nancy Spero', *Nancy Spero*, exh. cat., Smith College Museum of Art, Northampton, MA (1990)

Isaak, Jo Anna, 'Notes Toward a Supreme Fiction: Nancy Spero's Notes In Time on Women', *'Notes in Time' Nancy Spero and Leon Golub*, exh. cat., Fine Arts Gallery, University of Maryland Baltimore County, Catonsville (1995), pp. 30–43

Jones, Alan, 'The Writing on the Wall', *Arts* (October 1988), pp. 21–2

Kempas, Thomas, 'Zur Ausstellung', in *Nancy Spero: Bilder 1958–1990*, cat., Haus am Waldsee, Berlin and Bonner Kunstverein (1990)

Klein, Mason, 'Leon Golub and Nancy Spero, Roth Horowitz Gallery, New York', *Artforum* (September 2000), pp. 178–9

Laing, Carol 'Nancy Spero', *Parachute* (September–November 1987)

Lee, Jonathan Scott, 'Bodily Transcendence', *PsychCritique*, II/3 (1987), pp. 271–91

Line, Katy, and Helaine Posner, 'The Good Fight', *War and Memory: Leon Golub / Nancy Spero*, exh. cat., The American Center, Paris (Cambridge, MA, 1994)

McEvilley, Thomas, 'Nancy Spero, Josh Baer Gallery', *Artforum* (Summer 1986), pp. 123–24

Miller, Tyrus, 'Nancy Spero: Works since 1950, Museum of Contemporary Art, Chicago', SULFUR 24 (Spring 1989)

Nancy Spero, exh. cat., Institute of Contemporary Arts, London (1987) [contains essays by Jon Bird and Lisa Tickner]

Nancy Spero: Woman Breathing, exh. cat., Ulmer Museum, Ulm (1992) [contains essays by Brigitte Reinhardt, Noemi Smolik and Robert Storr]

Nancy Spero: Works since 1950, exh. cat., Everson Museum of Art, Syracuse, NY (1987) [contains essays by Leon Golub, Jo Anna Isaak, Dominique Nahas and Robert Storr)

Philippi, Desa, 'The Conjunction of Race and Gender in Anthropology and Art History: A Critical Study of Nancy Spero's Work', *Third Text*, 1 (Autumn 1987), pp. 34–54

Rose, Bernice, *Allegories of Modernism: Contemporary Drawing*, exh. cat., Museum of Modern Art, New York (1992)

Shottenkirk, Dena, and Nancy Spero, 'Dialogue: An Exchange of Ideas between Dena Shottenkirk and Nancy Spero', *Arts Magazine* (May 1987), p. 34

Siegel, Jeanne, 'Nancy Spero: Woman as Protagonist', *Arts Magazine* (September 1987), p. 10

Snyder, Jill, 'Sky Goddess – Egyptian Acrobat', *Artforum*, XXVII/7 (March 1988), pp. 103–5

Storr, Robert, 'Peripheral Visions', *Parkett*, 14 (1987), pp. 6–15

Temin, Christine, 'Bearing Witness', *Boston Globe Magazine*, 16 April 1995, pp. 18–19, 22–26

Welish, Marjorie, 'Word into Image: Robert Barry, Martha Rosler and Nancy Spero', *Bomb*, 47 (Spring 1994), pp. 36–44

Weskott, Hanne, 'Vorbild-Abbild-Bild', in *Nancy Spero in der Glyptothek, Arbeiten auf Papier, 1981–1991*, exh. cat., Glyptothek am Königsplatz, Munich (1991)

—, 'Differing Realities: Adriene Simotová and Nancy Spero', in *Détente*, exh. cat., VereinAusstellungs-organization (1991), pp. 74–7, 85–7

Withers, Josephine, 'Nancy Spero's American-born Sheela-na-gig', *Feminist Studies*, XVII/1 (Spring 1991), pp. 51–6

Wollheim, Richard, 'Painting, Drawing and Sculpture in the Reagan Years', *Modern Painters* (1992), pp. 49–53

Wye, Pamela, 'Nancy Spero: Speaking in Tongues', *M/E/A/N/I/N/G/*, 4 (November 1988), pp. 33–41

Selected Solo Exhibitions / Installations

KIKI SMITH

1982
Life Wants to Live, The Kitchen, New York

1988
Fawbush Gallery, New York

1989
Galerie René Blouin, Montreal
Concentrations 20, Dallas Museum of Art
Ezra and Cecile Zilkha Gallery, Center for the Arts,
 Wesleyan University, Middletown, CT

1990
Centre d'Arte Contemporaine, Geneva
Institute for Art and Urban Resources at the
 Clocktower, Long Island City, New York
Institute of Contemporary Art, Amsterdam

1990–91
Projects 24: Kiki Smith, Museum of Modern Art,
 New York

1991
Shoshana Wayne Gallery, Santa Monica
MAK Galerie, Vienna
University Art Museum, Berkeley
Corcoran Gallery of Art, Washington, DC
Greg Kucera Gallery, Seattle

1992
Kiki Smith: Sculpture and Works on Paper, Greg Kucera
 Gallery, Seattle
Unfolding the Body, Rose Art Museum, Brandeis
 University, Waltham
Fawbush Gallery, New York
Silent Work, Österreiches Museum für angewandte
 Kunst, Vienna
Moderna Museet, Stockholm
Bonner Kunstverein, Bonn

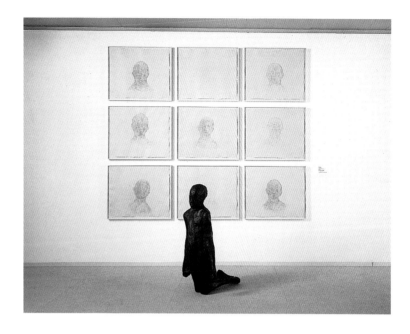

Shoshana Wayne Gallery, Santa Monica
Williams College Museum of Art, Williamstown, MA

1993
Anthony d'Offay Gallery, London
Fawbush Gallery, New York
Phoenix Art Museum

1994
University Art Museum, Santa Barbara
Louisiana Museum of Modern Art, Humlebaek
Galerie, René Blouin, Montreal
The Israel Museum, Jerusalem
Barbara Gross Galerie, Munich
Drawings, PaceWildenstein, New York

1994–5
Kiki Smith, Royal LePage Gallery, The Power Plant,
 Toronto

1995
Whitechapel Art Gallery, London

100 Kiki Smith,
Dark, 1997, paper,
celulose and indigo
matte medium
(figure) with
coloured pencil on
paper (drawings),
figure 88.3 × 43.2 ×
50.8 cm. (34.75 × 17
× 20 in.), drawings
54.9 × 66.7 × 3.8 cm.
(21.625 × 26.25 × 1.5
in.), installation
dimensions variable.

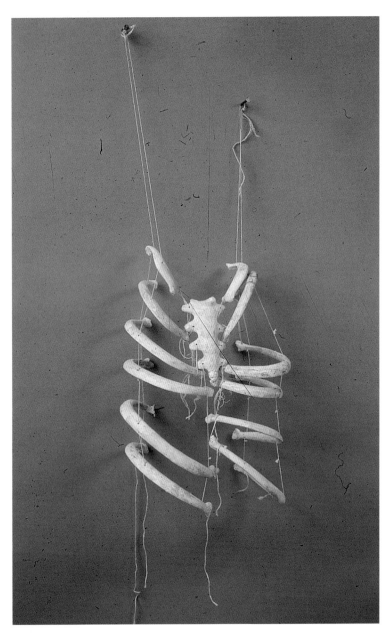

101 Kiki Smith, *Untitled (Ribs)*, 1987, terracotta, ink and thread, 50.8 × 38.1 × 22.9 cm. (20 × 15 × 9 in.).

opposite page
102 Portrait of Kiki Smith, New York, 15 January 1994.

Sculpture & Drawings, Anthony d'Offay Gallery, London
New Sculpture, PaceWildenstein, New York

1996
Kiki Smith: Werke / Works, 1988–1996, St Petri-Kuratorium, Lübeck
field operation, PaceWildenstein, Los Angeles

1996–7
Kiki Smith, Montreal Museum of Fine Arts, Montreal

1997
Once I Saw a Bird, Anthony d'Offay Gallery, London
Shoshana Wayne Gallery, Santa Monica
Kiki Smith 'Reconstructing the Moon', PaceWildenstein, New York

1997–8
Kiki Smith: Convergence, Irish Museum of Modern Art, Dublin

1998
Kiki Smith, Mattress Factory, Pittsburgh
Directions – Kiki Smith: Night, Hirshhorn Museum and Sculpture Garden, Smithsonian Institution, Washington, DC
Kiki Smith: All Creatures Great and Small, Kestner Gesellschaft, Hanover
Kiki Smith, Räume für neue Kunst, Wuppertal

1999
Kiki Smith, Barbara Krakow Gallery, Boston
Kiki Smith: Creation, Diözesanmuseum, Freising
Kiki Smith: 'You Art the Sunshine Of My Life . . .', The Fruitmarket Gallery, Edinburgh
Kiki Smith: Of her Nature, PaceWildenstein, New York

1999–2000
My Nature: Works with paper by Kiki Smith, St Louis Art Museum
Zetwenden: Rubblick und Ausblick, Kunstmuseum, Bonn

2000
Geneviève and the Wolves, Shoshana Wayne Gallery, Santa Monica

2000–01
Kiki Smith, Nassau County Museum of Art, Roslyn Harbor

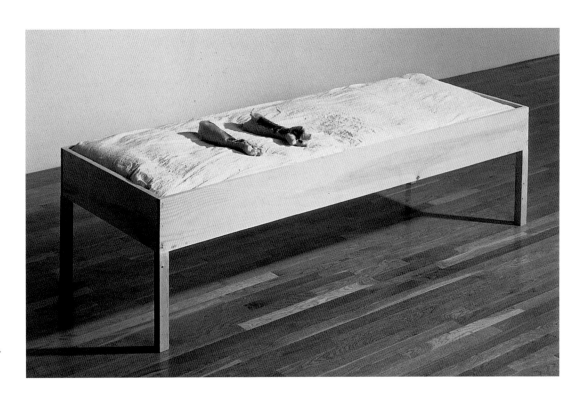

103 Kiki Smith, *Bed*, 1996, wool, cloth, wax and pigment.

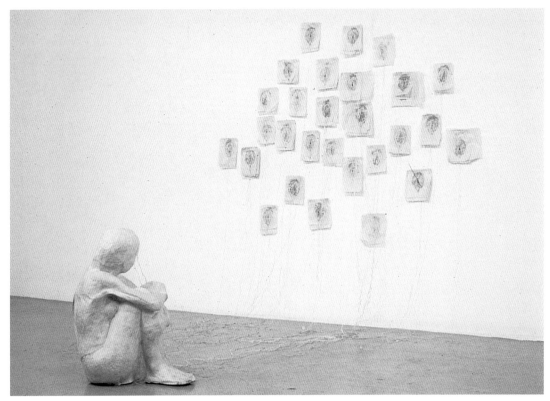

104 Kiki Smith, *Peacock*, 1994, papier-mâché and paper with ink, 67.3 × 44.5 × 54.6 cm. (26.5 × 17.5 × 21.5 in.), figure and 28 sheets of paper mounted to wall with paper strip extensions.

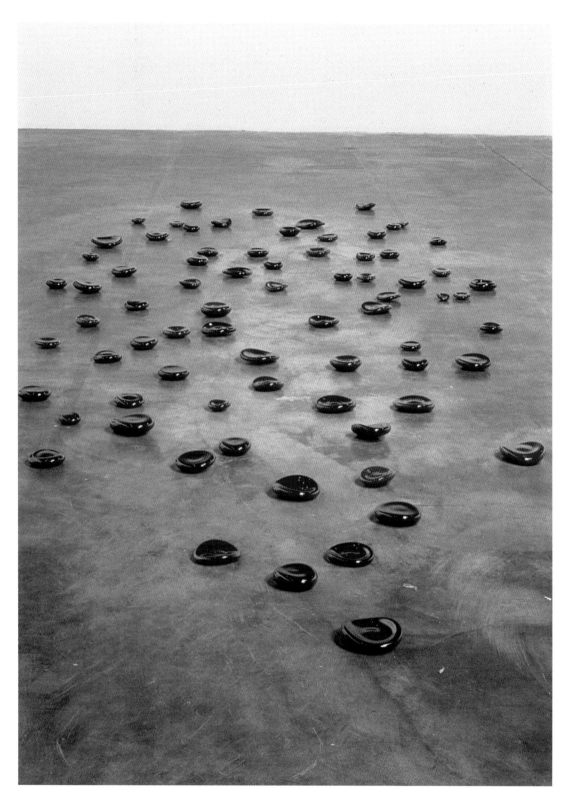

105 Kiki Smith, *Red Spill*, 1996, glass, 252 units, dimensions variable.

2003

BALTIC, The Centre for Contemporary Art, Gateshead
 (with Nancy Spero)

NANCY SPERO
SINCE 1987

1988

The Museum of Contemporary Art, Los Angeles
Barbara Gross Galerie, Munich
Rhona Hoffman Gallery, Chicago
Josh Baer Gallery, New York
Barbara Gladstone Gallery, New York

1989

Josh Baer Gallery, New York
Burnett Miller Gallery, Los Angeles
Le Grande Halle de la Villette, Paris
S. L. Simpson Gallery, Toronto

1990

Honolulu Academy of Arts
Gallery Hibell, Tokyo
Anthony Reynolds Gallery, London
Haus am Walsee, Berlin (toured to Bonner
 Kunstverein, Bonn; Gemeentemuseum, Arnhem)

2001

Kiki Smith: Telling Tales, International Center of
 Photography, New York
Kiki Smith: Small Sculptures and Large Drawings,
 Ulmer Museum, Ulm
Kiki Smith, University of Wyoming Art Museum,
 Laramie

1991

Jürgen Becker Galerie, Hamburg
Josh Baer Gallery, New York
Galerie Raymond Bollag, Zurich
Glyptothek am Königsplatz, Munich
Barbara Gross Galerie, Munich
Salzburger Kunstverein, Künstlerhaus Salzburg
Galleria Stefani Miscetti, Rome

2002

Kiki Smith: Realms, PaceWildenstein, 524 West 25th
 Street, New York

1992

Museum of Modern Art, New York
Ulmer Museum, Ulm

2002–3

Kiki Smith: Homework, The Fabric Workshop and
 Museum, Philadelphia

1993

Galerie Mathias Kampl, Passau
Greenville County Museum of Art, Greenville
Josh Baer Gallery, New York

1994
Malmö Konsthal, Malmö

1994–6
War and Memory: Nancy Spero and Leon Golub, The
 American Center, Paris; MIT List Visual Arts Center,
 Massachusetts Institute of Technology, Cambridge;
 Vancouver Art Gallery

1995
Barbara Gross Galerie, Munich
Residenzgalerie, Salzburg

1996
PPOW, New York
Jack Tilton Gallery, New York
Hiroshima City Museum of Contemporary Art
Galerie im Taxispalais, Innsbruck

1997
Documenta x, Kassel

1997–8
Barbara Gross Galerie, Munich

1998
Ikon Gallery, Birmingham
Crown Gallery, Brussels
2001
Barbara Gross Galerie, Munich
Vancouver Art Gallery, Canada
University of Massachusetts-Dartmouth

2002
Kunsthalle zu Kiel, Kiel, Germany
Galerie Lelong, New York
Trinity College, Hartford
Wesleyan University, Middletown, CT

107 Nancy Spero,
*The Black and the
Red III*, 1994, hand-
printing on walls.

108 Nancy Spero,
*Picasso and Fredricks
of Hollywood*, 1990,
hand-printed collage
on paper, 50.8 × 558.8
cm. (20 × 220 in.).

109 Nancy Spero,
Myth, 1990, 4 panels,
hand-printed collage
on paper, 218.4 ×
213.4 cm. (86 in. ×
7 feet).

2003
BALTIC, The Centre for Contemporary Art, Gateshead
 (with Kiki Smith)

2004
Centro Galego de Arte Contemporánea, Santiago de
 Compostela

INSTALLATIONS

Coptos Gateway, Ancient Egyptian Gallery, Museum
 of Fine Arts, Boston, 2003
Lincoln Center Subway Station, New York, 2002
Ikon Gallery, Birmingham, England, 1998
International Biennale of Cairo (American representa-
 tive), 1998
Jüdisches Museum der Stadt Wien, Vienna, 1996
 (permanent installation)
Heeresspital Innsbruck, Tyrol, 1996
New York Kunsthalle, 1996
Vancouver Art Gallery, 1996
Hiroshima City Museum of Contemporary Art

Residenzgalerie, Salzburg, 1995
Harvard University Art Museums, Cambridge, 1995
Centre Georges Pompidou, Paris, 1995
MIT List Visual Arts Center, Cambridge, MA, 1995
Malmö Konsthall, Malmö, Sweden, 1994
'War and Memory', The American Center, Paris, 1994
Stichting Artimo, Beurs van Berlage, Amsterdam, 1994
Ronacher Theatre, Vienna, 1993
 (permanent installation)
Jewish Museum, New York, 1993
Biennial Exhibition, Whitney Museum of American
 Art, New York
Harold Washington Library Centre, Chicago (perma-
 nent ceiling installation), 1991
Von der Heydt-Museum, Wuppertal, 1991
Circulo de Bellas Artes, Madrid 1991
Well Woman Centre & Westland / Blucher Street
 Junction, Derry, 1990
Smith College Museum of Art, Northampton, 1990
Prospect 89, Cupola Schirn Kunsthalle, Frankfurt
R. C. Harris Water Filtration Plant, Toronto, 1988
Museum of Contemporary Art, Los Angeles, 1988

Selected Public Collections

KIKI SMITH

Albright-Knox Art Gallery, Buffalo, New York
Allen Memorial Art Museum, Oberlin College, Oberlin
Art in Embassies, US Department of State, Washington, DC
Art Institute of Chicago, Chicago
Bonner Kunstverein, Bonn
Brooklyn Museum of Art, Brooklyn, New York
Cincinnati Art Museum, Cincinnati, Ohio
Cleveland Museum of Art, Cleveland, Ohio
Contemporary Art Museum, Honolulu
Corcoran Gallery of Art, Washington, DC
Des Moines Art Center, Des Moines
The Detroit Institute of Arts, Detroit
Fogg Art Museum, Harvard University, Cambridge, Mass.
Hallmark Cards, Inc., Kansas City
High Museum of Art, Atlanta, Georgia
Irish Museum of Modern Art, Dublin
Israel Museum, Jerusalem
Los Angeles County Museum of Art, Humlebaek
The Metropolitan Museum of Art, New York
Milwaukee Art Museum, Milwaukee
Moderna Museet, Stockholm
Museum of Contemporary Art, Los Angeles
Museum of Contemporary Art, San Diego, La Jolla, Ca.
Museum of Fine Arts, Boston, Mass.
The Museum of Fine Arts, Houston
The Museum of Modern Art, New York
The New York Public Library, New York
San Francisco Museum of Modern Art, San Francisco
Speed Art Museum, Louisville
The Stewart Collection, University of California
Tate Modern, London
Toledo Museum of Art, Toledo
Victoria and Albert Museum, London
Virginia Museum of Fine Arts, Richmond
Whitney Museum of American Art, New York
Yale University Art Gallery, New Haven, Conn.

NANCY SPERO

Art Gallery of Ontario, Toronto
Art Institute of Chicago
Australian National Gallery
Boston Museum of Fine Arts, Mass.
Centro Cultural, Mexico City
Corcoran Gallery of Art
Greenville County Museum of Art
Harvard University Art Gallery
MIT List Visual Arts Center, Cambridge, Mass.
Musée des Beaux-Arts de Montreal
Museum of Fine Arts, Hanoi, North Vietnam
Museum of Modern Art, New York
National Gallery of Canada, Ottawa
Philadelphia Museum of Art
Uffizi Gallery, Florence
Ulmer Museum, Ulm
University Art Museum, Berkeley, Ca.
Vancouver Art Gallery, Vancouver
Weatherspoon Art Gallery, University of North Carolina, Greensboro
Whitney Museum of American Art, New York

List of Illustrations

The authors and publishers wish to express their thanks to the following sources of illustrative material and / or permission to reproduce it. This list excludes such loaning bodies as required no additional credit information than their own names.

All of Nancy Spero's works illustrated, unless otherwise credited, were photographed by David Reynolds. Kiki Smith's works were photographed by Ellen Page Wilson, unless otherwise credited, and are Courtesy of the Artist and PaceWildenstein Gallery, New York.

21 Kiki Smith, *Eve*, 2001, manzinei (resin and marble dust) and graphite, 51.8 × 12.7 × 17.1 cm. (20 × 5 × 7 in.). Edition of three + two APs.

22 Kiki Smith, *Lilith*, 1994, silicon bronze and glass, 83.8 × 69.8 × 48.3 cm. (33 × 27.5 × 19 in.); unique, number one in a series of three + one unique AP.

23 a and b Nancy Spero, *Marlene, Sky Goddess, Lilith*, 1989, hand-printing and printed collage on paper, seven panels 2.7 × 3.7 m. (9 × 12 ft). Courtesy of the Artist and Galerie Lelong, New York.

24 Kiki Smith, *Flapper*, 2002, bronze, 52 cm. (20½ in.) high.

25 Kiki Smith, *Body*, 1995, cotton, polyester fibre fill, gold, 154.9 × 45.7 × 37.5 cm. (61 × 18 × 15 in.).

26 Kiki Smith, *Lucy's Daughters*, 1992, silkscreen and paper, 243.8 × 452.1 cm. (96 × 178 in.).

27 Kiki Smith, *Standing Harpie*, 2001, bronze, 121.8 cm. (48 in.) high.

28 Nancy Spero, *Let the Priests Tremble*, 1982, hand-printing on paper, 157.5 × 274.3 cm. (62 in. × 9 feet). Collection of Ohio State University.

29 Kiki Smith, *Untitled*, 1990, wax and pigment, life size. Collection of the Whitney Museum of American Art, New York.

30 Kiki Smith, *Untitled (Fallen Jesus)*, 1995, brown paper, methyl cellulose and horse hair, 134.6 × 45.7 × 127 cm. (53 × 18 × 50 in.). The Dakis Joannou Collection, Athens.

31 Kiki Smith, *Woman on Pyre*, 2001, bronze, 142.2 × 149.9 × 72.4 cm (56 × 59 × 28.5 in.).

32–3 Kiki Smith, *Blood Pool*, 1992, painted bronze, 35.6 × 99.1 × 55.9 cm. (14 × 39 × 22 in.).

34 Kiki Smith, *Honeywax*, 1995, beeswax, 38.1 × 91.4 × 50.8 cm. (15 × 36 × 20 in.). Collection of Milwaukee Art Museum.

35 Kiki Smith, *Pee Body*, 1992, wax, glass and pigment, life size. Collection of Barbara Lee, Emily Pulitzer and the Harvard Arts Museum.

36 Kiki Smith, *Virgin*, 1993, papier-mâché, glass and plastic, life size. Private Collection, USA.

37 Kiki Smith, *Mary Magdalene*, 1994, cast silicon bronze and forged steel, 152.4 × 50.8 × 53.3 cm. (60 × 20 × 21 in.). Photo: Herbert Lotz, courtesy of the Artist.

38 Kiki Smith, *Lilith*, 1994, papier mâché and glass, 43.2 × 78.7 × 81.3 cm. (17 × 31 × 32 in.).

39 Kiki Smith, *Lot's Wife*, 1996, silicon bronze with steel stand, 205.7 × 68.6 × 66 cm. (81 × 27 × 26 in.).

40 Kiki Smith, *Crescent Moon*, 2002, plaster over foam, 96.5 × 208.3 × 40.6 cm. (38 × 82 × 16 in.).

41 Kiki Smith, *Sirens*, 2001, bronze, various sizes.

42 Kiki Smith, *Moon on Crutches*, 2002, cast aluminium and bronze, dimensions variable.

43 Kiki Smith, *Reina*, 1993, burlap, plaster and sequins, dimensions variable.

44 Kiki Smith, *Tied to her Nature*, 2002, plaster over foam, 106.7 × 223.5 × 45.7 cm. (42 × 88 × 18 in.). Collection of Whitney Museum of American Art, New York.

45 Kiki Smith, *Fountainhead*, 1991, handmade book with photo-engravings on Abaca paper, 20.32 × 12.7 cm. (8 × 5 in.), edition of 100. Photo: Sarah Harper Gifford. Plate 13.

46 Kiki Smith, *Fountainhead*, 1991, handmade book with photo-engravings on Abaca paper, 20.32 × 12.7 cm. (8 × 5 in.), edition of 100. Photo: Sarah Harper Gifford. Plates 8 and 9.

47 Kiki Smith, *Fountainhead*, 1991, handmade book with photo-engravings on Abaca paper, 20.32 × 12.7 cm. (8 × 5 in.), edition of 100. Photo: Sarah Harper Gifford. Plate 15.

48 Kiki Smith, plate 4 from *Fountainhead*, 1991, handmade book with photo-engravings, 1.9 × 20.3 × 13.7 cm. (0.75 × 8 × 5.375 in.), one of an edition of 100. Photo: Sarah Harper Gifford.

49 Kiki Smith, *Fountainhead*, 1991, handmade book with photo-engravings on Abaca paper, 20.32 × 12.7 cm. (8 × 5 in.), edition of 100. Photo: Sarah Harper Gifford. Plate 5.

50 Kiki Smith, *Rapture*, 2001, bronze, 170.8 × 157.5 × 66.7 cm. (67 × 62 × 26 in.), edition of three + one AP.

51 Nancy Spero, 2003. Photo: Abe Frajndlich.

52 Nancy Spero, *Vulture Goddess*, 1991, hand-printing on beams (detail). 'Devil on the Stairs', ICA, Philadelphia.

53 Nancy Spero, *Minerva, Sky Goddess, Madrid*, 1991, hand-printing on walls and floors. Installation on

Terraza for 'El Sueno Imperativo', Circulo de Bellas Artes, Madrid.

54 Nancy Spero, *Minerva, Sky Goddess, Madrid*, 1991, hand-printing on walls and floors. Installation on Terraza for 'El Sueno Imperativo', Circulo de Bellas Artes, Madrid.

55 Nancy Spero, *The Goddess Nut*, 1990, hand-printed collage on paper, 106.7 x 279.4 cm. (42 × 110 in.).

56 Nancy Spero, *To Soar III*, 1991, hand-printing on ceiling. Permanent installation for Harold Washington Library, Chicago.

57 Nancy Spero, *To Soar III*, 1991, permanent installation at the Harold Washington Library Center, Chicago, handprinting on ceiling, 533.4 × 3,810 cm. (17.5 × 125 feet).

58 Nancy Spero, *Vulture Goddess*, 1991, hand-printing on beam (detail). 'Devil on the Stairs', ICA, Philadelphia.

59 Nancy Spero, *Sacred and Profane Love*, 1993, hand-printed collage on paper, 49.5 × 2,235.2 cm. (19.5 × 880 in.).

60 Nancy Spero, A *Cycle in Time*, 1995, hand-printing on silk, 76 × 428 cm (29.9 × 168.5 in.). Installation, Residenzgalerie, Salzburg.

61 Nancy Spero, *The First Language*, 1981 (detail of Panel 9), painting, collage and hand-printing on paper, 50.8 × 897.6 cm. (20 in. × 190 ft).

62 Nancy Spero, *Runway*, 2000, hand-printing and printed collage on paper, 497.8 × 50.8 cm. (196 × 20 in.).

63 Nancy Spero, *L'Anges, Merde, Fuck You*, 1960, oil on canvas, 43.8 × 55.9 cm. (17.25 × 22 in.). Collection of the Artist.

64 Nancy Spero in her New York studio, 1993. Photo: Susan Unterberg.

65 Nancy Spero, *Picasso and Fredricks of Hollywood*, 1990 (detail), hand-printed collage on paper, 50.8 × 548.6 cm. (20 × 216 in.).

66 Nancy Spero, *The Hours of the Night II*, 2001, hand-printing and printed collage on paper, eleven panels, 2.74 × 6.7 m. (9 × 22 ft.). Courtesy of the Artist and Galerie Lelong, New York.

67 Nancy Spero's studio, New York, 1978. Hand-printed work on paper, 1974.

68 Nancy Spero, *Codex Artaud*, 1971 (detail of panel VII), typewriter and painted collage on paper, 52 × 381 cm. (20.5 × 150 in.). Courtesy of the Artist and Galerie Lelong, New York.

69 Nancy Spero, *Homage To New York (I Do Not Challenge)*, 1958, oil on canvas, 119.4 × 78.7 cm. (47 × 31 in.). Courtesy of the Artist and Galerie Lelong, New York.

70 Nancy Spero, *Codex Artaud*, 1971 (detail of panel VI), 52 × 316.2 cm. (20.5 × 124.5 in.). Courtesy of the Artist and Galerie Lelong, New York.

71 Nancy Spero, *Hours of the Night*, 1974, hand-printing and painted collage on paper, 284.5 × 660.4 cm. (112 × 260 in.). Courtesy of the Artist and Galerie Lelong, New York.

72 Nancy Spero, *Notes in Time on Women*, 1979 (detail of panel 19), painted collage, typewriter and hand-printing on paper, 0.5 × 64 m. (20 in. × 210 ft). Collection of Museum of Modern Art, New York.

73 Nancy Spero, *Notes in Time on Women*, 1979, installation for exhibition *Notes in Time: Nancy Spero and Leon Golub*, Fine Arts Gallery, University of Maryland, Baltimore, 1995.

74 Nancy Spero, *Hours of the Night*, 1974 (detail of panels 6/7/8).

75 Nancy Spero, panel 8 from *Torture of Women*, 1976, painting, collage and hand-printing on paper, 50.8 × 3,810 cm. (20 in. × 125 feet). Musée des Beaux-Arts de Montreal.

76 Nancy Spero, *Notes in Time on Women*, 1979 (16 of 24 panels), painted collage, typewriter and hand-printing on paper, 0.5 × 64 m. (20 in. × 210 ft.).

77 Nancy Spero, *Notes in Time on Women*, 1979 (detail of panel 24).

78 Nancy Spero, *Notes in Time on Women*, 1979 (detail of panel 8).

79 Nancy Spero, *Torture of Women*, 1976, hand-printing and painted collage on paper, 0.5 x 38.1 m. (20 in. x 125 ft). Installation New Museum of Contemporary Art, New York, 1984. Collection of National Gallery of Art, Ottawa.

80 Nancy Spero, *Notes in Time on Women*, 1979 (detail of panel 9).

108 Nancy Spero, *Picasso and Fredricks of Hollywood*, 1990, hand-printed collage on paper, 50.8 × 558.8 cm. (20 × 220 in.).

109 Nancy Spero, *Myth*, 1990, 4 panels, hand-printed collage on paper, 218.4 × 213.4 cm. (86 in. × 7 feet).